Capturing the World

Capturing the World

The Art and Practice of Travel Photography

Nick Rains

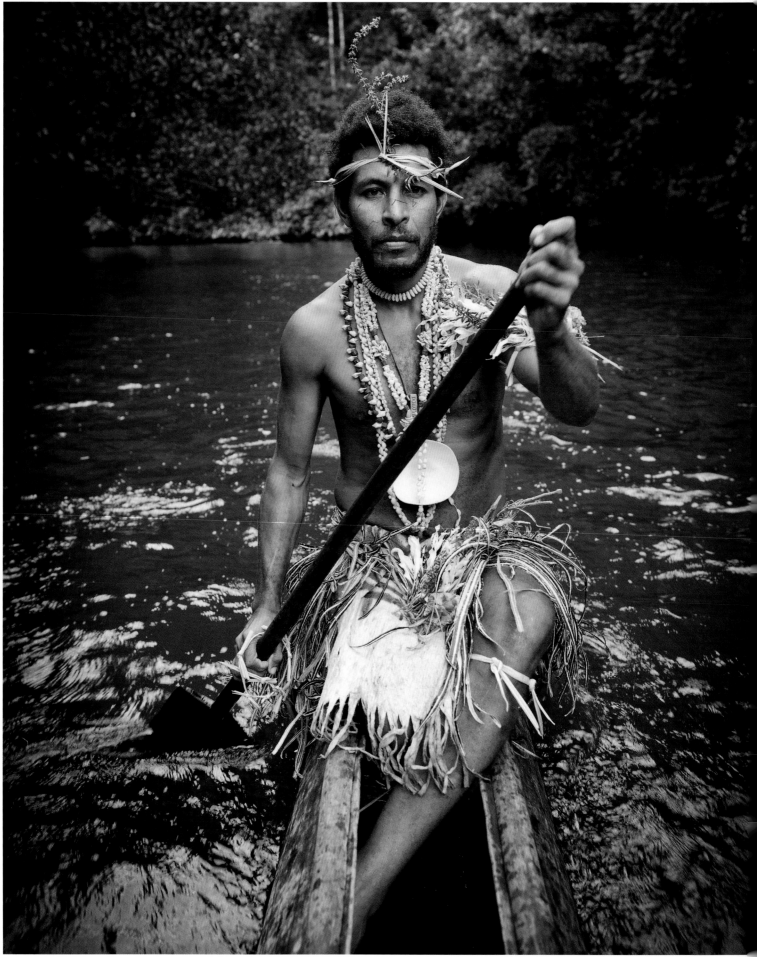

Tufi, Papua New Guinea | Leica S2 | 35mm | 1/90 sec @ f4.8 | ISO320

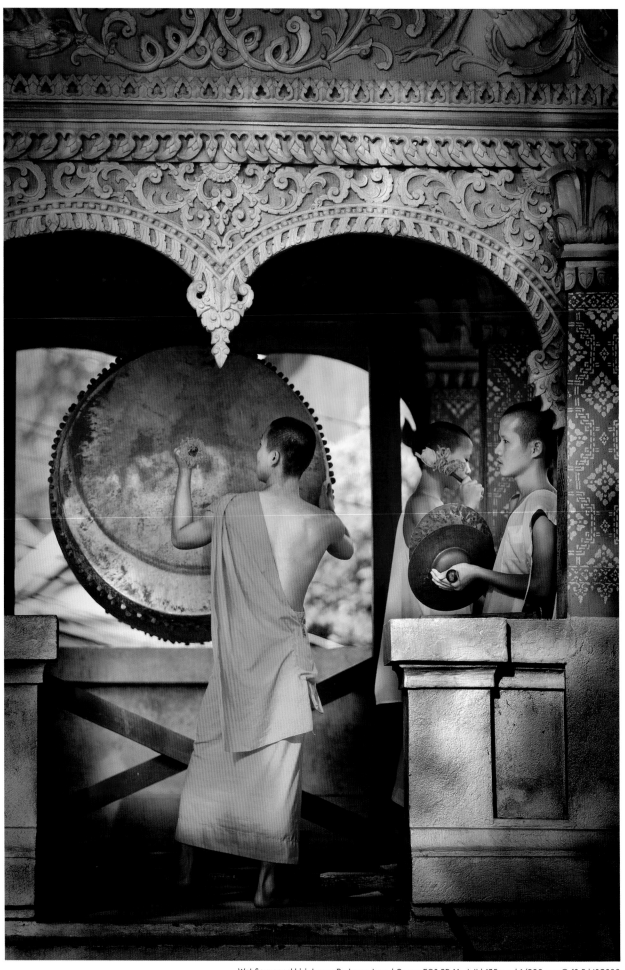

Wat Souvannakhiri, Luang Prabang, Laos | Canon EOS 5D Mark II | 135mm | 1/500 sec @ f2.5 | ISO200

Foreword

We all need moments, nostalgia fed by a photo, the whole travel thing enveloped in a frame. Beauty is encapsulated, scents restored, memories enriched – the photos the last thing we grab when we rush from a house fire.

Remember the glossy posters of exotic destinations taped to our bedroom walls as we grew up, or in share houses, forever feeling the pull of the road, the adventure, a destination. And we all want to bring back the perfected synthesis of the journey to put about in front of our friends and family – and sometimes hope for a grander distribution.

But to get to the right place at the right time, when the light and synergy is perfect, is not a haphazard experience. It takes ingenuity and well-practised planning, achieved with reconnaissance, mindfulness and experience.

Taking a shot can be easy, but picking the winners, polishing the gems, is the task and dedication of a lifetime spent pursuing the Zen moment. It's difficult to teach, harder to learn. And then there is the passion to do it and keep doing it, through the bleak times along with those of benevolence.

You can make your own luck but you still have to know what you want to shoot. You cannot teach rapport, you can't teach human interaction – you can only post-mortem that moment from a captured frame, for it was and is that reality. Once it was locked on a negative, but now it is locked into a digital moment condemned by entropy.

I've always just made my frames and only thought about it later. In these chapters, Nick alerts you to the problems and issues before you get there. He even leads you to apps that can help you with your shots – dreamt-of stuff in my war-torn past. Pay attention; there are details here you need to know that are not necessarily in the guide books or manuals.

Here you can learn: know what you want to capture, what is possible, the feasibility, the pitfalls, how to think it out, how and when to overstep, how to turn that phone or pad into something extra. This advice comes from longtime professional intuition and experience; you'll see it in Nick's stunning frames.

Photographers are a privileged bunch. We witness and shoot things that can range from the most profane (in war) to the most beautiful and amazing (in peace). The moment is ours to be able to put our own lick on a definitive 1/125th.

The very recording of our travels is in jeopardy unless some retain the passion to engrave history with memorable frames. Nick has all the patience of a Cheshire cat, old-world savvy, and that necessary attitude to the technicalities we now find ourselves immersed in and often bewildered by. With his stoic understanding, he conveys the patience necessary to create that perfect image. His is a flair to pass on those (Leica) honed skills and the grammar of our craft.

Nick's canvas is a digital chrome that leaves me still agape at his double rainbow, and at the Escher-scape of the cathedral in Milan. Even this old dog is up for a few new tricks ...

Tim Page
BRISBANE 2015

Introduction

'You either see or you don't see. The rest is academic. Anyone can learn how to develop. It's how you organise what you see into a picture.'

– ELLIOTT ERWITT

December 1985. The Air Romania flight is on final approach to Bangkok airport and staring out of the window is a 23-year-old man, absorbing the patchwork of paddy fields and palm groves that roll by, closer and closer as the old 707 extends its wheels towards the waiting tarmac. Playing through his mind is one thought: 'What on earth am I doing here?'

That was me, having never been further from home than the Spanglish holiday resorts on the Costa Brava. There I was in Thailand, with a single brick of Kodachrome in my Billingham bag, a Canon F1n and a Hasselblad, not much money and no clear idea what the next few weeks or months would hold. I had some vague commitments from a travel company to maybe use images of Thailand and Malaysia as well as a visa for Australia which would allow me to stay for a year or so.

My plan, such as it was, was to become a 'real' photographer. I had spent the previous two years photographing houses for real estate agents in the north of England to make a living. I wanted, very much indeed, to follow in the footsteps of the photographers who filled the *Telegraph* Sunday supplement with colour images of impossibly exotic locations around the globe, the legends at *National Geographic* – even becoming one of the anonymous cameramen who photographed hotels for the Thomas Cook and Thomson Holiday brochures would be fine with me.

In short, I didn't have a clue – not about taking photographs per se, but about how much more there is to travel photography than the act of pressing the button on the camera. In this book I'd like to share with you some of the lessons I have learned over the course of the ensuing 30 plus years, mostly lessons learned the hard way, by trial and error.

Like so many photographic 'genres', travel photography covers an extremely wide range of subject matter. A good set of travel images will contain people, architecture, landscapes, action, macro, nature and so on. It's therefore important to be able to shoot all these types of images as part of your normal repertoire and this book will use images of these different genres, and more, to illustrate the points of how you can get the best out of your travels.

To drill down a little deeper, I think it's fair to say that 'travel photography' is a bit of a misnomer in that it can include just about any sort of photography, but I do think we all know what is meant by the term. Most people would understand that travel photography is what you do when you go away to visit new places and take your camera along to record your trip. This could be on the other side of the world, or a trip to a different part of your home country.

Different motivations

Some people might be completely content to take a convenient compact camera or smartphone along on a trip, snapping whatever they can on the journey, to show to friends and family back home – taking 'visual notes' if you will. Another group of travellers will take photography a bit more seriously, using a more advanced camera and diligently recording their travel experiences.

A third group contains enthusiasts, photographers who 'travel-with-a-purpose', where the entire trip is focused on creating good images. Itineraries might be based around the best time of year or correct time of day to be in certain places and the broad emphasis will be on subjects that are first and foremost

visually appealing. This group is more likely to be out and about in the streets than to be visiting galleries and museums (which are actually hard to photograph well anyway, regardless of their fame).

There is a fourth group of course: professional travel photographers. Their motivations are a little different to everyone else in that there might be a specific brief to follow or a certain topic to be emphasised, but their photographic approach is very similar to that of the enthusiast.

Regardless of your travel motivation, taking good images is always more satisfying than taking ordinary ones. In this book I hope to offer advice and suggestions that will assist anyone with a camera to come back from a trip with pleasing photos that capture something of the places visited.

How this book works

This is not a regular photography textbook – there is no comprehensive step-by-step breakdown of all the technical stuff that photographers are always going on about. There are some technical sections for those who need a refresher, but the bulk of the book looks at real-world shooting situations and how to deal with them. I've selected 25 key photos, one for each chapter, and I discuss them with context and advice for similar situations.

I draw from my experience of shooting in all sorts of situations in many countries and, while there are plenty of ways to skin a cat, particularly in photography, at least you can be sure that what I tell you does in fact work. It might not be the only way to approach a situation, but it's the way I approached it – with the results that you'll see in these pages.

I've also included my top travel tips, particularly geared to photographers. I give a few easy pointers on what equipment to take, airport issues, backing-up, file storage and safety. Have a look at those hints to get a quick sense of some of the prep I do before a trip and daily housekeeping while I'm working.

Why we take photographs

Why are we motivated to take photos when we visit new places? I think there are two main reasons, aligned to a certain degree with the groups described above.

Firstly, we love to share our experiences with our friends and family, and our modern world is very visually oriented. We totally 'get' photos and to be able to show someone where we have been offers a richer experience than simply using words. Furthermore, photos are a kind of 'proof' that your verbal description is based on a real experience. The veracity of a photograph is still one of its strengths, regardless of how much post-processing is applied to the image once the photographer gets home.

Some people like making photos just for the pleasure of doing so. Yes, they want to show and share those images – and let's face it, there has never been a greater variety of ways to do this – but the primary motivation is the mastering of a skill and the creation of a 'pleasing image'.

Sometimes the motivation for a trip is solely a desire to head off and see new places; other times the trip is a means to a photographic end, that of finding stimulating and exciting subject matter and making great images. Of course a good photographer can make great images anywhere – at least in theory. But no-one can doubt the allure of exotic new destinations as a way to get the creative juices flowing!

What makes a good travel photo?

That's an easy one to answer; broadly speaking, the same criteria for any good photo apply to a good travel photo. By that I mean framing, light quality, drama and so on, which apply to any photographic genre, whether it's weddings, sport, landscape or travel. The only difference is, by our definition of travel photography, that the photo will have been taken on some sort of trip away.

More specifically, a good travel photo will capture something of the place where it was shot. This can be hard to achieve. What do we mean by 'capture something of the place'? Do we mean a face, a group, an activity, a landscape – or all of the above? Is it even possible to achieve a sense of place in a single photo?

I'd argue that it's only possible to achieve a sense of place in a single image if the image is 'of' something which is recognisable. The viewer cannot know where to mentally place the image unless there are some strong clues to make it recognisable. This of course leads us to the supposed trap of 'cliché', wherein something is so recognisable and iconic that it has been photographed a million times before. Or perhaps it has become iconic precisely *because* it has been so heavily photographed. Think Grand Canyon, Eiffel Tower, Uluru – you get the picture (pun intended).

So we have two conflicting impulses here. How do we make a single image which captures the essence of a place without creating a clichéd photo? This is a skill that the experienced travel photographer needs to develop, to be able to come up with an aspect of a familiar scene which is better, bigger, quirkier, more creative or just plain different to what has been captured before. With the current plethora of good quality digital cameras in the hands of millions of visitors around the world this is getting harder and harder – because pretty much everything has been photographed before and it is no longer sufficient to come back from a distant land with the straightforward recorded images that so wowed audiences in earlier times.

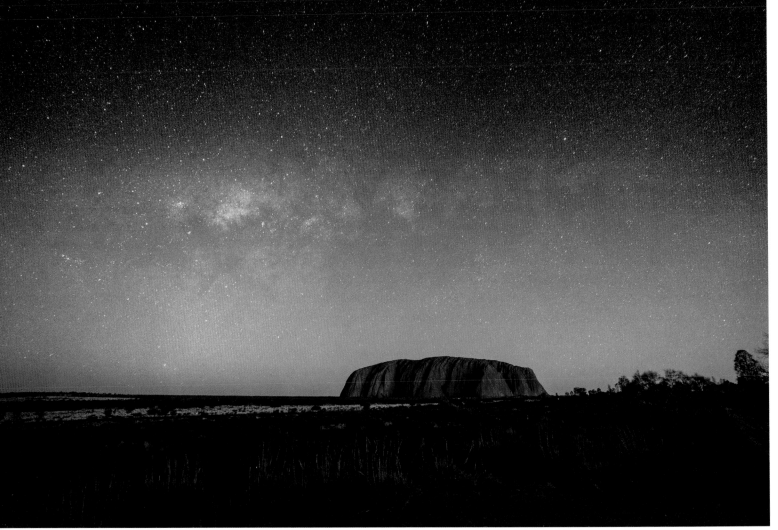

Uluṟu, Northern Territory, Australia | Leica SL (Typ 601) | 18mm | 60 sec @ f16.0 | ISO3200

In the past just the simple fact of having lugged all the old-style photographic paraphernalia to, say, Egypt and making a photo of the Sphinx, and then returning safely to the Royal Society was impressive. When you consider that audiences had never seen such sights before, it's easy to believe how amazed they would have been. Nowadays a photo of the Sphinx could easily be dismissed as a cliché.

Familiar not clichéd

It is a real pity that the word 'cliché' has such a negative vibe to it. The reason a photo becomes considered a cliché is not because it's inherently bad but most often because it's been over-used. That photo of the Sphinx was actually a great image when it was first made and remains so today. It might also be that a certain scene can only be photographed from a particular place because all the other angles are simply and obviously inferior. Thus it is inevitable that such an image will become considered a cliché even though it's actually a strong image – it's familiarity that's the problem here, not the image itself.

A case in point would be the classic shot of Uluṟu at sunset, the luminous red rock exploding out of the flat desert. There is only one spot you are allowed to take the sunset image from, so everyone gets the same image. If you go looking for a different angle you'll either fall foul of the park rangers or get an image which might be different, but is not necessarily better, because the rock is an entirely different shape when viewed from other directions. The 'standard' shot might be a cliché on one level but in the right conditions it is still capable of being incredible. Think water cascading off in a rare rainstorm, think spectacular stars – or both!

Just because a place has been photographed a million times does not make it unworthy of your attention. Your photograph always has the potential to be the best ever taken – certainly the best you've ever taken – because nature might, just might, gift you with perfect light; you just need to be there with your camera.

Recognising the moment

Nowadays we see lots of top-notch imagery on the TV, online, in magazines, on billboards. If you are a photo enthusiast then you may be familiar with the curated photo-sharing sites such as 1x and 500px where wonderful creative images pour in every day. Don't let this cause you to despair. I find that looking at amazing images makes me want to go out and make my own great shots to hang on my wall, enter into competitions or submit to photo-sharing sites. It's inspirational and aspirational all at the same time.

Creating the quintessential single iconic travel image requires a lot of things to come together in, dare I say it, a lucky convergence.

Maybe 'fortuitous' is a better word but there are so many factors that you cannot ever control. Regardless of how skilled (or unskilled) you are there will come a time when everything just lines up and 'click', there it is, an award-winning image with all the elements in their right place, perfect light, perfect background and so on. A large part of this, beyond technical photographic skill, is recognising such a moment.

Furthermore, it can take quite a lot of effort to put yourself in a position where the potential for great images is maximised. This is why a veteran travel photographer will tend to create a higher proportion of photos worth keeping than enthusiasts – not because better gear was available but because he or she had done the research, planned where to be and when to be there, and maybe even preconceived the shot they wanted to take.

Hopefully the discussion of images in this book will address many of these aspects of travel photography and, by seeing how a successful image was made from start to finish, you'll come to understand a lot more about the process of creating fine travel images.

Back to Thailand, 1985. I learned a valuable travel lesson there from, of all people, an Alaskan king crab fisherman called Tom.

In 1985 the 'traveller' culture had yet to become the major industry it is today and somewhere in the house I even have my dog-eared copy of Tony Wheeler's *South East Asia on a Shoestring*, the classic 1981 second edition with the yellow cover.

I caught the bus from Bangkok to Phuket – 13 hours through the traffic and the humidity, my first overnight bus trip. Westerners were not that common, so hearing Tom's American accent was a relief and we got talking. Turns out Tom worked on the fishing boats for six months of the year, earned a bucket load of money and spent the other six months travelling on his own. We ended up in the same hotel in Phuket – not through any karmic coincidence I might add, but for the simple reason that there was only one hotel in Phuket back then.

My lesson was learned the following day when we caught a longtail boat to see 'James Bond Island' (a location for the 1974 film, *The Man with the Golden Gun*) and then on to the island of Ko Phi Phi. We landed on, to my eye anyway, an unbelievably perfect beach lined with coconut palms and Tom said to me, 'This is cool, I'm staying here'.

'What about your bags back in the hotel?' I said, looking at his half-full knapsack.

'This is my bag,' he said.

I thought back to my towering backpack in my hotel room, full of clothes and whatnot, and realised that he had what he needed, nothing more, nothing less. It was quite an epiphany for me, although I still cannot pack that light!

The lesson was basically to take only what you need when travelling. I will always have more luggage than most because I need a certain amount of camera gear to do my job, but when I pack for my next trip I always remember that conversation with a crab fisherman on Ko Phi Phi.

This early part of my budding career as a travel photographer did not play out so well. I had problems in Singapore with film processing, my Hasselblad proved very hard to use for travel photos and I had not really tuned my eye to what photos would be commercially useful.

I subsequently arrived in Australia where my fortunes changed forever when I became involved with the press coverage of the America's Cup. I ended up working directly for Canon, assisted the *TIME* and *Sports Illustrated* magazine photographers, met editors and over the course of 14 months I 'evolved' from a total neophyte into a professional.

A note on captions: The captions throughout include both the location and technical data of the camera I used, with the lens size, shutter speed, aperture and ISO.

Get
in close

Holi Festival, Bithoo, Rajasthan, India

I had been invited to celebrate Holi by village elder Harish Bhati, on the right in the blue polo shirt. The men were sitting inside the entrance to a big courtyard and I sat down with the older guys to ritually share some refreshments. It's this aspect of getting in close that leads to good photos – you can't (or shouldn't) just wade in and start shooting. Sitting awhile, accepting the sugar cakes and tea, it's all part of the local customs. To take the shot it was important to keep the exposure correct for the foreground and quietly wait for a moment when the interaction between the men was interesting, and when no-one was looking at me.

– LEICA M (TYP 240) | 18MM | 1/45 SEC @ F6.8 | ISO400

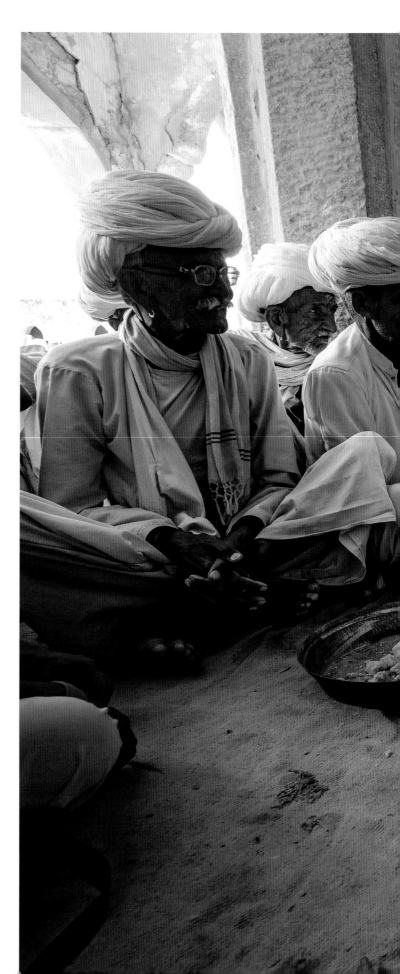

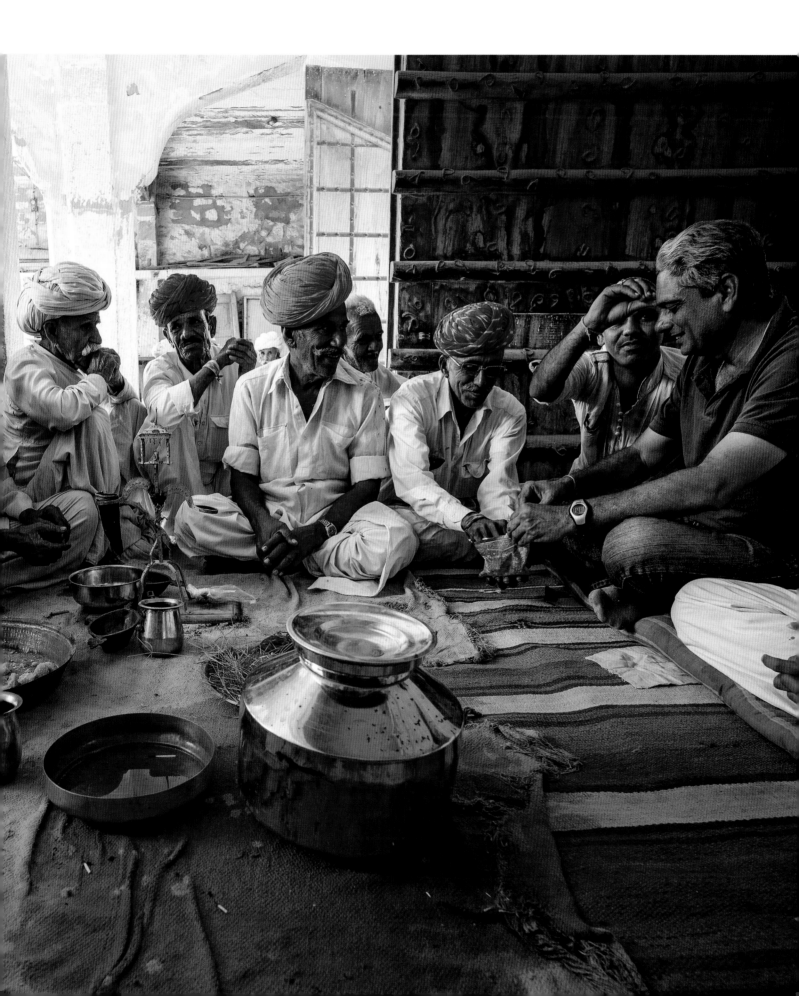

'If your pictures aren't good enough, you're not close enough.'

– ROBERT CAPA

Travel photography is all about sharing your experiences – not just showing your viewers what you saw but also giving them a sense of being there.

Getting in close is often easier said than done, but standing away, using a telephoto lens, is a guaranteed way to produce images with little sense of immediacy. I like to mix up my images with a variety of viewpoints but nothing can compare to the impact of an image that was shot really close in, one that demonstrates that you were part of what was going on, not just a distant observer.

It's a challenging thing to do; a photographer's natural inclination is to observe, not take part, so moving in, approaching strangers and making contact will be hard. But if a job is worth doing it's worth doing well, so leave your comfort zone behind and make that first step.

A guest in Rajasthan

The image that opens this section was shot during the Holi celebrations in India, in a small village not far from Jodhpur called Bithoo. The reason I have included this photo, apart from the fact that I really like it, is that I was invited to take part in the celebrations as a guest, not just as a passer-by. Being included in this way leads to the kinds of photographic opportunities that you cannot simply come across unless you are very lucky, and I prefer not to rely on luck in my work.

Holi Festival, Rajasthan, India | Leica M (Typ 240) | 18mm | 1/60 sec @ f4.8 | ISO400

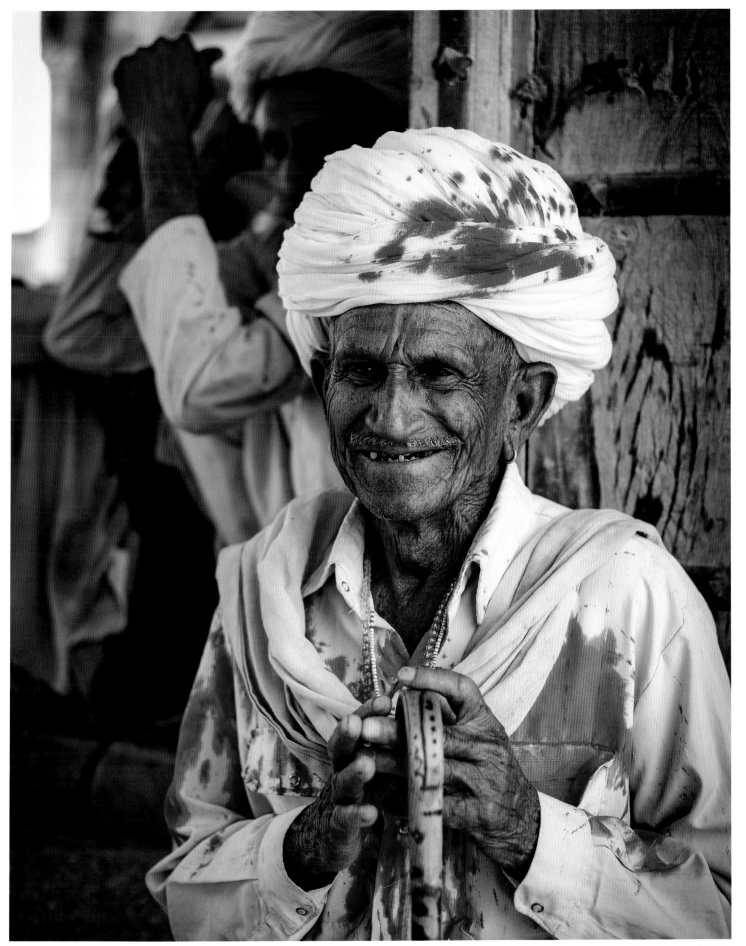

Holi Festival, Rajasthan, India | Leica M (Typ 240) | 50mm | 1/250 sec @ f4.0 | ISO200

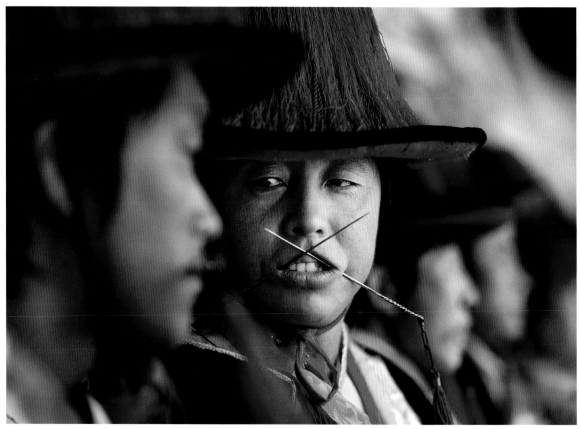

Shaman Festivals, Suhuri Temple, Tongren, China | Leica S2 | 120mm | 1/350 sec @ f2.8 | ISO640

I was invited to sit down with the village elders and the local headman and partake of some refreshments. It's terribly important to say 'yes, thank you' to this welcome, regardless of what you're being offered, because in many parts of the world hospitality is a Big Deal and to refuse is to be rude. Accept graciously even if, as in this case, you don't know if the water is suitable for delicate Western stomachs. I was also wondering about the sugary substance being offered around but was assured by my guide that it was just that, sugar.

In any event, I drank, ate and smiled. This led to big smiles and friendly nods all around, after which everyone pretty much got on with talking about whatever it was that they had been discussing before I arrived. It's at this point, after the social niceties have been observed, that you can get out your camera and, with permission and slowly at first, start making images.

There was plenty of light in the courtyard so I let the camera's meter worry about exposure, leaving me free to concentrate on expressions and I managed to capture the moment when headman Harish was being ritually anointed with purple powder.

Earn an invitation

During the Shaman Festivals in Qinghai Province, northwest China, I witnessed the ritual piercing of young men's cheeks, something that you're not normally allowed to photograph.

I had been photographing all the ceremonies in and around Tongren during the previous week. I'd been quiet, deliberately keeping out of everyone's way, and had been able to create some good images. What was missing were some of the more intimate shots, the 'backstage' events if you like.

On about the eighth day I was surprised to be approached by the Shaman himself, who indicated that I should go with him. I followed him through the temple forecourt to where the local men were preparing for a ritual where their cheeks are pierced by large steel needles. He made a camera clicking motion with his hands and indicated that it was OK for me to shoot.

To say I was surprised is a bit of an understatement, but I didn't hesitate, working my way to the front of the throng, right up to where the next 'victim' was being skewered.

The images I got are powerful examples of the visual impact that can be achieved if you are able to get right into the thick of things.

Afterwards I asked my guide why I had been singled out from amongst the large numbers of other foreigners with cameras to be privy to the ritual. He told me that the same elders run all the daily events and that 'I had been noticed'. I took this to mean that they had seen me being careful not to get in the way, not being intrusive with my photo making and generally being respectful. Being invited to see more was my reward.

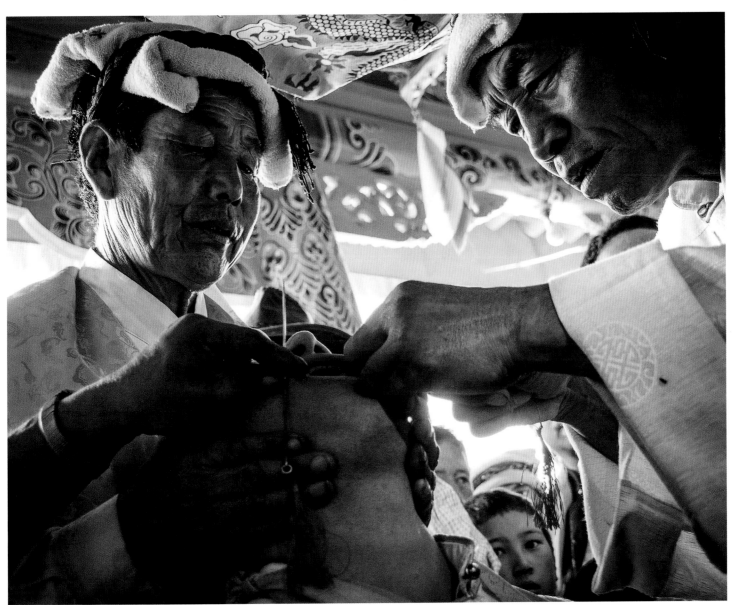

Shaman Festivals, Suhuri Temple, Tibetan Plateau, Tongren, China | Canon EOS 60D | 24mm | 1/30 sec @ f4.0 | ISO400

Events

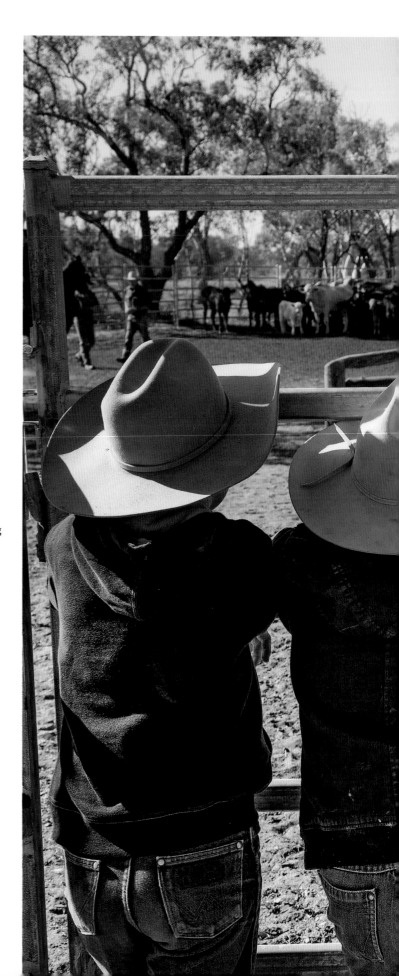

Gymkhana, Windorah, Australia

Outback events like this are great for getting shots of country people, because it's normally quite difficult to see groups of people together in these communities, due to the great distances between outback stations. All cultures have their own distinct 'look' and, in this case, a stockman's hat is what the well-dressed cattle hand wears. Identifying some sort of typical clothing like this clearly places the shot in the outback of Australia, and the repeating pattern of five hats makes the image that much stronger, particularly when framed to show the context of the cattle mustering in the background.

— CANON EOS 5D MARK II | 38MM | 1/250 SEC @ F8.0 | ISO200

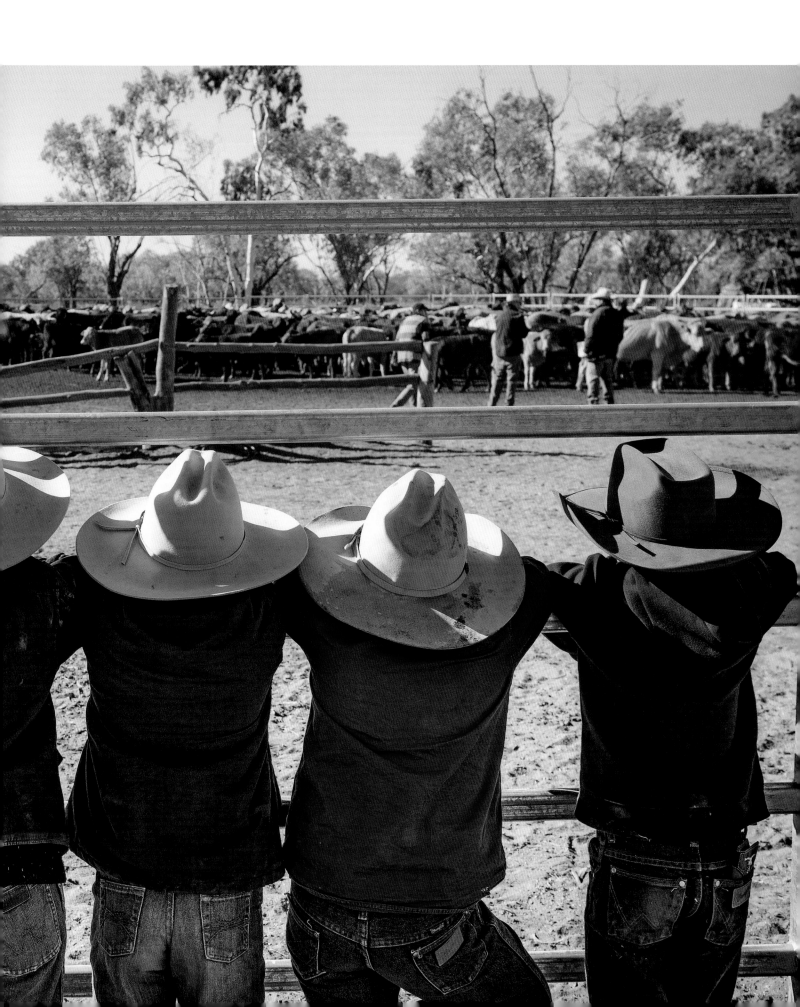

01 Organised public events are a 'photo rich environment'

02 Check in with the organisers for best access

03 Watch your backgrounds for corporate logos and other distractions

04 Telephoto lenses are very handy

'If you want to take more interesting pictures stand in front of more interesting stuff.'

– JOE MCNALLY

There is an infinite amount of photography subjects out there in the wide world – just about everything you can actually see can be turned into a photograph whether it's you (a selfie), your family, where you visit and so on. How exactly you use your camera to create interesting images depends as much on what you are shooting as on what you want to achieve.

When you are travelling, either in your home country or on an overseas trip, subjects will commonly present themselves one at a time – a new vista as you drive around a corner, or an interesting building at the side of the road. Each new subject will generally require a certain approach but one exception to this is when you try to make photographs at an 'Event'.

I'm talking here about those wonderful opportunities for photography presented by community and cultural events – think in terms of a religious festival, a commemoration, a local fair near home, a farmer's market and so on. These require a somewhat different approach to general travel photography. I am going to use the example of the Windorah Gymkhana in western Queensland in Australia to explain what I mean by event photography.

Firstly, such events, whether small or large, are photographically confusing. There is always a lot going on – activities over which you have no control whatsoever – and it's easy to become overwhelmed by all the action. For the photographer it's going to need to be all fly-on-the-wall stuff, shooting as things happen, reactive rather than creative. This is not at all straightforward.

Secondly, you will always have little choice over time of day so you are often forced into shooting when the light is poor; you can almost guarantee that something really interesting will happen when the sun is in the wrong place! In fact this is a classic conundrum – do you try to capture amazing moments regardless of the light quality or do you prefer to make each image when the light is perfect and accept that you will inevitably miss other opportunities. Trying to achieve both is certainly possible, but not easy!

Here are 10 pointers to help you get the best from an event.

1. If at all possible, find the organisers, or elders if it's a cultural event, and ask if it's OK to shoot some photos and, more importantly, find out if there are places which you should avoid. At smaller community events the organisers are usually perfectly happy to accommodate you but at bigger events this might not be so easy. If you offer to send some of your photos in for them to use on their Facebook page or website that usually works as a good icebreaker!

2. Grab a copy of the program or schedule if there is one, so you know where particular events are being held and what time they kick off. A map is useful here too. Go and have a look at the different locations and try to make a judgement about where the light will be best. Some will be in difficult-to-shoot places with poor backgrounds and others might be just perfect. Often, for events such as this one in dusty western Queensland, having the sun behind the action will give you the best results because the sun picks up the dust and this creates atmosphere.

Windorah Gymkhana, Queensland, Australia | Canon EOS 5D Mark III | 300mm | 1/640 sec @ f2.8 | ISO200

3. Many events will happen more than once or will last some time. Take this opportunity to watch the proceedings and get a sense of how the action is likely to unfold. The cattle roping event at Windorah had many contestants and because they all did essentially the same thing I was able to work out where to stand to get the best angle with a clear view of the action and with the sun slightly behind.

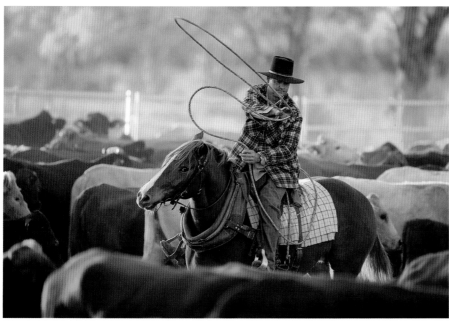

Windorah Gymkhana, Queensland, Australia | Canon EOS 5D Mark III | 300mm | 1/320 sec @ f2.8 | ISO200

4. Be on the lookout for details, patterns, repeating shapes, quirky items and other eye-catching features. Close-ups of boots with spurs, decorated horse tails, belt buckles, dogs in utes and so on worked well for this event and the same can be said for other events whether local or more exotic. All these subjects are part of the overall sense of place and should be captured in order to add to the story you are telling. I used a 300mm lens quite a lot at this event but a decent long lens would help here too: a 70–200mm zoom is probably ideal. Anything of 135mm or longer will be useful.

5. Autofocus is not necessarily your best friend. AF is quick and convenient but when things are moving quickly it's all too easy for the camera to get confused and focus on the wrong thing. In the cattle roping event the AF insisted on focusing on the wooden roping rails instead of the ringers behind. Because all the action was in the same spot each time I could turn off the AF and fix the focus slightly beyond the rails, then wait for the right moment.

6. I am a big fan of getting close to the action with a wide lens. This is fine in markets, on the street and so on, but at events there is a danger of you simply getting in the way. The last thing you want is to interfere with the competitors so my advice in these circumstances would be to work with that longer lens and generally keep clear. Exceptions would be when shooting amongst the spectators on the safe side of the railings.

7. Don't be afraid to engage with the participants and ask to shoot a photo or two. The best way to get good close-ups of interesting competitors' faces is not during the events but afterwards when they have done their 'thing' and are relaxing with their friends.

8. Watch your backgrounds. This is critical. It's all too easy to be so focused on the subject that you miss the awkward shapes or colours in the background. The worst things are commercial billboards, which are quite common at events like this one. Nothing worse than a brilliant shot of a ringer roping a steer with the golden dust hanging in the air, and then seeing a bright-red soft drink ad in the

Windorah Gymkhana, Queensland, Australia | Leica Q (Typ 116) | 28mm | 1/60 sec @ f2.8 | ISO3200

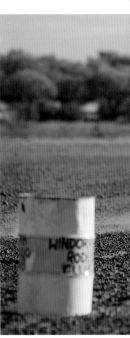

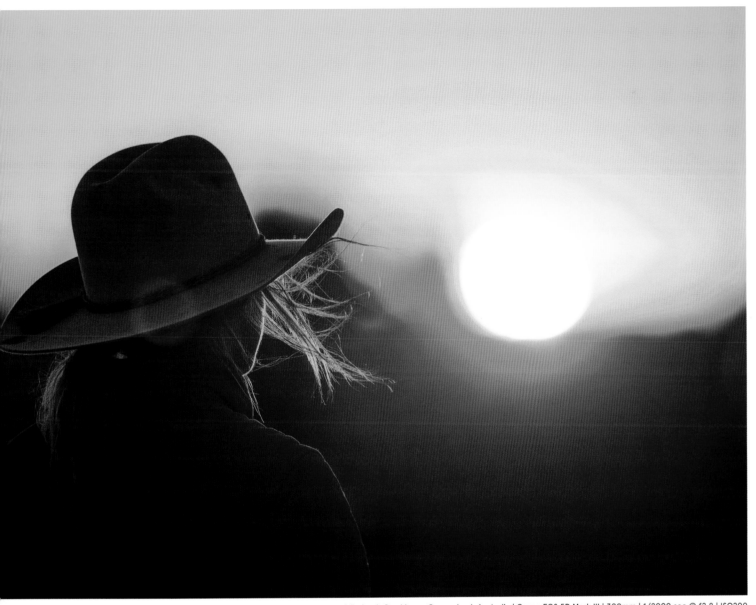

background when you view the photo later. Your eye is very good at concentrating on the subject and filtering anything else out of your consciousness – the camera does not do this and captures everything equally. Backgrounds can make or break a photo.

9. Relax and be open to unexpected opportunities. You can't photograph everything, so be selective, take your time and aim for quality over quantity. A modest number of interesting images in great light will be far more satisfying than a photo of every competitor in every event.

10. Enjoy the event. Try sitting back for a while and soaking up the atmosphere. Taking half an hour to sit and watch will freshen your mind and re-energise your creativity.

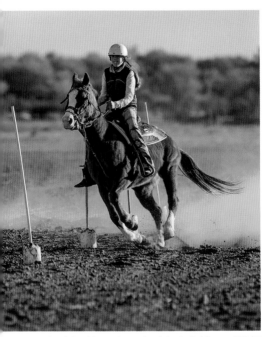

Windorah Gymkhana, Queensland, Australia | Canon EOS 5D Mark III | 300mm | 1/1600 sec @ f3.5 | ISO200

Smartphones

There is an expression in the photography world: the best camera is the one you have with you. Given that smartphones are so common these days, and that we almost always have them with us, then it follows that, some of the time at least, your phone is your best camera.

Smartphone cameras are extremely convenient and they are easy to use, which means that people often turn to their phone to grab a shot when they don't want to go to the trouble of getting their 'proper' camera out. Convenient does not always equate to good, so let's look at the pros and cons of using a phone as a camera and discover ways to make the most of them.

Positives

— Image resolution in good light can be surprisingly good. iPhones can make A3 prints with a bit of care and they are plenty good enough for the Web.

— The internal processing of the image seems to deal with contrasty subjects quite well.

— No controls to worry about, and the auto-only design works well enough most of the time.

— Very light and convenient to use; most people carry their phones with them at all times.

Negatives

— Small sensors and tiny lenses limit the quality of the image. Low light ability is very limited compared to a dSLR for example.

— Only one focal length unless you 'zoom' the shot digitally (which reduces quality) or add an external lens adapter.

— Shutter response is often sluggish – you can easily miss fast-moving subjects unless you shoot a burst.

— Phones only produce JPEGs not raw files thus limiting the quality.

— No built-in tripod mount for long exposures – third-party clips are useful for this.

— Hard to hold steady at arm's length.

I'll be mostly concerned with Apple's iPhone here, since it's the one I have most experience with, having owned each model since the iPhone 3. I'm told the Samsung range of phones also has excellent imaging ability and can be modified by third-party apps much like the iPhone.

Manila airport | iPhone5

Preah Khan, Angkor, Cambodia | Sweep panorama on iPhone5

Image quality

Image quality can be excellent, within the limits of the phone's sensor design. I have made excellent A3 prints from an iPhone 5, prints that no-one could pick as having been taken on the phone. I simply treated the image like any other photo and applied my usual polishing methods in Adobe Lightroom, but even straight out of the phone itself the image can print really well.

Once the light levels begin to drop then the image quality drops off in direct proportion. What looks just fine on the phone's screen can in fact be very noisy and lacking in contrast if you try to make a print. Low light limits are to be expected; however, small sensors (make that tiny) are always limited in their light gathering ability so don't expect too much in the dark!

Operation

The iPhone 5 and 6, straight out of the box, have a few controls that are very helpful but not immediately apparent.

Two excellent features spring to mind. The first is the ability to shoot a very fast burst of images rather than one image, thus making it far easier to get the moment 'just right'. Hold the shutter button down and the phone will fire off a burst of images at 10 per second. Right away you can pick the best one or more out of the sequence as 'keepers' and delete the rest.

The other feature I like is the ability to specify the focus and the exposure point by pressing and holding your finger on the screen where you want the camera to focus. You can also swipe your finger up and down to the right of the focus box to manually increase or decrease the exposure – great for backlit subjects which sometimes come out as a silhouette. Unlike many cameras, if the image looks good on the phone's screen, it will look just as good after you have taken it.

The iPhone has a shutter button on the screen but it's a bit awkward to use and hold the phone steady at the same time.

Better to use the volume control buttons on the side to take the shot as they fall under your fingers more naturally as you grip the phone.

Advanced features

PANORAMAS

Phones can do more than just take single shots. Most have some sort of panorama tool where you set the camera to panorama mode, then, starting at the left, trigger the camera and turn to the right slowly, following a prompt on the screen. This is called a sweep-panorama and the internal processor joins together a whole series of stills 'behind the scenes'. You end up with a shot which is a lot wider than a single shot could ever be, anything from slightly wide to a full 360 degree panorama.

HDR

Highly contrasty subjects sometimes need more than one photo to capture the entire range of tones between the brightest parts to the shadows. Most current model phones have some sort of auto HDR (high dynamic range) mode which takes multiple shots and squashes them together into one photo. The results can be a bit varied but many times you do get a better result than shooting a normal, single image.

THIRD-PARTY APPS

The true power of the iPhone, and to a certain extent Android-based phones, is the wealth of add-on applications that you can get either for a few dollars or totally free. Searching in the iTunes store for photography apps shows over 1400 different choices!

A straightforward photo will satisfy most people but why not express your creativity and produce something with more flair. You can add texture overlays, frames, grunge effects, drama, film grain – the list is long – in fact there is such a huge range of options available via different editing apps that there is a whole photography activity called iPhoneography with forums, photo sharing, competitions and so on.

Sugarloaf Rock, Western Australia | iPhone 6 | 4.1mm | 1/1000 sec @ f2.2 | ISO80

The built-in camera controls are OK but there is a lot more you can do with the camera by using third party apps which take the basic functions of the camera and extend them, often to considerable lengths.

Some apps have become almost 'standard' for people wanting to squeeze more out of their phone camera, and also to do a bit of post-processing. Here are a few that I use regularly.

VSCOcam and Camera Awesome These two give you more nuanced control over camera functions such as white balance, focus points, ISO, etc. 'Manual' allows full control of all camera controls much like you get on a fully fledged dSLR.

ProHDR This is a more advanced version of the camera's own HDR feature and does a better job of dealing with high-contrast subjects. TrueHDR works well too.

Snapseed This is one of the best from a host of apps that can do all sorts of 'creative' things – some good, some a bit ordinary and some appallingly tacky! It comes free from Google, so its pedigree is impeccable. Snapseed allows you to easily take your photo and turn it into a work of art with controls such as Tune Image, Crop, Frame, Grunge, Drama, Detail, Grain and so on. It's easy to use and very powerful – so much so that even though I have tried other apps, I keep coming back to this one.

Your phone camera can indeed be a viable alternative to a 'real' travel camera but only as long as you are aware of its restrictions. Your camera phone is likely to be the one you turn to if something crops up that you just have to catch and a modest quality photo is better than no photo at all.

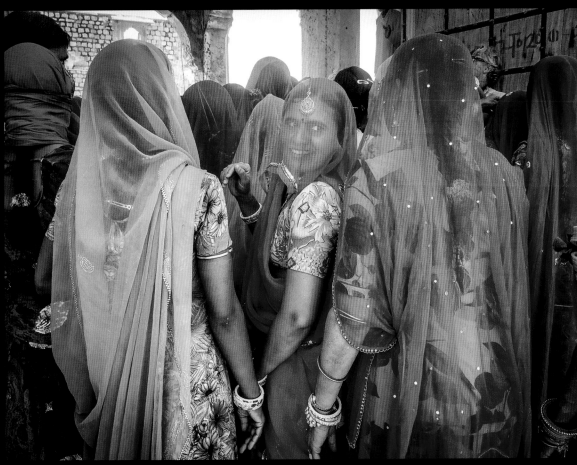

Chandelao, Rajasthan | iPhone 6 | 4.1mm | 1/200 sec @ f2.2 | ISO32

Anticipation

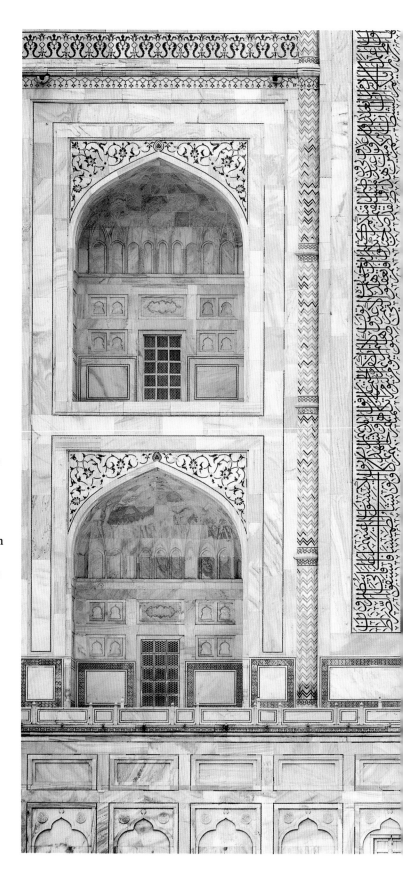

Taj Mahal, Uttar Pradesh, India

Having found out the hard way that there is no access to the river edge to get a shot of the Taj Mahal reflecting in the water, I opted to go for a more graphic shot by closing right in on the repeating shapes of the arches and the amazing calligraphy on the columns. Perspective is compressed with long lenses, so I used a 300mm lens to get in tight. Flat, hazy light at dawn meant that contrast was not a problem, so then it was just a case of waiting for a gap in the stream of visitors walking through the shot. The solitary security guard is there for scale and this human element makes the building look all the more massive.

— CANON EOS 5D MARK III | 300MM | 1/25 SEC @ F4.0 | ISO100

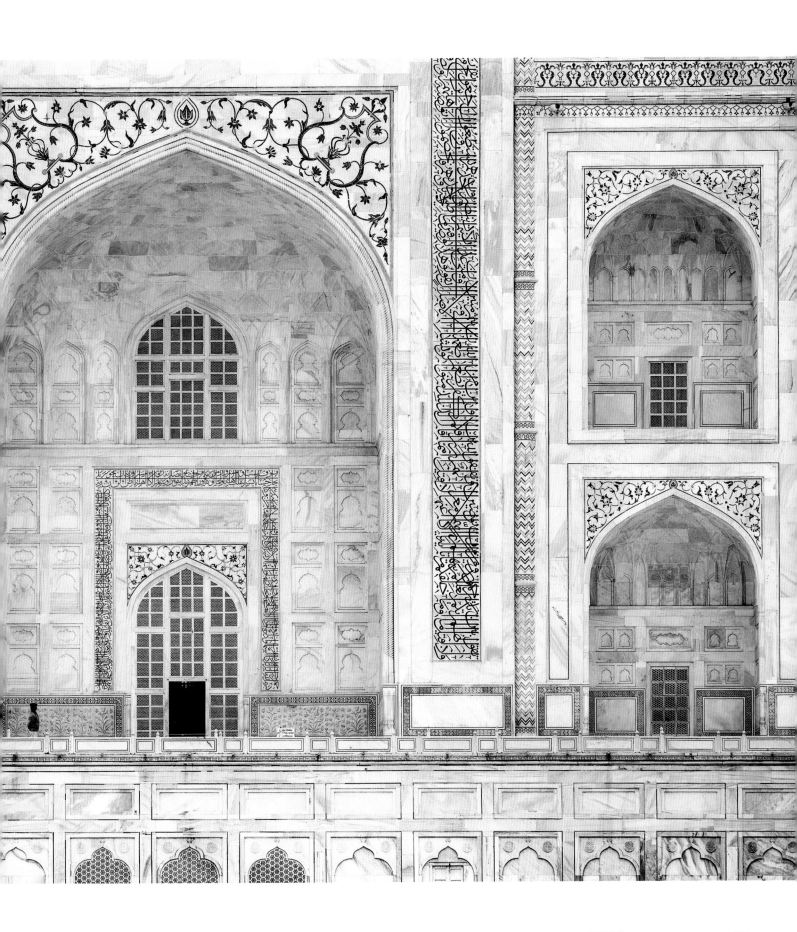

01 Have a clear idea of what you would like to shoot

02 Be prepared to completely change your ideas if necessary

03 Think on your feet

Osian, Thar Desert, Rajasthan, India | Canon EOS 5D Mark III | 45mm | 1/125 sec @ f7.1 | ISO200

'No plan survives contact with the enemy.'

– HELMUTH VON MOLTKE

Here's a question all photographers must ask themselves before heading out to a local shoot or leaving on an extended trip: what am I going to photograph? Or maybe the question should be: what photographs will I create? A subtle difference, but an important one.

'What am I going to photograph?' is easy to answer because you will almost certainly have some sort of preconception of what you are going to see, because you have probably chosen to make the trip partly based on photos you have already seen. Personally, I do a lot of research on Google – the images section will give you a good idea of the visual possibilities for just about any location, so you should know roughly what's on the cards.

'What photographs will I create?' is a harder question to answer because, whilst you might have a good idea of what images you would like to shoot, you can't know for certain whether that is even possible until you actually get to the location and see what's what.

Imagine there is a spectrum of photographers. At one end you have a photographer who is locked into a specific shot that they have fixed in their head and will go to the ends of the earth to achieve, but who risks missing other rich opportunities. At the other end is a photographer who has no real inkling of what's coming up and has no particular goal in mind, which leads to a lack of direction and focus in their work. Somewhere between

these extremes is where you need to be – with a clear idea of what you want to shoot, but with enough flexibility to throw out any preconceptions when you actually see what is possible.

This is where 'informed anticipation' comes in. This is when you are able to balance the potential against the actual whilst retaining your own style and ambition: *potential* in the sense of things you hope might happen and the *actual* being what does happen. Potential images can, of course, be converted to actual images, in which case you can say that your plan worked!

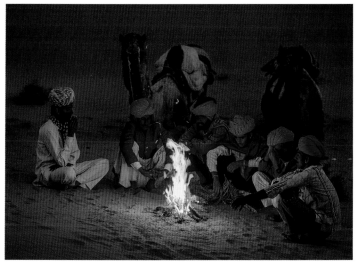

Osian, Thar Desert, Rajasthan, India | Canon EOS 5D Mark II | 135mm | 1/50 sec @ f2.8 | ISO400

A mental library of images

I approach new locations with a mental array of images that I would like to take, or more specifically, images that I would like to be able to take. This is crucial because you absolutely need some direction and structure to your photographic aspirations. However, I am also quite prepared to throw out those initial ideas when I get to my destination and find out what is truly possible given the circumstances. There is no point going to the Taj Mahal wanting a photo of the reflection of the mausoleum in the river – something you might have seen in a Google search – and then being so deeply disappointed after you see the recently installed barbed wire fence along the river's edge that you don't look for other photos! Accept that you just can't do that photo and move on.

I use that example because that's exactly what happened to me. I'd seen some wonderful photos showing this glorious scene of the Taj Mahal reflected in the Yamuna River, which flows just beyond the northern wall. At dawn, I thought, the light would be perfect ...

When my guide took me to the north bank of the river, the first thing I saw at the gate to the park (Mehtab Bagh) was a sign saying 'No tripods'. Bad start. Then, on heading down towards the river, I saw the barbed wire fence way back from the water's edge, and the security guards wandering around toting rifles. No amount of polite discussion would budge the officials and you can only push so much, particularly when the people you are arguing with

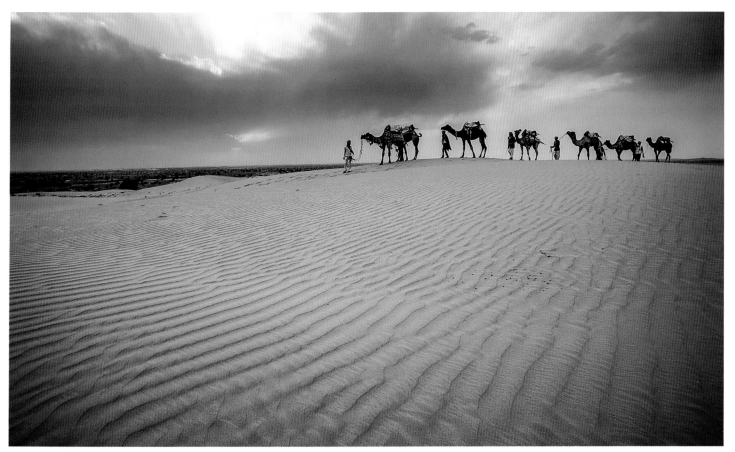

Osian, Thar Desert, Rajasthan, India | Canon EOS 5D Mark II | 17mm | 1/125 sec @ f6.3 | ISO400

have guns. As a word of warning, in my opinion it's just not worth ignoring official signs and fences to get your photo. Whilst you might get away with it, if you do get caught the potential for major angst is very high and you might even end up in jail.

I did eventually manage to get a permit for a tripod – that's a long story for another time – and was able to return at dawn a couple of days later and shoot the image at the start of this chapter, but I was not able to get near to the water's edge for my reflection photo. That photo was not possible. I had to put the unfulfilled potential image out of my mind and concentrate on the next actual image. The image I had in my mind never came to pass, but the photo I ended up getting, entirely unplanned, was one of a set which won me the AIPP Travel Photographer of the Year 2014.

One other advantage of anticipating the images you would like to be able to make is that you will arrive with a fully formed set of mental photo templates that you can 'fit' to the various scenes that you encounter as you travel. You will have some types of images in your head that you just happen to like, for whatever reason. One of my own numerous mental templates is where rays of light shine through dust or fog, so, as soon as I see light rays, I'll be hunting around for a subject to fit to the lighting conditions. Another might be regular, repeating objects – a formally arranged row of trees, identical statues, lines of cars and so on.

Osian, Thar Desert, Rajasthan, India | Leica M (Typ 240) | 50mm | 1/250 sec @ f4.8 | ISO200

Osian, Thar Desert, Rajasthan, India | Canon EOS 5D Mark II | 300mm | 1/400 sec @ f2.8 | ISO400

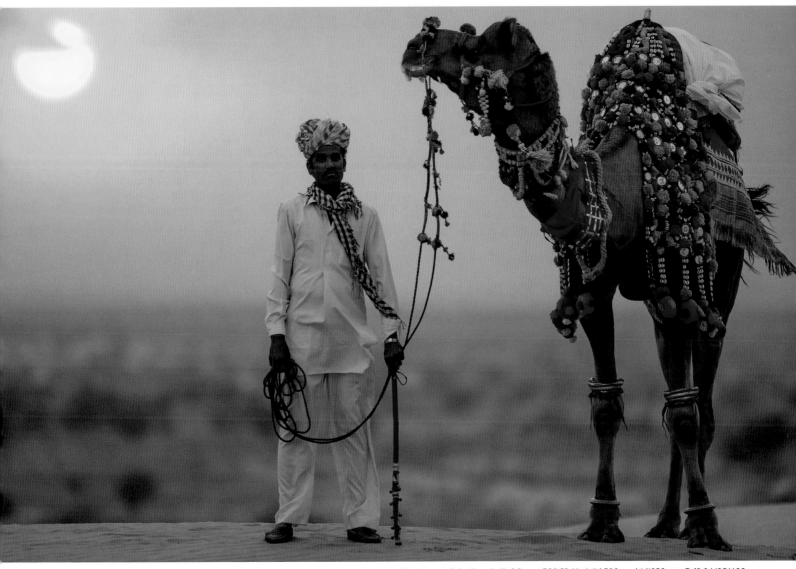

Osian, Thar Desert, Rajasthan, India | Canon EOS 5D Mark II | 300mm | 1/1250 sec @ f2.8 | ISO1600

Refer to your mental library

Having this mental library of potential images gives you a place to start when planning a trip. Some of these will be inspired by images you've seen, but some you'll create yourself. You'll have your own personal idea of what images you would like to create, so file those away in your mental photo library and see if they can be created when you arrive.

I had an image I wanted to shoot when I saw that my India itinerary included the Thar Desert. It's not particularly original, I know, but the idea of a lone camel and rider standing on a sand dune edge with the fiery ball of the sun (or moon, I'm not fussy!) setting behind was something that appealed to me. So that's what we tried to create.

My guide located a group of cameleers and their animals and we rode off to some bare dunes near camp in the late afternoon. A quick look at The Photographer's Ephemeris on my iPhone (see p. 033) showed me where the sun would be setting, so all systems were go. That was the anticipated photo, the potential image.

Of course, the weather didn't know this and proceeded to supply us with thick clouds, gusty wind and even a few spots of rain – after days and days of uninterrupted clear blue sky.

We stuck it out, did some portraits, endured the sand blasting as the wind picked up and hoped for the best. Ten minutes before the sun was due to set, the wind dropped and the sun appeared as a pale red disc through the haze. The 'potential' had turned to 'actual' and after ten minutes of frantic camel-wrangling to get the perfect position it was all over and my preconceived idea had been turned into an actual photograph.

Chapter 04

Stakeout

Erdenedalay, Mongolia

We had stopped briefly to grab some supplies as we headed west from the Gobi Desert and I was quite taken with the insanely fluorescent orange of this small supermarket. I loved the cyrillic letters which neatly placed the location in Mongolia (or Russia I suppose) so all I needed for this image to work was a figure. I waited for someone to approach and as luck would have it the second person to come past was a man in classic Mongolian boots and hat. It's usually best to have a figure entering the frame, not leaving it, so I had to shoot just before he reached the steps. Strong colours, interesting cubist shapes, cyrillic letters and man in traditional clothes. Click, done.

— LEICA M (TYP 240) | 75MM | 1/1000 SEC @ F6.8 | ISO200

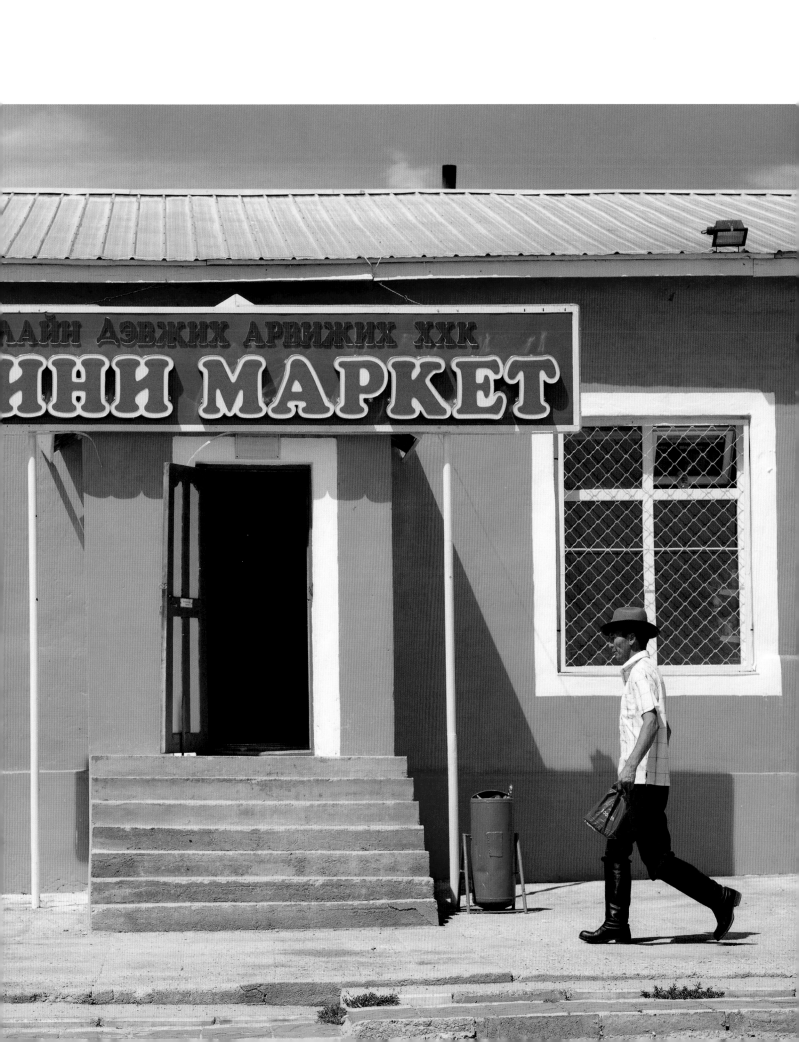

'It's not just when you shoot, or what you shot, or where you shoot, it's the combination of the three.'

– JAY MAISEL

Anyone who has been to one of my workshops or read some of my articles will know that I bang on about backgrounds a lot. This is for a very good reason – backgrounds can completely make or break a shot. This is true of all photos but is particularly critical when shooting images of people.

Our eyes and, more importantly, our brain allow us to be completely aware of the main subject and to ignore peripheral distractions. Cameras 'see' everything equally and assign no subjective importance to objects, whether they are in the centre of the frame, the edges or in the distance. The old 'lamppost growing out of the head' rookie mistake is no exaggeration; it is incredibly easy to miss what is going on behind the subject. The first time you'll notice it is when the image is presented to you on your camera viewing screen in two dimensions.

Backgrounds also support the subject, giving context to the main point of attention. I would argue that good backgrounds are just as important as the main subject in many images. So how do we control them?

Long Wu Lamaserey, Tongren, China | Leica S2 | 35mm | 1/15 sec @ f11.0 | ISO80

Wutun Village, Tongren, China | Leica S2 | 120mm | 1/125 sec @ f11.0 | ISO160

Select a great background

One technique used by experienced street or travel photographers is the 'stakeout'. Find a great background first and then let your subject enter your shot, shooting the frame when they are in the right place. In other words, rather than choosing the subject and then looking for a great background, reverse the process and choose your 'stage' first.

In this way the relationship between the subject and the background becomes a matter of timing, not camera framing. When I say 'timing' what I mean is that you first choose an interesting background and frame it in such a way that it is pleasing in its own right from a composition point of view. Then imagine a person in your composition and identify the exact place they need to be to balance the image. Then, you wait.

When a person enters the shot you don't follow them with the camera, you let them come to you (without moving the camera) and press the shutter at the moment when they are in the place you chose. That's where the timing comes in.

It's not easy but it is very effective. It involves a certain amount of good fortune because you won't know who is going to come along or whether they are the right person for the shot. It's not totally random though; there are ways you can capture the right person in just the right place if you can look for patterns in the movement of people as they come past you.

The photo above is from China, a temple in Wutun village near Tongren in Qinghai Province. I loved the strong and slightly garish colours but the image needed a person to give it some extra appeal. The photo is primarily about the temple and the colour, not the person. The person adds scale and context of course, but also provides something for the viewer to discover once they have noticed the colours and enjoyed the shapes. It's like a little reward for their attention – seeing the small figure coming along the side corridor, spinning the prayer wheels as he goes.

This was an easy stakeout. Prayer wheels are spun as the person walks in a clockwise direction around the outside of the temple. Many people will walk multiple circuits so when I found my 'stage' it was just a case of waiting for the same person to come back.

Wait for your subject

The image opposite from Battambang in Cambodia was another good example of a stakeout, but this time with random players on my stage. The view was from the balcony of my hotel and a certain patch of sunlight in the afternoon created long shadows on the asphalt as a varied selection of motorbikes whizzed past, with an even more varied array of cargo. Once more, waiting for the subjects to come into frame was the key – I'd spot potential subjects a way off, then see if they came into just the right spot with no other bikes in the frame. This one appealed to me because the four people on board were all wearing the same type of thongs and the huge dish was the same colour as the bike.

This shot is also a panning shot. Because I was repeating the same shot over and over with different subjects I could experiment with photographic techniques. Looking at the metadata I can see that I shot this at f8 and 1/60 sec. A relatively slow shutter speed like this, applied to a fast moving (and close) motorcycle, whilst panning the camera at the same speed as the subject, will tend to blur the road as it whizzes past but keep the bike sharp.

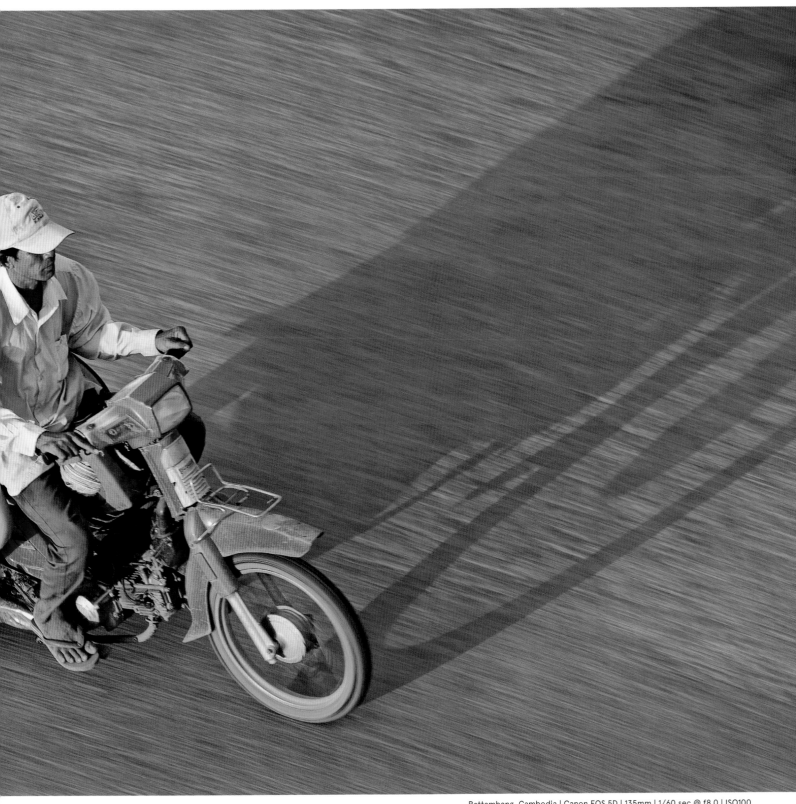

Battambang, Cambodia | Canon EOS 5D | 135mm | 1/60 sec @ f8.0 | ISO100

Exposure

If you're serious about photography, you must understand the fundamentals that make up exposure. When we talk about 'setting the exposure' it means choosing a combination of three things – shutter speed, ISO and aperture – that results in an image which is neither too dark nor too light, but 'just right'. The critical thing to remember is that whilst many different combinations of these three settings can give the same overall exposure, the consequences of altering each of the three settings are very different. Let's look at each setting and then how changing them affects your image.

Anastasia Bay, Russia | Canon EOS 5D Mark II | 44mm | 1/400 sec @ f5.6 | ISO200

Shutter speed

This is a measure of how long the sensor is being exposed to light: in other words, how long the shutter is open for. The longer this is, the more time the sensor has to collect light and the lighter the exposure will be. If light levels are very low it will take longer to collect enough light for a decent exposure at any given aperture and ISO setting and, conversely, if the light levels are high a fast shutter speed will be appropriate.

To use a hosepipe analogy, the shutter speed is the time for which the tap is turned on. The longer you run the tap the more water comes out. In this analogy the water is the equivalent of the amount of light; the more light, the brighter the image.

Shutter speeds are expressed in fractions of a second; a 1/1000 second shutter speed is a lot shorter than 1/60 second and thus lets in less light. The shutter speed sequence is mostly standard from one camera to another – some use intermediate settings – but the main sequence is 1/2, 1/4, 1/8, 1/15, 1/30 and so on. It's open ended too, you can have a very long shutter speed of 30 seconds (or longer) or a very short one 1/8000 second (or even shorter). See p. 042 for further explanation.

ISO

The sensitivity of a camera's sensor is expressed in terms of its ISO, which is a term dating back to the days of film when the International Organization for Standardization set standards for the sensitivity of film. The same term is used now because of its familiarity, but really it's just a measure of the amplification of whatever signal the sensor picks up, much like the volume control on a stereo amplifier.

The higher the sensitivity, the less light is needed at a given shutter speed and aperture to give a correct exposure.

ISO is expressed in terms of a number such as ISO100 which doubles for each step (or 'stop', a term used for a single step of any of the three settings). ISO400 is thus two 'stops' higher than ISO100. The minimum is usually 100 but depends on the camera; the maximum also depends on the camera, usually about 3200 but as high as 104000 on some high-end models. See also p. 056.

Aperture

The size of the aperture in the lens determines how much light falls on the sensor in a given time – a small aperture lets through less light in a given time than a wide one. To go back to the hosepipe analogy, water flows at a higher rate through a wider pipe and thus more water will come out in a given time than from a narrower pipe.

One confusing aspect of apertures is that smaller numbers actually mean wider apertures. Apertures are expressed as f-stops or f-numbers – an aperture of f8 is a smaller (wider) aperture than f4.0 and lets in less light by two stops. All lenses use the same sequence of f-stops starting at somewhere between f1.0 and f4.0, and then progressing through f5.6, 8, 11, 16, 22 to a max of about f32. The beginning and end points depend on the lens design but the numbers used are the same. F8 on one lens is the same as on another lens. Find more on apertures on p. 072.

Bering Island, Russia | Leica M (Typ 240) | 18mm | 1/60 sec @ f9.5 | ISO400

Exposure trinity

I use this term 'trinity' because the three settings above are all inextricably linked, in that if you change one you need to change another to maintain the same exposure. The hose analogy works well here too: a fatter pipe (aperture) fills a bucket (correct exposure) in a certain amount of time (shutter speed). A narrower pipe will obviously take longer to fill the same bucket. The water pressure is the ISO, so at a higher pressure the bucket will fill faster too.

So, if you change the shutter speed from 1/4 second to 1/8 second you will end up with an image that is one 'stop' darker because you are opening the shutter for less time. If you also change the aperture from, say, f8 to f5.6 (one aperture stop wider) then that will make the image lighter by the same amount and the two will cancel out exactly.

Each of the three settings works in 'stops' which are equivalent from one setting to another – doubling the ISO and halving the shutter speed will give you the same exposure.

Consequences

Each setting has its own role and consequences – and this is the crux. Whilst different combinations of settings can give you the same overall exposure, they will alter other things depending on which setting you are changing and it's this aspect that allows great control over the image's 'look'.

Shutter speed Controls blur, or lack of blur. Slow shutter speeds mean the subject (or camera) might have moved during the exposure and the image will record as a blur, not a sharp image. Slow shutter speeds often require a tripod whilst fast shutter speeds are good at freezing motion – for example sports photography.

Aperture Controls how much of the image is in focus. Small or narrow apertures (high numbers) means more of the scene is in focus, wide apertures (low numbers) mean less of the scene is in focus. A good example is portraiture where you might want the background out of focus and the eyes sharp – use a wide aperture.

ISO Using a high ISO will add 'noise' to the image so it needs to be used with care. ISO100 will usually be noiseless, but ISO3200, depending on the camera, might show quite a bit of speckly grain.

Setting correct exposure

Setting a correct exposure is easy because the light meter in all modern cameras is very good and in general you can trust it to get it right – but choosing the appropriate combination of shutter speed, aperture and ISO is what gives an image its distinctive characteristics and knowing the consequences of each is an important skill to master.

Here are a few pointers for three common scenarios:

Fast action Prioritise shutter speeds to get a sharp image, use wide apertures and/or high ISO to keep the shutter speeds high.

Landscape Use low ISO for maximum quality and mid-range apertures like f11 for good depth of field. If the shutter speed drops too low for hand holding use a tripod.

Low light High ISO might be necessary depending on the subject. If it's moving you'll still need a fast shutter speed but if it's static, a long shutter speed using a solid tripod might be fine.

Sun and moon

Li River, China

There are almost no cormorant fishermen these days who still wear traditional capes and hats, so this is a planned shot. They still fish like this but are more likely to be wearing a baseball cap and sneakers. You need to hire a fisherman and my subject here makes a living doing this – for people like me, for advertising or movies. My guide arranged the model, and I planned the shot using The Photographer's Ephemeris app on my phone. I needed a place with an excellent background where we would have a clear view of the setting sun and this app enabled me to do that easily. All we had to do was to direct our fisherman to the right place in the river (lots of arm waving) and then let the camera do the rest.

— LEICA S2 | 70MM | 1/125 SEC @ F8.0 | ISO160

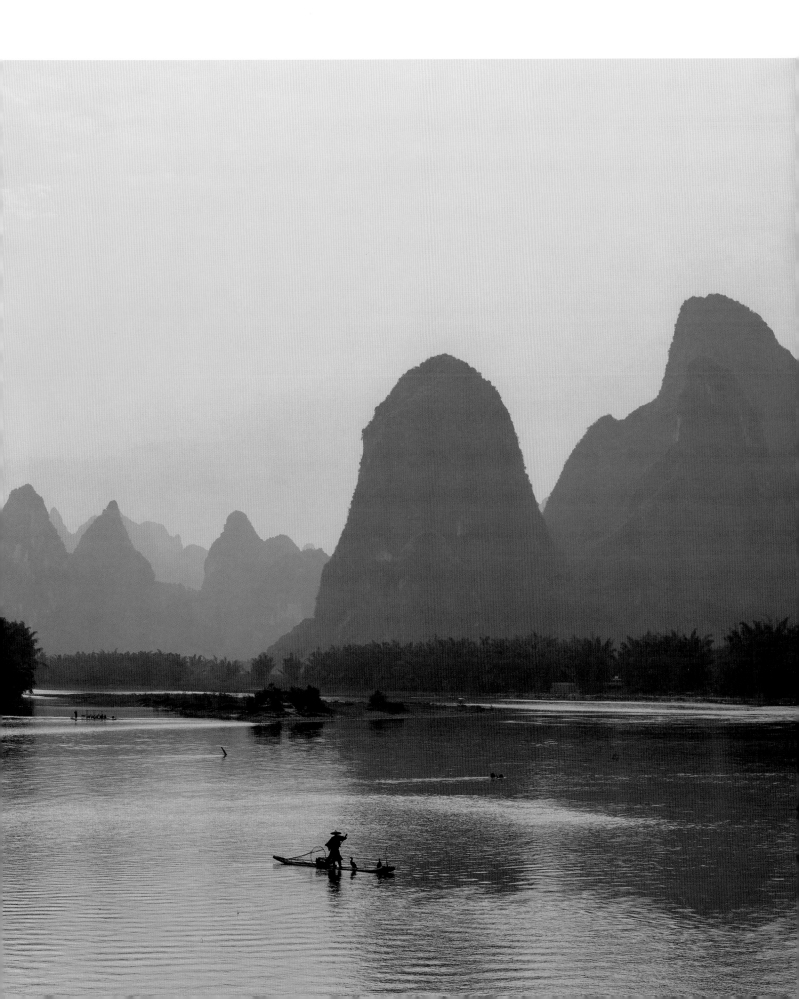

01 The position of the sun affects the look of your photos

02 Pre-visualise your shot with the sun (and moon) in mind

03 Use an app to work out sun and moon positions

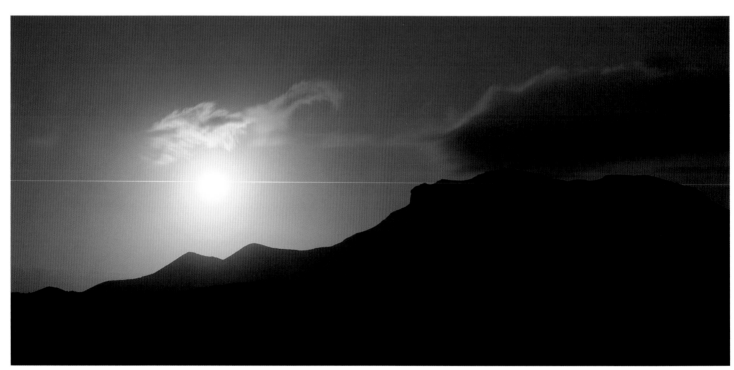

Bluff Knoll, Western Australia | Leica S2 | 70mm | 8 sec @ f4 | ISO160

'When we are given gifts, we must be quick and able to accept them.'

– JAY MAISEL

Let's talk about light – not the quality of light per se (see Chapter 7), but the light source – where it actually comes from.

With the exception of artificial light, all the light that you use to expose your photos comes from the sun, either directly or indirectly. On a cloudless day you have direct light from the sun as well as indirect light from the blue sky; on a cloudy day you have sunlight diffused through the clouds acting as a big natural soft-box; at night, as long as it's not a new moon, you'll be lit up by sunlight reflected from the surface of the moon – moonlight.

It's pretty obvious then that the sun is quite important! Where it is in the sky, what time it rises above the horizon in the morning, when it sets and what direction it shines from relative to you and your subject is of critical importance to the look of your photo.

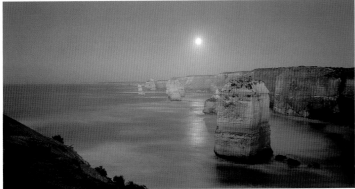
The Twelve Apostles, Victoria, Australia | Ebony RSW45 | 57mm | 15 sec @ f11 | ISO100

Sunset

The opening shot to this chapter shows the Li River in China with a lone cormorant fisherman poling his raft across the water. The setting sun shows off the huge karst rock formations, depicting them in semi-silhouette, which emphasises the rows of domes receding into the distance. This was a designed photo; by using TPE on my phone I established that the sun would be over the river at about 6.00pm and would dip further to the right as the evening progressed. As it turned out, the sun disappeared into the haze soon after this shot was made, but knowing where the sun was going to be was a huge advantage nevertheless.

Luckily for us, Johannes Kepler (1571–1630) refined the theory of Copernicus's heliocentric model of the solar system, then Sir Isaac Newton (1642–1727) further developed the laws of planetary motion and gravitation. These luminaries of natural philosophy established that the movements of the planets around our sun are extremely predictable and if you know your position on the Earth you can calculate exactly where the sun and moon will be at any time – in the past, present or future.

What this means for photographers is that we can predict, with a great deal of confidence, when and where the sun will rise and set. So too with the moon. We can pre-visualise our photograph and be in the right place at the right time so that the sunlight falls on our chosen subject just so.

Sun and moon apps

If this all sounds a bit complex, well, take heart. I'm sure Sir Isaac would have loved modern smartphones because they can be used to establish, with uncanny accuracy, just where the sun will be on any given date. Certain clever people, often photographers as well, have written apps that do the calculations for you, hidden behind a neat visual interface which clearly shows you what's going on.

Once you know where you are on the face of planet Earth (use the latitude and longitude as measured by the smartphone's internal GPS), then the laws of planetary motion can be applied to determine a local time and compass bearing for sunrise, sunset, moonrise and moonset. That time can be today, or tomorrow, or any date you like in the future.

There are numerous sun and moon apps out there in smartphone land – personally I tend to use one of the first to appear called The Photographer's Ephemeris (TPE). It's available as a paid app for smartphones or as a free online tool on their website (www.photoephemeris.com). The cool part is not so much the fact that the sun and moon positions can be calculated, but that they can be overlaid onto a map or satellite view courtesy of Google Maps or other online mapping resources.

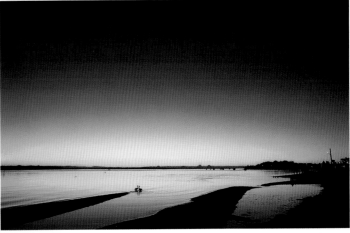
Bribie Island, Australia | Canon EOS 5D | 24mm | 3/10 sec @ f8.0 | ISO100

Full moon

The full moon always occurs when the moon is directly opposite the sun in the sky. In the morning the moon is setting just as the sun rises, and in the evening the moon is rising just as the sun dips below the horizon. Using an app like TPE it is reasonably easy to work out where the moon is going to be and to coordinate that with the timing of first or last light of the day. In TPE the blue lines show the moon's direction, and the yellow lines show that of the sun. At the time of a full moon they will be opposite one another, but it's important to remember that the moon will not rise at the same point on the horizon as the sun rises. The moon follows its own path in orbit around the Earth.

This image of the huge monocline Mount Augustus, located in central Western Australia, was taken from a place I had worked out ahead of time. I wanted the moon to the left of the mountain and I wanted the evening glow, post-sunset, to be illuminating the red rocks. Using TPE I could determine the time, about 20 minutes after sunset, knowing that the moon would have risen to a point in the sky where it was in a good place compositionally. If you think about it, 20 minutes after sunset must also be 20 minutes after moonrise on the day of a full moon.

The moon looks great over city skylines, not as a double exposure (which always looks wrong to me) but when the moon really is hanging over the skyscrapers. Because the moon's position in the

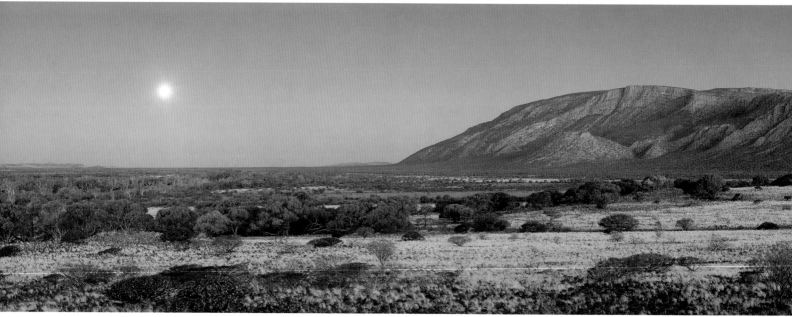

Mount Augustus, Western Australia | Canon EOS 5D | 85mm | 4 sec @ f5.6 | ISO100

034

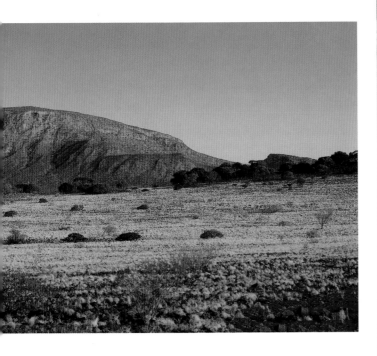

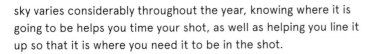

Brisbane, Australia | Canon EOS 5D Mark II | 135mm | 5 sec @ f4.0 | ISO100

sky varies considerably throughout the year, knowing where it is going to be helps you time your shot, as well as helping you line it up so that it is where you need it to be in the shot.

Take this image of Brisbane city with the moon rising over Spring Hill as an example. There was a full moon on 1 August 2015 but, as seen from Mount Coot-tha Lookout, the moon rose way to the south of the city, at a bearing of 102 degrees. There are very few decent vantage points to the north which would align the moonrise with the city buildings. Step the clock forward to 27 October 2015 and from the same vantage point at Mount Coot-tha, the moon rises directly over the city at a bearing of 81 degrees, quite a big difference, as seen in the screenshots from TPE to the left.

Chapter 06

Long exposures /low light

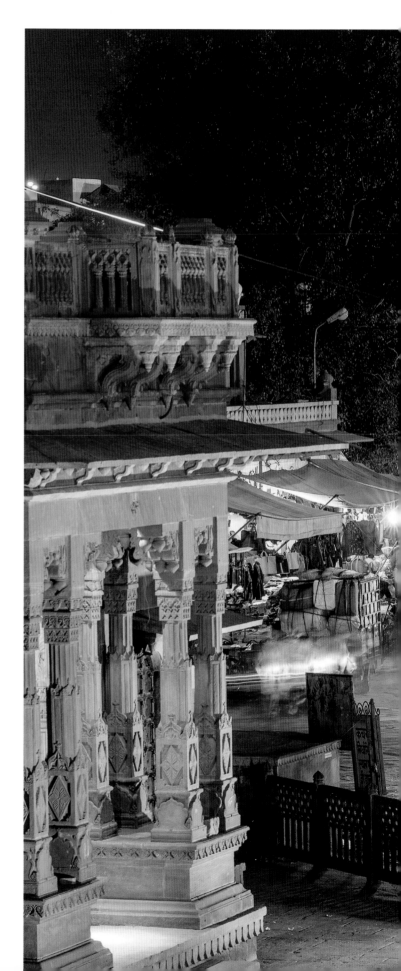

Jodhpur, Rajasthan, India

Low-light situations can be handled in two ways. For a sharp image where all movement is frozen you'll need to use a high ISO and/ or a wide aperture to get a fast shutter speed. On the other hand, buildings, landscapes and the like don't move, so as long as you can hold the camera steady (tripod), you can use a low ISO, a slow shutter speed and still get a crisp image. In this case I have chosen to capture the hustle and bustle of the market square at dusk by using a slow shutter speed and low ISO to capture the static buildings but at the same time allowing anything that's moving to blur as it moves during the exposure. Cars, people (and cattle) are all depicted with varying degrees of blur, depending on how much they have moved during the four-second exposure.

— LEICA M (TYP 240) | 90MM | 4 SEC @ F13.0 | ISO200

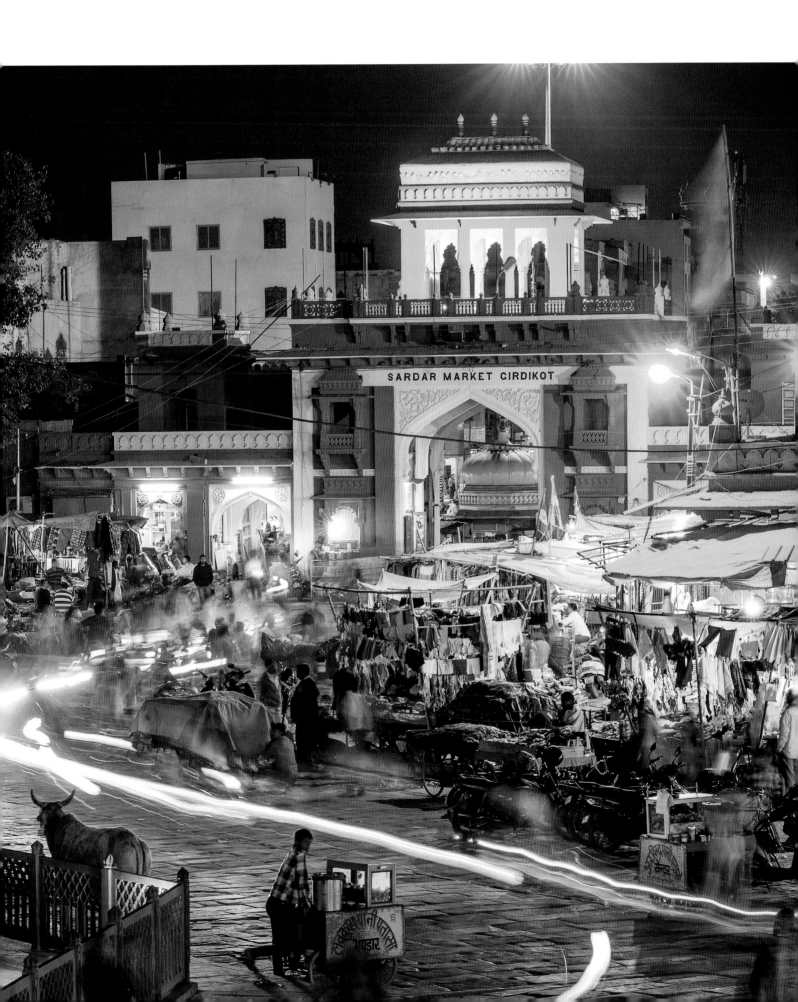

01 **Be aware of the potential for camera shake**

02 **Consider using a tripod if the subject is essentially a static one**

03 **High ISO can allow hand holding but be aware of image noise – varies by camera type**

Bridgetown, Western Australia | Leica S2 | 35mm | 24 sec @ f11.0 | ISO160

'Taking photographs is such an instantaneous act. The recognition and the acting on the recognition, depending on your equipment, is close to instantaneous.'

– JOEL MEYEROWITZ

In other chapters we discuss the source of light and the 'quality' of light, but here I want to set the scene by looking at the 'quantity' of light.

Your camera does not care how much light there is – it will recommend some settings of apertures and shutter speeds to make sure that the sensor gets enough intensity of light on it for long enough to make a decent exposure. What it does not do (some compact cameras aside) is tell you what the consequences of these settings are, in particular the shutter speed setting.

If I was to pick one single issue that leads to technically poor photos it would have to be not noticing that the camera has chosen a slow shutter speed when the light levels have reduced for some reason. The results are blurry photos due to camera shake and disappointment for the photographer.

The challenges of low light

Low light challenges cameras. Almost all cameras from phones up to top-of-the-line dSLRs can take excellent photos when there is plenty of light; it's when the light levels drop that the problems start. Trying to take photos indoors, after being in the bright sun – perhaps later in the evening after the sun has set – is a challenging, and yet very common, situation where there is simply not much light around and we need to deal with that to keep shooting good images.

The easiest solution to the shutter speed problem is to use a tripod. If the subject is static and you can fix the camera's position too, then the shutter speed becomes irrelevant and just about any length of time will do up to the limits of the camera's settings, usually 30 seconds.

However, if the camera cannot be put on a tripod and must be hand held then you need to be wary of using a shutter speed that is too low to be able to give you a sharp image. I cannot stress enough the importance of keeping an eye on the numbers displayed in the viewfinder. If the shutter speed drops below a certain number then you need to be aware of that and act accordingly as I discuss below (also see pp. 036–037).

Know your camera's strengths

The image on the next page is from deep inside a temple in Ulaanbaatar, Mongolia. There was no light apart from the candles and it was so dark I had to feel with my feet before taking a step so I didn't trip over something in the deep shadows. There was certainly a shot here but how to capture it? I wanted the candles sharp, I wanted to see the people's faces and I wanted to see something of the background. I also did not want to disturb my subjects' devotions – to do so would be not only disrespectful but would destroy any sense of authenticity. Imagine, 'Hey guys, over here, hold still a sec …' Er, no, I don't think so.

Kariijini National Park, Western Australia | Canon EOS 5D Mark III | 17mm | 30 sec @ f4.0 | ISO1600

Wat Athvear, Siem Reap, Cambodia | Leica M (Typ 240) | 50mm | 1/30 sec @ f2.8 | ISO3200

This is where good knowledge of your camera's strengths comes in very handy. I was using a Leica M (Type 240), which has excellent high ISO characteristics. I also had a 24mm f1.4 Summilux lens with amazing light-gathering abilities. By shooting at f1.4 I maximised the amount of light coming into the camera and by choosing an ISO of 3200 I could achieve a shutter speed of 1/60 second, which is sufficient to reduce the risk of camera shake and to freeze the movement of the subjects. Tripods were not allowed, and even if they had been, they don't stop your subjects moving!

Shooting the image, once my technical decisions had been made, was all about being ready for a combination of people's faces and positions to come together in a harmonious whole. You'll 'know it when you see it' – such things often defy analysis but the more you examine good photography in books and online, the more sensitised you'll become to what works and what does not.

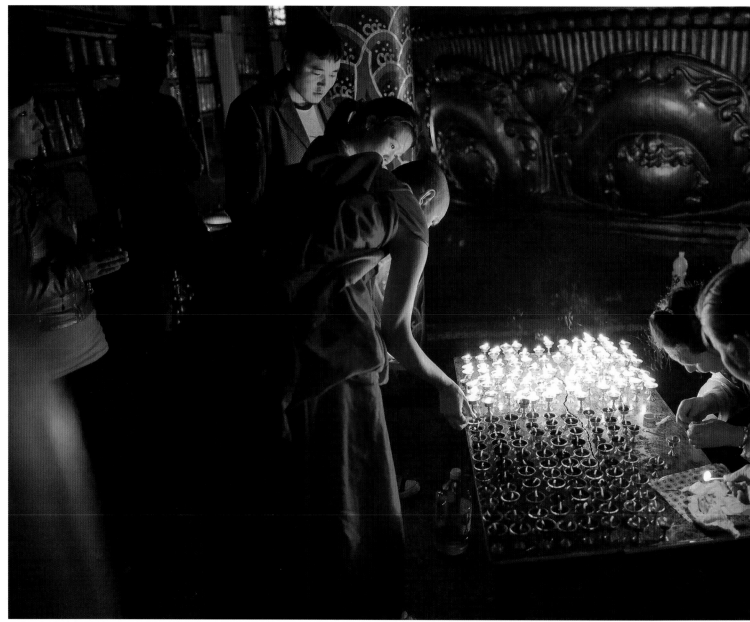

Gandan Monastery Complex, Ulaan Baatar, Mongolia | Leica M (Typ 240) | 24mm | 1/60 sec @ f1.4 | ISO3200

It is at the lower extremes of light levels where the abilities of high-end cameras show their worth. This is what you pay the premium prices for. A 'normal' 24mm lens on a mid-range dSLR would have a widest aperture of f2.8, or a wide-angle zoom might be only f4, and that's assuming the camera could even work at ISO3200. This smaller aperture requires a longer exposure (at the same ISO) to get the same exposure, so my shutter speed might have been as low as 1/15 or 1/8 and I would have been at very high risk of camera shake as well as subject movement.

Use it creatively

The market scene from Jodhpur on pages 46–47 shows how low light and movement can be used to creative effect. Low light, in this shot, was my friend and it would be hard to get this effect in other circumstances. By the way, don't think of low light as a problem to solve; it genuinely offers opportunities for photographers who are prepared to experiment a bit.

Camera movement *always* needs to be eliminated. A blurry shot due to camera movement, unless planned that way for artistic effect, is a reject shot 99% of the time. Subject movement on the other hand is capable of showing motion in what is usually a frozen slice of time. If objects move during the time of the exposure they will leave a trail across the frame as opposed to a sharp image. If some things are moving and some are not then you can, as in this example, depict the hustle and bustle of a busy marketplace with interesting lighting provided by both artificial and natural light.

I used a tripod for this shot, so the buildings are crisp but the movements of the people, bikes, cars and cows have been allowed to record as ghostly lines.

Leica S2 medium format camera and I had already established through experimentation that the image sensor was fine up to ISO640. Beyond that it dropped off rapidly in quality. I also knew that the insanely good S-System lenses were perfectly sharp wide open, something that cannot be said for cheaper lenses, particularly zooms, where shooting wide open can result in a soft image.

When I saw this young man I had no time to work out the options. I simply set the aperture to wide open (f2.8 in this case) to get the highest shutter speed possible, knowing the ISO was already set to 640. I framed the shot and checked the meter, seeing a shutter speed of 1/125. All good, click …

Now, I could have gone for ISO320 and a shutter speed of 1/60. But, firstly, there was little time, and secondly, risking camera and subject movement for an image with slightly lower noise is not a gamble I am prepared to take. Better to be sharp and slightly noisy than blurry but with low noise. Noise can be dealt with in post-processing, blur cannot.

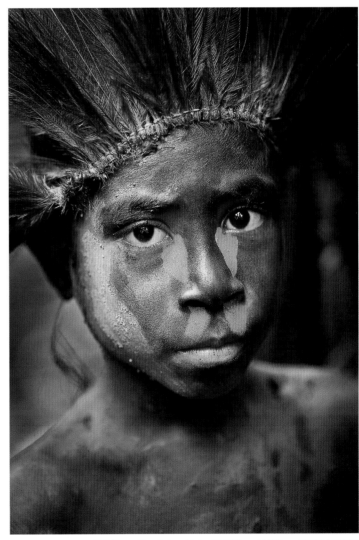

Tufi, Papua New Guinea | Leica S2 | 120mm | 1/125 sec @ f2.8 | ISO640

Know your camera's limits

Sometimes you don't get the chance to think too much about a shot – opportunities crop up suddenly so you should be aware of your camera's abilities and where its limits lie. The best way to do this is to test your camera out at home. Shoot some hand-held images indoors (of the cat is fine, just don't tell anyone) and see at what ISO the image becomes unusable and how low shutter speeds can go before you end up with a shaky photo. Bear in mind that looking at images on the computer screen at 100% is incredibly unforgiving and noise that looks unbearably bad can in fact be far less overt when a print is made or the image is scaled down for the internet.

The image of the boy from Papua New Guinea is a good example of being aware of my gear's limits. I was using the new (at the time)

Shutter speed

Mana Island, Fiji | Leica SL (Typ 601) | 31mm | 60 sec @ f19.0 | ISO100

In order to record a photograph, the imaging sensor in a camera needs to be exposed to a measured amount of light. This will vary depending on the brightness of the scene and so, to achieve the correct overall exposure, the camera needs a way to control the amount of light entering the camera.

The shutter is one way in which the camera does this, by controlling the length of time that light will be able to reach the sensor. In its resting position the shutter sits in the path of light entering the camera. When a picture is taken the shutter moves out of the way – allowing light to pass through to the sensor before returning once again to its resting position. The time that the shutter is out of the way is measured in seconds or fractions of a second and is referred to as the shutter speed. To cover as many lighting situations as possible, modern cameras have a huge shutter speed range that can stretch from 30 seconds to an incredibly quick 1/8000 of a second.

The importance of controlling shutter speed

Being able to alter the camera's shutter speed does a lot more than simply provide the correct exposure. It can also be used to control the amount of motion blur in the picture. If you have ever taken photos in low light (especially without a flash) then you've probably noticed that any movement produces a blurred image. This is because when it's dark, the shutter has to be open for longer in order for the imaging sensor to receive enough light. If the subject, or camera, moves within that time frame the movement is recorded as blurred in the photo. In bright light this is much less of a problem because the shutter is only open for a fraction of a second.

Normally, when set to full auto, the camera will try to set the fastest shutter speed possible given the ambient light levels. This is so that the chances of camera shake and blurring are kept to a minimum, resulting in clearer, crisper photos. However, knowing that shutter speed essentially controls motion blur, it's also possible to use it creatively in our photography. As a general rule of thumb the longer the shutter is open, the more motion blur we can introduce to the picture.

You can control the shutter speed by either using full manual mode or the TV (Time Value) setting, where you choose the shutter speed and the camera chooses an appropriate aperture to give the correct exposure.

Fast or slow?

Take the classic example of flowing water or other 'white water' scenes. Using a longer shutter speed means that anything moving through the frame, in this case the water, becomes blurred. The result is the quintessential image of almost misty white water flowing over the rocks as in the examples here, showing the effects of different shutter speeds.

If slow shutter speeds can be used to great effect by adding motion blur to our pictures, it's also possible to use fast shutter speeds to freeze the action, capturing a moment in time that would otherwise be hard to see.

Kurrawa Beach, Gold Coast, Queensland, Australia | Canon EOS 7D | 300mm | 1/2500 sec @ f4.0 | ISO100

South Pine River, Queensland at different shutter speeds – from top :1/250 1/30 1/4 sec

The photo of surf lifesavers in action on Australia's Gold Coast was taken using a fast shutter speed, freezing the wave as it crashed over the rowers. The very short duration of the exposure has completely stopped any movement. It's even possible to make out individual drops of water captured in mid-air.

Controlling motion blur is an essential skill when it comes to conveying an impression of movement in our pictures. Having an understanding of shutter speeds and their effects on an image is not only important in terms of achieving correctly exposed photos, it also opens up a lot of creative possibilities. It gives you, the photographer, control over time itself; it makes it possible to capture moments that reveal something about the subject that we would otherwise never see.

Chapter 07

Quality of light

Borobudur, Java

Backlighting and low mist are always fertile conditions for good photos. An elevated vantage point is handy too, because the various graphical elements in the photo tend to separate out and give a good sense of depth through the effect of aerial perspective. I found a small hill about 2 kilometres to the west of Borobudur and walked up there in the pre-dawn darkness, having scouted out the spot the previous day. Long lenses exaggerate the effect of mist, so I lugged my 300mm up knowing that it would be the right tool for the job. Then it was a simple case of using a solid tripod, framing the shot carefully and using the self timer to take the photo to avoid vibration.

— CANON EOS 5D MARK II | 300MM | 1/20 SEC @ F4.0 | ISO100

01 Observe the way the light falls on your subject

02 Different subjects look best under different qualities of light

03 Harsh, high light, such as at midday, is often poor for photos

04 For soft, warm, low light, shoot around dusk and dawn

Angkor Wat, Cambodia | Leica M (Typ 240) | 50mm | 1/90 sec @ f3.4 | ISO200

'What's the best type of light? Why, that would be available light ... and by available light I mean any damn light that is available.'

– W. EUGENE SMITH

It has been said that there is no such thing as bad light, just light that's inappropriate for what you have chosen to shoot. What is fantastic for one subject can be dreadful for another. Try shooting a rainforest scene on a bright sunny day or a tropical beach on a cloudy day! It just doesn't work. But a rainforest on a cloudy day can have a wonderful soft misty atmosphere and a white sandy beach lapped by clear blue water looks fantastic on a sunny day.

'Quality' of light is a slippery concept but I'm going to define it as the characteristic of light that complements your subject or adds a certain mood to the photograph. Quality in this sense does not mean good or high quality. What it means is that the light itself has a quality, a certain characteristic, which adds to the overall impact of the photo. Examples are soft light, low angled light, backlight, hard light, side light, diffused light and so on.

Some subjects simply work best with particular light types or qualities. In the rainforest example below, the nature of the light on a bright but overcast day, especially after rain, imbues the photo with an appropriate mood of fertility, growth and lushness. It also, from a technical point of view, lowers the contrast of what is an impossibly harsh scene under full sunlight.

Direction and size of the source

Direction plays a big part in determining light quality and refers to the direction from which the light falls on the subject.

Front light is light coming from the same direction as the camera and tends to be flat, with minimal shadows and offers no modelling or shaping of the subject.

Side light offers good modelling because the shadows emphasise shape and texture.

Backlight picks up edges, hair particularly, and brings out any atmospheric effects like mist or fog. Backlight also means that the front of a subject is lit only by the rest of the sky, which tends to be flat, directionless light, good for portraits.

Mana Island, Fiji | Leica SL (Typ 601) | 18mm | 1/750 sec @ f6.8 | ISO50

Savoli River, New Britain, PNG | Canon EOS 5D | 31mm | 1/45 sec @ f5.6 | ISO800

For me, in order of preference: side light from about 45 degrees offers a 'classic' quality of light and brings out texture and three-dimensional shapes. Side light from 90 degrees brings out fine textures from grungy old walls or rough surfaces. Backlight is great for portraits in otherwise hard light, great for misty or foggy scenes and brings out dust beautifully. Hard front light is generally dull and lifeless but soft front light can be flattering for portraits.

The second factor which determines light quality is the size of the source. The size of the light source affects its hardness or softness. A big light source tends to be soft, a small one tends to be harsh. For example, a cloudy day offers you a huge soft light source where the light comes from above, whereas a sunny day at noon will give you harsh light with deep shadows. The sun at dusk or dawn tends to be lower contrast and more flattering than in the middle of the day. Open shade also has a large soft light source – the blue sky – but it will have a blue cast to it. Learn to recognise different light qualities and work with them to your advantage – working against the light is a recipe for poor photos.

The opening image is from Java and shows Borobudur at dawn from a distant vantage point. Because we are looking roughly east, the scene is backlit and the commonly occurring humidity mist is exaggerated by the dawn light coming from behind. The trees form a series of highlights almost like paper cutouts. Their overlapping shapes give extra depth to the view because your eye has no trouble interpreting which elements are in front of others. Occlusion (overlapping objects) is a strong visual clue for depth.

I shot this image with the full knowledge of what was possible; it is a strongly pre-visualised image. The mist is reasonably predictable, the vantage point is high so you are not looking directly into the

dawn sky and the downward view has the effect of spreading out the tree shapes vertically over the frame so there is more depth. Lastly, using a 300mm lens compressed the scene from front to back, exaggerating and flattening the perspective slightly.

All these characteristics had to be in place for this strongly backlit shot to work.

Employ directional light

The image of the parade in China above is also backlit, this time with hazy sunshine so the light is not too harsh but still has some direction to it. The smoke blowing around the temple courtyard is picked up by the rear light and gives the whole scene a slightly medieval feel. When shooting into the light like this a decent lens hood is a must – you want the lens elements to be shaded from the sun but at the same time you want the light to be coming towards you. This can be hard to balance but you'll see any lens flare through the viewfinder so at least you can adjust your angle to moderate it.

Soft directional side light is wonderful for portraits because it brings out the shapes of the cheekbones, chin and nose. Close, large sources of light can be soft and still have a clear direction

as shown in this portrait of a young Buddhist monk in Cambodia below. I have used the light from the window as the light source and you can clearly see the way the light wraps around the subject's face. This is front light from his perspective, but side light from mine. Window light (with no direct sun shining in) is one of the best places to shoot portraits, particularly if it is slightly above eye level – set your subject back slightly so the light is

Peepal, Rajasthan, India | LEICA M (Typ 240) | 50mm | 1/2000 sec @ f3.4 | ISO400

directional and you will see many different possibilities for good portraits (just watch your shutter speeds!).

If you want to emphasise textures, then strong raking side light works well. Sunlight spilling across the subject will bring out every bump and wrinkle. This street scene (above) in Pipar, Rajasthan, caught my eye because the old shop front was strongly side lit from a 45 degree angle above. The light slants across the doors in such a way as to bring out the grain in the timber and the diagonal shadows add a dynamic element to a static shot. Having the old man squatting in front of the door is the cherry on top and the light even adds some texture to his well lived-in face. Soft light would have been nowhere near as effective.

Front light is hard to work with because it casts very few shadows and so texture and shape tend to be less obvious. The image of El Capitan in Yosemite National Park (right) is strongly front lit but the climbers show up clearly and set the scale (see Chapter 14). Sometimes you have to shoot in whatever light conditions are available at the time and, tipping my hat to W. Eugene Smith's quote, just do the best you can!

One final thing to ponder – backlight and harsh light are handled by cameras and lenses in different ways. Some cameras cannot handle the contrast of harshly lit scenes, and some lenses perform very poorly when the light shines into the front element during a backlit shot. Experimenting with your gear in different lighting conditions is important so that you can anticipate how it will respond to different lighting qualities before you go out shooting.

El Capitan, Yosemite, USA | Canon EOS 5D | 300mm | 1/1500 sec @ f4.5 | ISO100

Aerial photography

Bremer Bay, Western Australia

From the air, harvesting machines leave all sorts of interesting patterns in the crops as they go about their work. I chose to fly as late in the day as I dared because I wanted the low sun to pick up the textures in the wheat and illuminate the dust kicked up by the harvester. Low light means slower shutter speeds, which then leads to unsharp photos if you are not careful. High-quality fast lenses (expensive) really come into their own here because I was able to shoot at maximum aperture with no loss of quality, thus getting the highest shutter speed possible.

— LEICA S2 | 120MM | 1/750 SEC @ F2.8 | ISO640

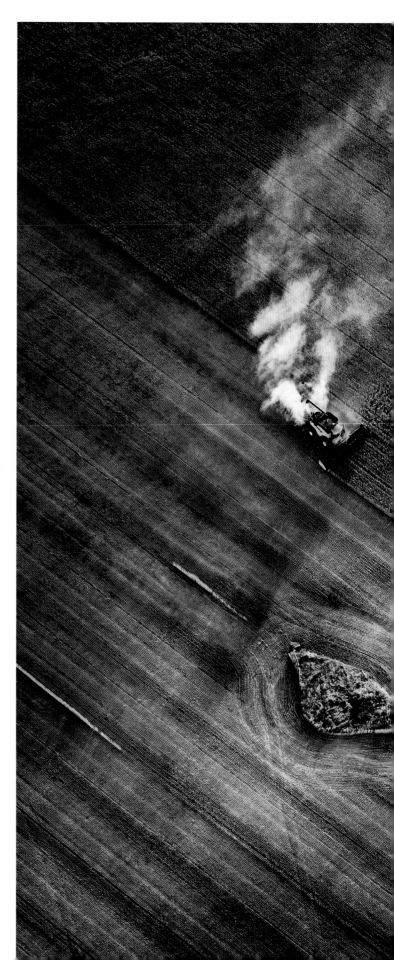

01 **Aerial photographs add a new and interesting viewpoint to travel image sets**

02 **High shutter speeds are crucial to getting sharp images**

03 **Minimise equipment changes whilst in the air – use big memory cards**

'The money and fame that photography can bring you are wonderful, but nothing can compare to the joy of seeing something new.'

– JAY MAISEL

The biggest single issue with aerial photography is actually getting a sharp shot – the wind buffets the camera, the subject is constantly moving and you have to work quickly because at $20 per minute (!) for a chopper you can't waste any time.

This is where 'fast' lenses come in. Using fairly wide apertures such as f4 or f2.8 will give you high shutter speeds, resulting in a higher proportion of sharp images: add to that the ability of modern digital cameras to shoot at ISO800 or even ISO1600 with minimal noise and I can shoot early or late in the day, when the sun is only just above the horizon, casting those lovely long shadows.

I find that a standard lens is just the right focal length for much of my aerial work. A 28mm or 24mm is too wide and you often get the rotor blades in the shots; a 70–200mm zoom is great but harder to work with. I like to find my shot and then get the pilot to do a tight banked orbit so I can shoot straight down. This flattens the perspective and makes the image that little bit more abstract.

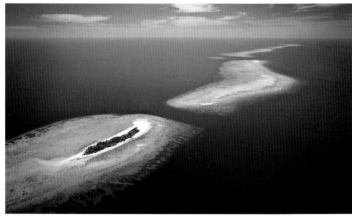

Lusancay Islands, Papua New Guinea | Canon EOS 5D | 24mm | 1/350 sec @ f5.6 | ISO400

Then it's all down to shapes and forms, plus, of course, the quality of the light.

Accurate autofocus is a great asset too. In fact I have found that I get better results trusting the AF than I do focusing by eye. A decent 50mm lens or mid-range zoom will give me a very high percent of sharp images when I stop trying to focus myself and just let the camera do its job. After all, everything in the shot is at least a few hundred metres away so depth of field is not an issue, even at f2.8 or f4.

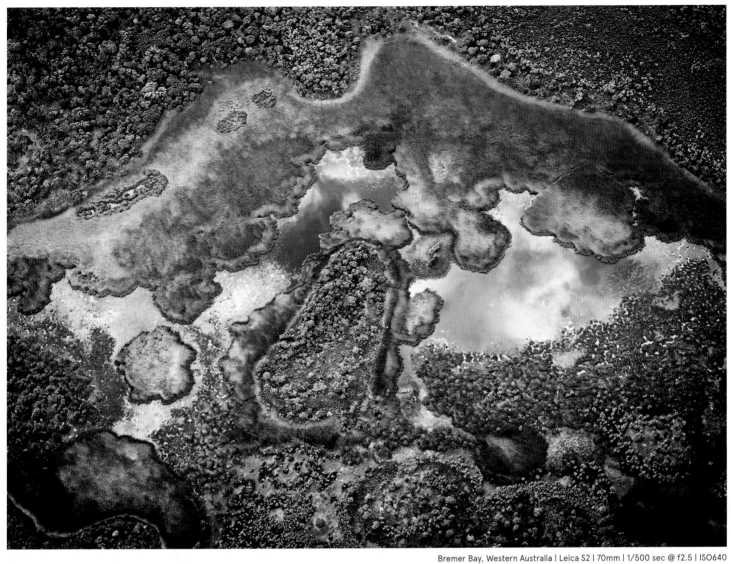

Bremer Bay, Western Australia | Leica S2 | 70mm | 1/500 sec @ f2.5 | ISO640

In bright sunshine I will generally set the camera to Aperture Priority, choose an aperture that will give me a sharp image (which rather depends on the lens) and set the ISO to about 400. This will give me an exposure of roughly 1/1000 sec @ f5.6 or better. Let the meter do the work but watch that shutter speed – if it drops below 1/500 sec you might consider either opening the aperture up a bit or going up the ISO scale.

Light planes

Small fixed-wing aircraft, like the ubiquitous Cessna, make good platforms for shooting. OK, they can't hover in mid-air like a chopper but they can cover more ground, are often available in places that don't have helicopters and are less expensive to charter. Details differ, but on many Cessna 210s, for example, the passenger window can swing up and out, even latching under the wing sometimes. This gives you plenty of room to shoot – but don't protrude your camera lens past the window frame otherwise the prop wash will buffet the camera severely.

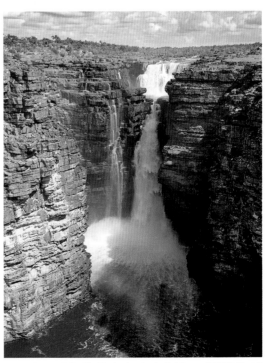

King George Falls, The Kimberley, Australia | Canon EOS 5D Mark II | 39mm | 1/750 sec @ f8.0 | ISO400

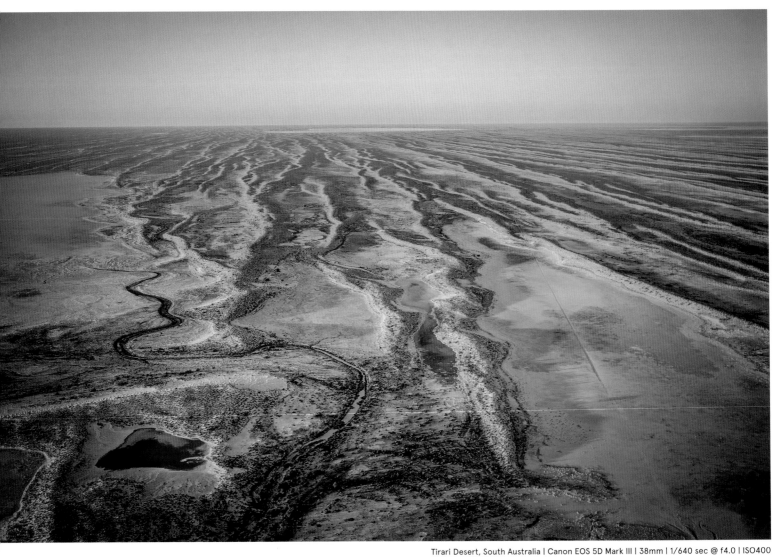

Tirari Desert, South Australia | Canon EOS 5D Mark III | 38mm | 1/640 sec @ f4.0 | ISO400

Lens hoods are best left on the ground – you're shooting down so flare is a non-issue and the shape of the hood can act as a wind scoop, further destabilising the camera.

One trick I have learned about shooting from any unstable platform is to turn on the continuous shooting mode and squeeze off shots in multiples. It's amazing how often the first shot is a little soft but the second or third is actually sharper. Pixels are free, remember, so shoot bursts.

Helicopters

In many ways choppers are the ideal shooting platform, if a little on the pricey side, but they are prone to significant vibration and severe wind buffeting if you take the door off. Yes, you have a great, 180 degree uninterrupted view with no wing struts and other impediments, but once you lean out even a bit, the prop wash from above makes it hard to keep the camera still.

Most helicopters tend to judder in a hover; they are much smoother in a slow forward motion, so avoid the temptation to call out 'Stop!' when you see a shot you like. A steady 20–30 knots of forward progress will often be a lot smoother than either faster or slower.

Leave all loose objects on the ground – chopper pilots tend to get a bit antsy if they see loose lens caps swirling around the cabin. Dress warmly too, even if it's hot on the ground. The air temp at 2500 feet or higher will be a lot cooler than on the ground and with the door off it's going to be drafty!

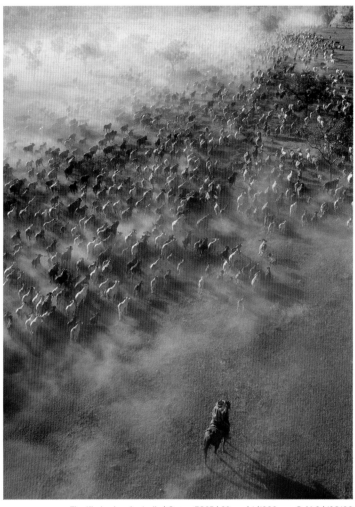

The Kimberley, Australia | Canon EOS3 | 28mm | 1/1000 sec @ f4.0 | ISO100

In the air

I prefer to take one camera and one lens – usually a 24-70mm f4 because it's versatile and has an image stabiliser built in, but I might take a 50mm f1.4 or something similar if the light levels are low. Make sure the memory card is clear, and of a reasonable capacity – the last thing you want to do is to be swapping cards around. Check the battery is fully charged for the same reason. Essentially, keep things as simple as possible and concentrate on finding the images, not on juggling lenses and cameras.

Lusancay Islands, Papua New Guinea | Canon EOS 5D | 29mm | 1/250 sec @ f5.6 | ISO200

ISO

The three basic camera settings that most affect your images are shutter speed (p. 042), aperture (p. 072) and ISO. Here I explain the role of ISO, essentially an indicator of the camera's sensitivity.

ISO (pronounced EYE-soe) is the shortened name, but not an acronym, for the International Organization for Standardization, which sets all sorts of standards for different things around the world. In this case it represents a standard scale for the *sensitivity* of a camera's sensor. It is simply a scale which reflects the sensitivity to light of the capture device. A doubling of the ISO number represents a doubling of the sensitivity, therefore ISO400 is four times the sensitivity of ISO100.

For a photographer this is important because it affects the choice of which aperture and shutter speed to use to get a correct exposure. The three are firmly linked; if you change one you will have to change at least one of the others to get the same exposure.

Lady Elliot Island, Great Barrier Reef, Australia | Canon EOS-1D X | 24mm |
1/90 sec @ f2.8 | ISO3200

Juggling ISO, aperture, shutter speed

At a fixed aperture, increasing the ISO will increase the shutter speed. Changing the ISO from 100 to 200 means the sensor is twice as sensitive, therefore it needs half the light to get a correct exposure. Thus a shutter speed of 1/60 second at ISO100 will be the exact equivalent of a shutter speed of 1/125 second at ISO200. 1/125 second exposes the sensor for half the time of

Mankameshwar Temple, Agra, Uttar Pradesh, India | Leica M (Typ 240) | 90mm | 1/30 sec @ f3.4 | ISO3200

1/60 second but the doubled sensitivity only needs half the time to give the same exposure.

At a fixed shutter speed, increasing the ISO will decrease the aperture size. Changing the ISO from 100 to 200 means the sensor is twice as sensitive, therefore it needs half the amount of light to get a correct exposure. Thus an aperture of f8 at ISO100 will be the exact equivalent of an aperture of f11 at ISO200.

If you leave the ISO fixed, as is usual, then if you choose a faster (or shorter) shutter speed (faster = less time open) then you will need to open the aperture the equivalent amount to allow the same amount of light in. Go from 1/60 second to 1/125 second and you will need to open the aperture from f11 to f8 to get the same exposure.

Sarangan, Java, Indonesia | Leica M (Typ 240) | 28mm | 1/25 sec @ f3.4 | ISO3200

So, to keep the same exposure you need to juggle the three controls of aperture, shutter speed and ISO setting. Remember: if you change one, you must change at least one of the others.

But wait, that's not all. Like shutter speeds and apertures, ISO also affects the way your images look. Apertures affect depth of field, shutter speeds affect motion and ISO affects actual image quality.

Noise

Back in the days of film, high speed films, those with high ISO ratings were inherently grainy – this was the price you paid for sharp images in low light. It's much the same now, not that there is any grain as such, but since the ISO setting is actually an amplification (or gain) applied to the image, not only does it amplify the signal (light) but also the noise.

All electronic devices have a certain amount of random noise in the system; think of the 'hiss' on a stereo if you turn the volume right up. If you think of increasing the ISO on a camera as turning up the volume then you will get the visual equivalent of hiss, known as noise. It looks like random granularity and purple 'splotches'. It's quite simple really – if you amplify the signal you also amplify the noise (engineers call this the S/N ratio or signal to noise ratio).

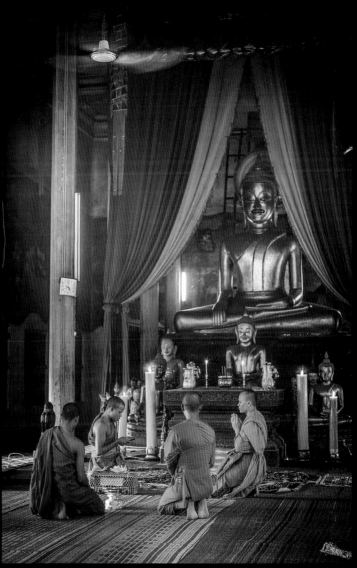

Wat Bo, Siem Reap, Cambodia | Leica M (Typ 240) | 50mm | 1/25 sec @ f8.0 | ISO1600

So ISO offers a trade-off. If you want a sharp image and need a fast shutter speed you can open up the aperture – but only so far and at the expense of narrower depth of field. If you turn up the ISO to get higher shutter speeds then you must consider the effects of noise on the final image.

My advice is to make getting a sharp image a priority. Given that current digital cameras are very low in noise anyway, it's far better to use the ISO setting to keep your shutter speeds up than to risk an indistinct image. A sharp but noisy image is more useful than a noiseless but blurred image any day!

Chapter 09

<u>Patterns</u>

Incense sticks, Hoi An, Vietnam

I came across these artfully arranged incense sticks at a roadside stall. Repeating shapes are often a good subject for a semi-abstract shot, so by using a medium telephoto lens I was able to exclude any distracting elements and thus make the shot slightly more intriguing. Diagonals are more dynamic than horizontal lines so I composed the shot from an angle, with the bunches of sticks receding to the right, becoming less and less sharp by using limited depth of field to make it look much more 3D. The sticks that are in focus are the yellow ones, chosen because warm colours tend to come forward in photographs, and lighter areas attract the eye more too.

— CANON EOS D60 | 135MM | 1/250 SEC @ F2.8 | ISO200

01 Repeating shapes and patterns are strong compositional tools

02 Patterns can be highly abstract, or quite obvious

03 Think and look laterally: patterns can be found in surprising places

'To me, photography is an art of observation. It's about finding something interesting in an ordinary place ... I've found it has little to do with the things you see and everything to do with the way you see them.'

– ELLIOTT ERWITT

Patterns are all around us, if you only take the time to look for them. Patterns also make for compelling images, particularly if they are ever-so-slightly abstract so that it's not immediately apparent what they are. Repeating shapes can fall into the category of patterns too, so I'll include them in this discussion as well.

Mekong Delta, Vietnam | Canon EOS 60D | 44mm | 1/60 sec @ f5.6 | ISO400

The image at right fits all of the At a Glance suggestions above. It's a pattern, it shows repeating shapes and it's a little bit abstract.

You are looking at a different take on incense sticks in Vietnam, as seen at a roadside house in the Mekong Delta, where small home businesses crank them out by the thousands, and all made by hand too. At first glance it's a simple photo, but more thought needs to go into these kinds of photos than you might think.

Windsor Castle, United Kingdom | D-LUX 5 | 13.9mm | 1/640 sec @ f4.0 | ISO100

Firstly, I have cropped in very tight on the subject to totally 'abstract' it from any surroundings or context. This gives it a stronger appeal because the viewer has to work a little harder to identify the subject. Not all images need to give away the whole story immediately; let the viewer do a little work and they will enjoy the moment of understanding when they work it out.

Secondly, the composition is loosely based around the rule of thirds, with the red wooden stems occupying about one third of the frame compared to the yellow incense paste. The stronger colour occupies the least space too; this balances up the respective colour 'weights'.

Thirdly, I have deliberately included some sticks which are not lined up with the rest. Vertical and horizontal lines are static; diagonals are more dynamic. Including the diagonal sticks introduces some tension into the image and makes it more pleasing to look at.

Working with patterns

Patterns crop up throughout the natural and man-made worlds, seen in sand, clouds, fabrics, architecture, and so on. Finding them is mostly a matter of 'seeing'. Once seen, the photography is simple, technically, but not always so simple compositionally. I'd even go so far as to say that once a pattern has been seen, turning it into a compelling image is actually quite tricky.

Light quality has a big part to play. For example, a pattern made up mostly of textures will only really show up well with strong raking side light. Patchy side light is really good too, because the side light shows up the texture whilst the patchy light gives variation, something that is subtly appealing to the viewer's eye. If you look closely at the incense stick image you'll see that the light comes strongly from the left, giving dimension to each round stick, and the light coverage is not even, there's a faint patch of brighter light in the centre.

Repeating shapes offer lots of photographic opportunities. The image of Windsor Castle in London above is a good example – the gothic arches and small windows repeat nicely so I have carefully framed the shot to make sure they are evenly spaced across the frame. The single guard, resplendent in his red tunic and bearskin, breaks the pattern with a strong splash of colour. Note the guard is well off centre; if he was in the centre the image would be far too rigid and static.

Holocaust Memorial, Berlin, Germany | M9 Digital Camera | 50mm | 1/350 sec @ f9.5 | ISO160

Composition

Patterns need not be symmetrical. In Berlin, the Holocaust Memorial comprises of a vast array of huge grey stone blocks arranged in rigid lines but varying in height. There is a multitude of ways to photograph such an important memorial and in this image I have gone for the semi-abstract once more, framing the blocks so as to eliminate too many obvious clues. I have also gone for a diagonal composition, offsetting the rigid rectangles against strong diagonal lines and receding sizes for a strong 3D effect.

The fishseller in Vietnam is less obviously pattern-based, that is until you realise that most of the shapes in the photo are actually circular. Hat, bowls, plates, baskets and tin, they are all round. Only the figure and the tiles break the theme. If I had been able to I'd have got up a bit higher to eliminate the hand in the top left corner but it was not possible – as it was I was on tippy-toes to try to get as much height as possible, wishing I was 6'4" or more.

Don't forget to look up and down. Inside monuments and temples, the floor and ceiling are often as ornate as the walls and can be made into interesting images. One of the images on the opposite page is of the ceiling of one of the rooms in the 'Baby Taj' or the Tomb of I'timad-ud-Daulah in Agra, India. It's not a big room so I had to lie on the ground with the camera pointing straight up to get these shots. It's important that each shot is rigidly composed – these are both framed as centrally as possible to emphasise the symmetrical patterns.

Vietnam | Canon EOS D60 | 20.0 mm | 1/90 sec @ f5.6 | ISO100

Tomb of I'Timad-ud-Daulah, Agra, Uttar Pradesh, India | Leica M (Typ 240) | 18mm |
8 sec @ f4.0 | ISO400

Akbar's Tomb, Agra, Uttar Pradesh, India | Leica M (Typ 240) | 18mm | 1/15 sec @ f4.8 | ISO3200

Leica Factory, Wetzlar, Germany | Leica M (Typ 240) | 18mm | 1/25 sec @ f4.0 | ISO200

Looking down can reveal patterns and shapes, too. The stairwell in the new Leica factory in Germany is a study in organic curves, reminiscent of a nautilus shell.

Negative spaces can work as patterns too. Shooting out from a corridor inside Angkor Wat in Cambodia, the shapes are made by the lighter temple wall in the background and silhouettes of the dark stone columns in the foreground. There is a positive/negative dynamic going on here; your eye readily flips between looking at the dark shapes and the light shapes because they are so similar.

Banteay Samre, Cambodia | Sony A7r | 50mm | 1/100 sec @ f5.6 | ISO100

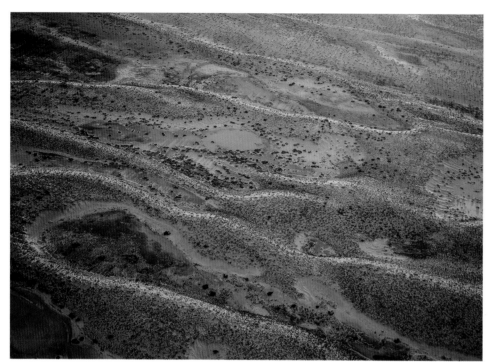

Tirari Desert, South Australia | Canon EOS 5D Mark III | 41mm | 1/500 sec @ f4.0 | ISO400

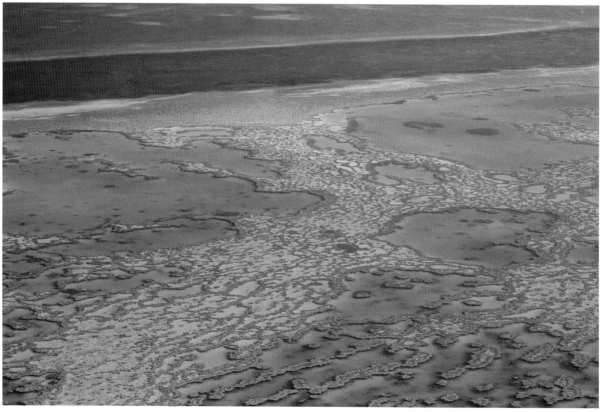

Great Barrier Reef, Australia | Canon EOS5 | 85mm | 1/1000 @ f4.0 | ISO100

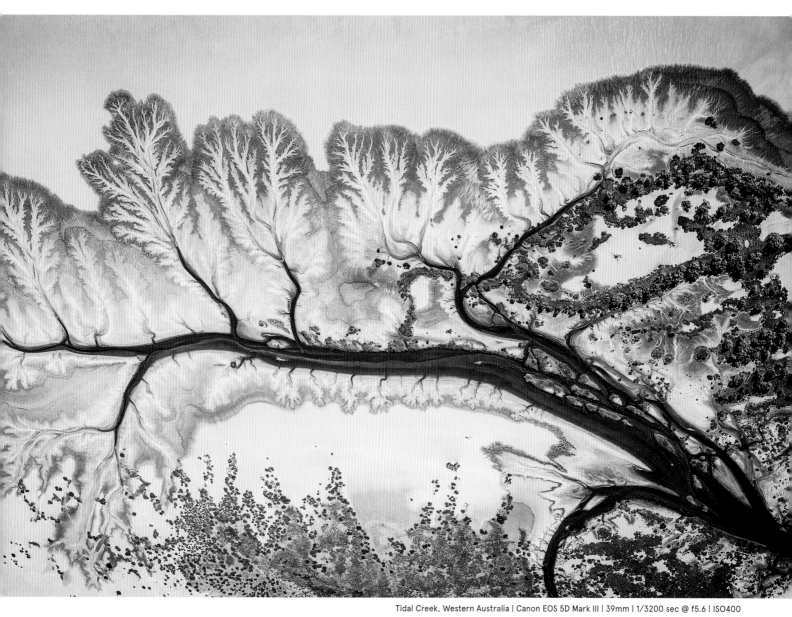

Tidal Creek, Western Australia | Canon EOS 5D Mark III | 39mm | 1/3200 sec @ f5.6 | ISO400

Dales Gorge, Western Australia | Canon EOS 5D Mark III | 61mm | 3/10 sec @ f14.0 | ISO100

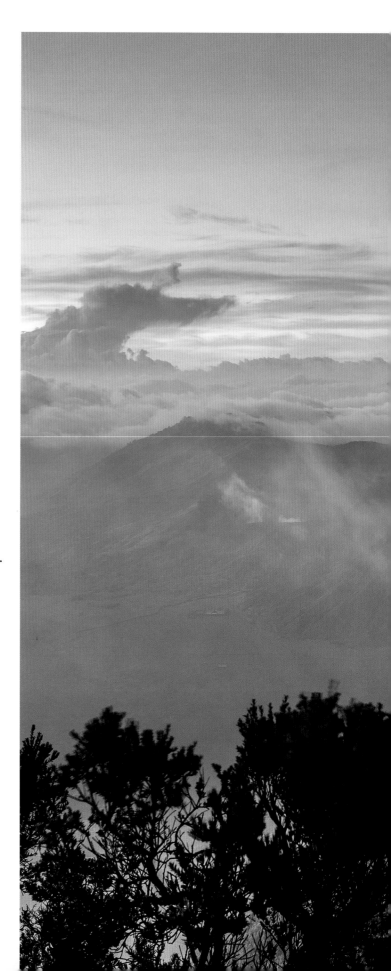

Chapter 10
<u>Landscapes</u>

Mount Bromo, Java

After rising at 03:30 and taking a one-hour jeep trip to the lip of this massive volcanic caldera I was amazed to see – absolutely nothing. In the pitch black of night none of what you can see in this photo was visible. I was there so early, well before anyone else arrived, because I had been told that it can get very busy at dawn. This was an understatement; by the time there was enough light to shoot, there would have been a thousand people packed into the large lookout area. I had staked out a good corner spot with a decent view and made sure no-one could inadvertently intrude into the photo. Then it was just a case of shooting as the light changed and letting the camera do its stuff. Be prepared!

— LEICA M (TYP 240) | 28MM | 1/2 SEC @ F6.8 | ISO200

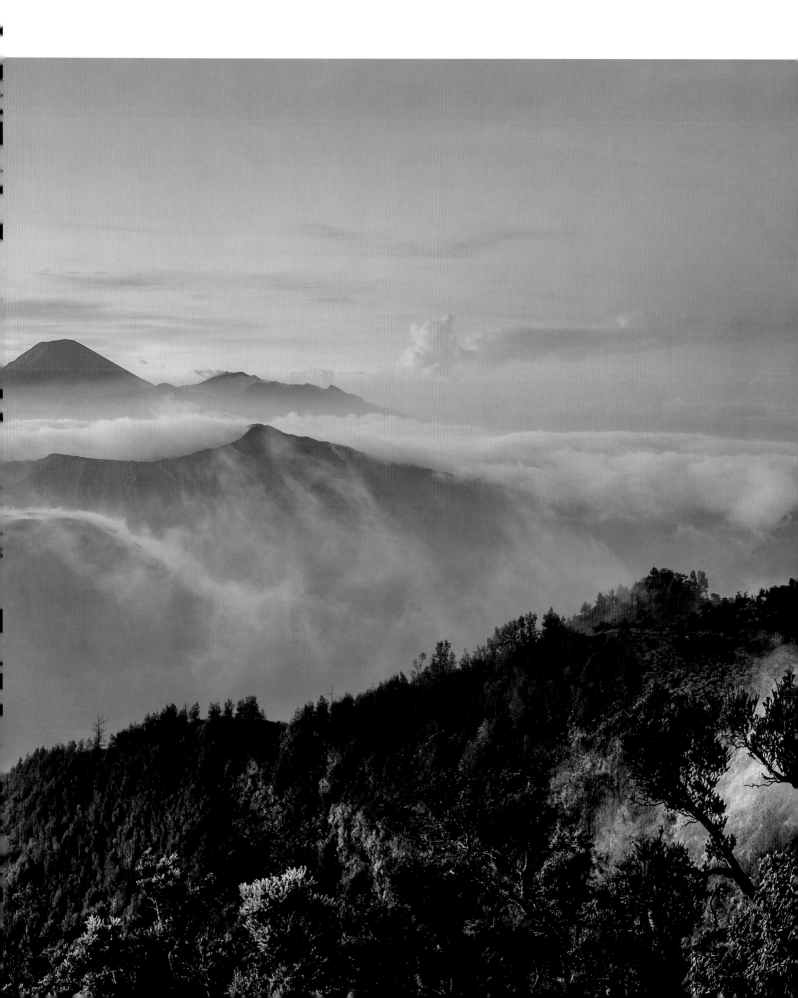

01 Landscape photography is about being in the right place at the right time

02 Landscapes are easy to shoot but hard to do well

03 Rule of thirds composition is a good starting point for landscapes

Monet's Garden, France | Leica M (Typ 240) | 75mm | 1/125 sec @ f3.4 | ISO400

'f8 and be there.'

– WEEGEE (ARTHUR FELLIG)

Weegee was a New York street and crime scene photographer in the 1930s and 40s and is supposed to have made this comment when asked about his photographic techniques. He is really saying that it's all about being in the right place at the right time, rather than any specific photographic technique.

Landscape photography is an essential part of travel photography. You need to show the 'where' just as much as the 'who'. Weegee's pithy rejoinder is particularly apt these days because modern cameras are so good at automatically getting the focus and exposure correct that you can *almost* remove them as variables. I say 'almost' because a correct exposure can be obtained from many different camera settings, specifically shutter speeds, apertures and ISO, so an understanding of what they each mean is an important part of the craft.

In the case of landscape photography you really could, in theory, just use f8 and let the camera automatically choose the shutter speed. You'd not go too far wrong and at the very least you'd end up with a useable photo.

What is absolutely critical, however, is *being there*. The greatest landscape photos ever taken still necessarily relied on the photographer being in exactly the right place at exactly the right time. The amount of effort expended on fine landscape photography is heavily weighted towards logistics

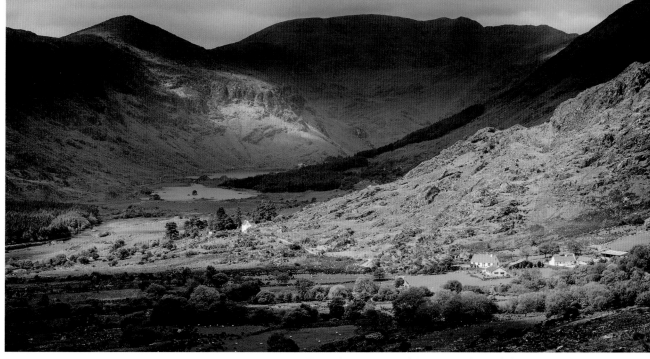

Black Valley, Kerry, Ireland | Canon EOS 5D | 85mm | 1/180 sec @ f8.0 | ISO100

of travel and access more than it is towards any specific photographic technique.

It's true that landscape photography is technically quite easy to do, but it is really hard to do *well*. Even the legendary landscape photographer Ansel Adams acknowledged, 'Landscape photography is the supreme test of the photographer, and often the supreme disappointment'. I have heard the comment so many times from my photography students: 'It just didn't come out like I saw it'.

Obviously 'landscape photography' is an entire, even vast, topic unto itself, and is the sole subject of a wide range of existing books, but here are my tips on things to keep in mind when shooting the 'where' images.

1. Vista-type images almost always look best in the first and last hours of the day, with the sunlight raking across the scene from the side. The long shadows add contrast and pick out the shapes of the landforms, making the scene much more three dimensional than when the sun is directly overhead. The colours will be warmer too and much more visually appealing than hard midday light, which tends towards the bluer or cooler tones.

2. The exception to tip #1 is for beaches and tropical water. Clear blue water under vivid sunny skies looks at its most sparkling when the sun is high.

3. Clear blue skies never look as interesting as cloudy skies. When the sky is 30–60% cloud you will get lots of interesting variations of lighting as patches of sunlight show through scudding clouds.

Kanbula National Geographical Park, Tibetan Plateau, China | Leica S2 | 120mm | 1/1000 sec @ f3.4 | ISO160

4. Clearing bad weather is a great time to head out. When the sun finally breaks through after a storm there is a good chance of spectacular light.

5. Classic landscape photographs often incorporate some sort of foreground interest which can add depth to the image.

6. Most landscape photos are made up of two parts – the sky and the land. Try to make them both interesting.

7. Wide-angle lenses (24–35mm) make good general purpose landscape lenses. Much wider than 24mm and the exaggeration of perspective can push your subject well into the distance, leaving the sky and foreground occupying too much of the frame.

8. If using a really wide lens (21mm or wider), try to take your camera a bit higher by standing on something. The higher you can get your camera position the more the foreground is stretched out.

9. Telephotos make good landscape lenses too. You can pick out details and textures, particularly from high vantage points.

Mekong River, Vientiane, Laos | Canon EOS 5D Mark II | 135mm | 1/180 sec @ f2.0 | ISO800

Cape Leveque, Dampier Peninsula, The Kimberley, Western Australia | Ebony RSW45 | 57mm | 1/15 @ f16 | ISO100

10. Unless you want a symmetrical photos (for example, the reflection in a lake), place your horizon low in the frame to emphasise an interesting sky, and high in the frame to emphasise an interesting foreground.

11. Classic landscape images are sharp from front to back. Using f11 or f16 on a wide-angle lens will help give you enough depth of field (see p. 150).

12. Given that landscapes are mostly static subjects, using a tripod is usually a good idea. You can then use a low ISO for maximum image quality without having to worry about camera shake. In a pinch, rest the camera on your bag on a rock or fence rather than trying to hand hold it (see p. 192).

Aperture

Courthouse Towers, Utah, USA | Canon EOS 5D | 24mm | 1/6 sec @ f16.0 | ISO100

The aperture is a crucial component of photographic lenses. It's an adjustable iris that can be altered to be a narrow hole or to be as wide as the inside of the lens allows. Why is it important? Well, if shutter speeds determine the length of time light shines on a camera's sensor, then the aperture controls the intensity or brightness of that light. Think of it like a pipe. A narrow pipe can only let so much water through in a given amount of time whilst a wider pipe can let through more.

Your eye has an iris, and it will be small on a bright day and wide when the light levels are low. This is exactly how a camera's aperture works – the aperture controls the intensity of light entering the camera.

This is very important for two reasons: exposure and depth of field (see also p. 028 and p. 150).

To achieve a correct exposure the aperture acts as a 'balance' to the shutter speed. The camera's sensor needs a specific amount of light to optimally capture all of the tones in a scene. A short exposure (high shutter speed) means a greater intensity of light is needed; conversely, during a long exposure (low shutter speed), less intensity is needed to get the same amount of light onto the sensor.

The units of aperture are expressed as f-numbers; to be precise the f-number is the focal length (f) of the lens, divided by the physical size of the iris opening. In other words, it's a ratio and so is independent of the lens itself when calculating exposure; f8 on one lens is the same as f8 on any other lens.

Exposure control

On a sunny day outdoors there is a given amount of light falling on the subject; this is not something you can control, but you can control how much light falls on the sensor and for how long, by setting different combinations of aperture and shutter speeds. If an aperture of f16 and a shutter speed of 1/60 sec results in a correct exposure, then an aperture of f4 and a shutter speed of 1/1000 sec will result in the same correct exposure.

Mount Warning, NSW, Australia | Canon EOS 5D | 85mm | 1/180 sec @ f5.6 | ISO200

Yenwaupnor Village, Rajat Ampat Islands, Indonesia | Canon 1Dc | 135mm | 1/500 sec @ f2.8 | ISO200

Make sense of the numbers

One of the hardest things to get your head around is the terminology; a small aperture is actually a large number and vice versa. f16 is a small aperture physically whilst f2.0 is a large aperture physically. So, when someone says that they used a small aperture they might mean f16, and a large aperture might mean f2.8.

The other confusing aspect is that each single stop represents a doubling or halving of the light intensity, even though the number only changes by a multiple of 1.4. Thus f4.0 lets in exactly half the light that f2.8 does.

Both have been changed by 4 steps (known as stops), but in opposite directions.

Thus: f16 @ 1/60, f8 @ 1/250 and f4 @ 1/1000 all result in the same exposure.

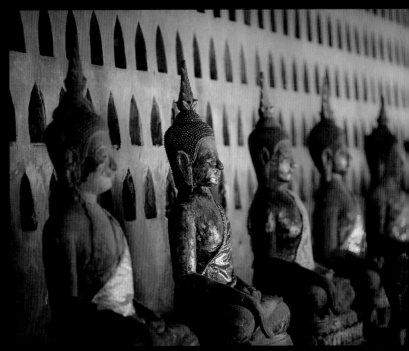

Wat Sisaket, Vientiane, Laos | Canon EOS 5D Mark II | 135mm | 1/500 sec @ f2.0 | ISO1600

Jenny Lake, Wyoming, USA | Canon EOS 5D | 17mm | 1/30 sec @ f11.0 | ISO100

Apertures are a fundamental part of the capture process. All cameras need lenses and all lenses have some sort of aperture through which the light is passed. As we have seen, apertures have a great influence on how the image looks and a full understanding of this, and the way they interact with shutter speeds, will help you craft fine images and get more satisfaction from your photography.

Black
and white

Fowlers Bay, South Australia

With the wind sand-blasting my legs up to the knees and gusts blowing sand all over the camera, it was not possible to swap lenses during this shoot without risking damage to the inner workings. The light was sensational so I kept shooting with the 180mm lens that was already on the camera – lucky the Leica S is very well weather-sealed. The sand was actually a muddy yellow colour and the sky was not blue but a stormy bruised colour, so I imagined this would make a good B&W shot. In monochrome it's all about the textures, the shapes of the ripples and the drama of the sand blowing from the dune's apex.

— LEICA S (TYP 006) | 180MM | 1/250 SEC @ F5.6 | ISO100

01 **Black-and-white, or monochrome, images are frequently seen as more 'creative'**

02 **Subjects with little colour or too much colour can make good B&W photos**

03 **Setting your camera to B&W mode gives you a good monochrome preview of the end result**

'The fact is that relatively few photographers ever master their medium. Instead they allow the medium to master them and go on an endless squirrel cage chase from new lens to new paper to new developer to new gadget, never staying with one piece of equipment long enough to learn its full capacities ...'

– EDWARD WESTON

Edward Weston has a point – it's easy to be caught on the 'one more lens' treadmill where the gear seems to define what you shoot rather than the other way around. On the other hand, black-and-white photography has its roots in the very origins of photography itself, and the nostalgic mood that good B&W images evoke is a testimony to the power of what was once a technical limitation and is now seen as the height of sophistication and, dare I say it, 'artiness'.

B&W is a simplification of photography: no longer can you rely on the crutch of vibrant colours; the shapes, textures and tones need to work together in a harmonious whole to achieve a pleasing

Shaman Festivals, Suhuri Temple, Tibetan Plateau, Tongren, China | Leica S2 | 35mm | 1/350 sec @ f9.5 | ISO160

image. Camera gear has little to do with it either; the pleasing greyscale values that make up a good B&W image owe more to the seeing than the shooting. Sure, the image needs to be sharp and well exposed but the gear really becomes subordinated to whatever it is that you point it at.

Art and B&W

Colour is easy – everyone shoots in colour, we see in colour, our world is in colour. Once you take away that colour you are taking one more step away from reality, heading into the realms of the abstract.

Take out the colour and all we have left is shapes, which are defined by different tones of grey, from almost black through to almost white. Those shapes become the focus of our attention, so they need to be organised in a pleasing manner. This is where the rigour required of B&W comes in.

In travel photography colour is by far the most published medium; magazines, advertising, TV, books all use colour imagery. It has mass appeal, no doubt about it. From an artistic point of view, B&W is still seen as a more creative medium and some of the top players in the photography world shoot only B&W. Check

Petropavlovsk, Kamchatka, Russia | Canon EOS 5D Mark III | 23mm | 3 sec @ f5.6 | ISO100

out Sebastião Salgado's book *Genesis*; I doubt you'll find a finer body of work, shot in locations all over the world and it's all in monochrome.

Blizzard in Lithgow, NSW, Australia | Leica S2 | 180mm | 1/90 sec @ f5.6 | ISO160

Milan, Italy | Leica M (Typ 240) | 90mm | 1/250 sec @ f8.0 | ISO200

B&W subjects

If your subject has little colour in it, it might make a good B&W image. Images where the colour is critical to understanding or decoding the subject tend not to work so well.

A tropical beach scene with a clear blue sky is more likely to work better in colour because the 'blueness' is an integral part of the appeal of such a subject. A mountain range with storm clouds could be a good candidate for B&W because it's the drama and majesty of the scene that you are trying to capture and colour is not really adding much. Look up Ansel Adams's 'Clearing Winter Storm, Yosemite' for a sublime example of this.

Portraits can work in either medium but personally I prefer B&W. Faces appear more clearly defined in B&W; character lines, skin texture and hair all become that much more apparent than the same shot in colour.

Some subjects just have too much colour, so much so that your eye has trouble knowing where to start looking. Classic advice in photography composition often suggests 'simplifying the image'. This can mean tightening up the shot to remove distracting objects but it can also mean removing the colour.

B&W camera or mode

There are only two dedicated B&W cameras on the market at the time of writing – the Leica M-Monchrom and the Phase One IQ2 Achromatic digital back. Both produce absolutely amazing monochrome results but are obviously limited in that you cannot shoot colour should you need to.

All other cameras capture colour information in one form or another, but almost all can be set to a B&W Creative Mode which

Ta Prohm Temple, Angkor, Siem Reap Province, Cambodia | Canon 5D | 24mm TSE | 1/20 sec @ f9.5 | ISO200

internally converts the image data to a monochrome JPEG file. There are also settings in a camera's menus that allow you to alter the contrast of the final image as well as options like sepia toning, as seen below, and so on.

With the B&W mode enabled, the image you see on the LCD screen on the rear of the camera will be B&W, so this mode is a great way to visualise the way the image will look when the colour is removed. You can check out how the different colours are being translated to a grey value and so judge if the image is worthy or not.

There is one more very cool feature that is not terribly obvious, even if you read the camera manuals. If you shoot in raw (and you should) then the camera creates a B&W preview to display on the back but still shoots a colour raw file. If you set the camera to shoot raw+JPEG then you can have the best of both worlds – a B&W JPEG but also a normal raw if you change your mind later!

Shuangpenxixiang Village, Qinghai Province, China | Leica S2 | 35mm | 1/30 sec @ f11.0 | ISO160

Chapter 12

Street

Spice market, New Delhi, India

Making 'visual sense' out of a situation as frenetic and seemingly random as the streets of Old Delhi is certainly challenging. There comes a point in time when the elements in a shot do align in some sort of pleasing or coherent manner and it's up to you to firstly recognise such a moment, and then actually capture the shot. This entails shooting a lot of frames and trying to make sense of what's going on around you, something that becomes easier with practice.

— LEICA M (TYP 240) | 18MM | 1/180 SEC @ F6.8 | ISO400

01 **Pure street photography is challenging**

02 **Learn to operate your camera without having to think about it**

03 **Watch for repeating patterns of behaviour**

04 **Zone focusing is a powerful tool for fast reactions**

'In that split second, when you realize something truly remarkable is happening and disappearing right in front of you, if you can pass a camera before your eye, you'll tear a piece of time out of the whole, and in a breath, rescue it and give it new meaning.'

– JOEL MEYEROWITZ

If travel photography encompasses just about all possible genres of photography, then street photography would have to be one of the narrowest categories to fall within the oeuvre. Judging by commentary on photography forums and in conversation with other photographers, street photography is considered to be one of the purest forms of photography and at the same time one of the hardest at which to excel.

My somewhat verbose definition of street photography goes like this: Observed single moments of urban life with little or no influence by the photographer and captured in such a way as to be surprising, dramatic, amusing and/or visually appealing.

Jodhpur, Rajasthan, India | Leica M (Typ 240) | 18mm | 1/180 sec @ f5.6 | ISO400

India is a wonderful place to shoot spontaneous street images but it's so busy, so overwhelming and so complex that it can just be too much; it's easy to be frustrated with your results. Take it slowly in these sorts of settings and you'll get your shot. But street photography need not be restricted to exotic places – your home town can offer just as many opportunities. Think in terms of markets, particularly farmer's markets or large well-established markets in country towns. All the same principles of drama, interest and surprise apply.

You'll know it when you see it

Let's examine how the opening photo of this chapter came to be. This shot works for a number of reasons. The moment of capture sees three men loading goods onto a hand-cart in Chandni Chowk (Old Delhi). They are in a perfect sequence – from bale on head to lowering off head to putting on the cart. The stage was set by the guy reclining to the left of frame and the food cart to the right. Backlight gives a nice hazy atmosphere and casts interesting shadows, as well as adding a bit of depth as the street recedes into the distance. The image was shot on a Leica M (240) with an 18mm lens, an excellent camera and lens combination for this kind of work.

Compare to some previous shots (right), taken moments before – I think you'll agree that none really gel as well as the final shot. It only takes one thing to ruin the shot: an awkward position, someone scowling at the camera, or just a disconnect between the various elements. It's all a bit tricky to pin down in words but you'll know it when you see it.

Henri Cartier-Bresson will be forever associated with the term 'the decisive moment', even if he did not in fact coin the expression. It's attributed to one Jean Francois Paul de Gondi (Cardinal de Retz) 1613–1679: 'There is nothing in this world that does not have a decisive moment'. The expression became the title of Cartier-Bresson's most famous book.

Catching a moment in time when everything comes together in the frame to become a visually organised and interesting image is quite an art. It demands mastery of the equipment to the level where focusing and exposure become not just second nature, but completely unconscious thoughts. You will be totally concentrating on the apparently random and mobile relationships of your chosen subjects within whatever space is in front of your camera. You will not be consciously concerned with exposure or focusing, both of which need to be just happening without you having to stop and think.

Observe the flow of movement

Movements of people on the street are not random. People are all going to and from somewhere, so if you can get a sense of the ebb and flow of movement it becomes easier to take an educated guess about how a series of interactions might progress.

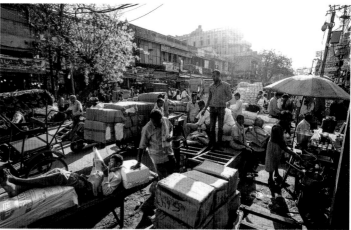

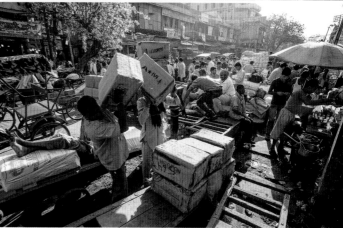

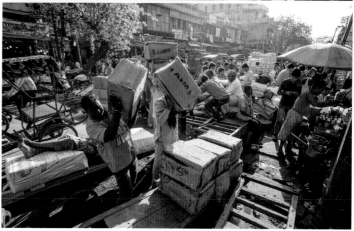

New Delhi, India | Leica M (Typ 240) | 18mm | 1/180 sec @ f16.0 | ISO400

Choke points are good – street corners, alleyway entrances, etc. – because they set a physical limit to where people can be. Spend some time just looking, watching for subtle patterns and you'll soon find that there are opportunities that occur, more often than not, in similar locations.

Observation is all about trying to get a sense of the flow of people, how they are interacting, what might happen next and where it might happen.

OK, so that's the ideal, but in reality there are plenty of opportunities to shoot on the street that are far less demanding. Relatively static scenes abound in busy cities – street vendors hawking their wares, bus stops crowded with passengers, pedestrians crossings at the lights; these all happen in predictable locations, and in a repeated fashion. This becomes more 'stakeout' than 'street', but the overlap is significant. You can still shoot excellent street images using the stakeout techniques outlined in Chapter 4.

Pre-focus for more consistent results

Autofocus, for all its amazing speed and accuracy, can only do so much. It can't read your mind, it can only react to what you point the camera at. If what you are pointing the camera at is close, moving quickly and frequently going behind other moving objects, i.e. people in a crowd, then AF will struggle. It will focus on something with no trouble at all – the problem is whether it's focused on what you needed it to focus on!

I like to de-couple autofocus from the shutter button – check your camera manual, but somewhere within those 4276 pages of dense diagrams there will be a way to set the main shutter button

New Delhi, India | Leica M (Typ 240) | 50mm | 1/125 sec @ f6.8 | ISO400

to trigger the exposure meter and the shutter but not the AF. The AF can be triggered by your thumb on another button, often on the back above the LCD screen and labelled 'AF-On' or something like that.

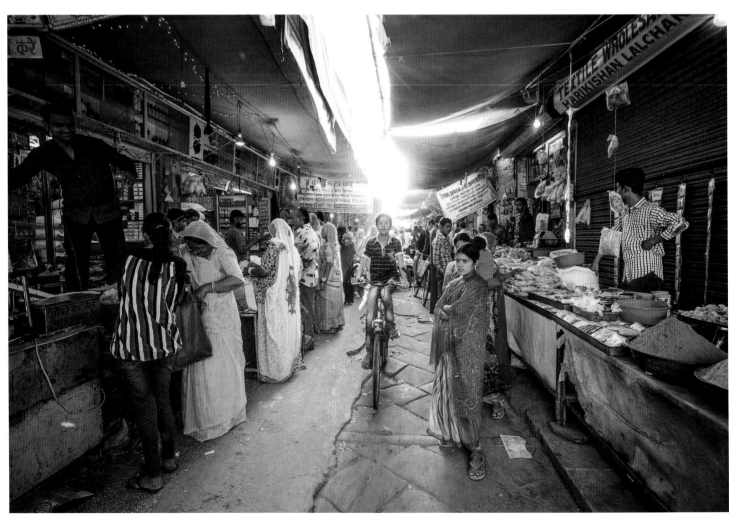

Jodhpur, Rajasthan, India | Leica M (Typ 240) | 18mm | 1/90 sec @ f16.0 | ISO800

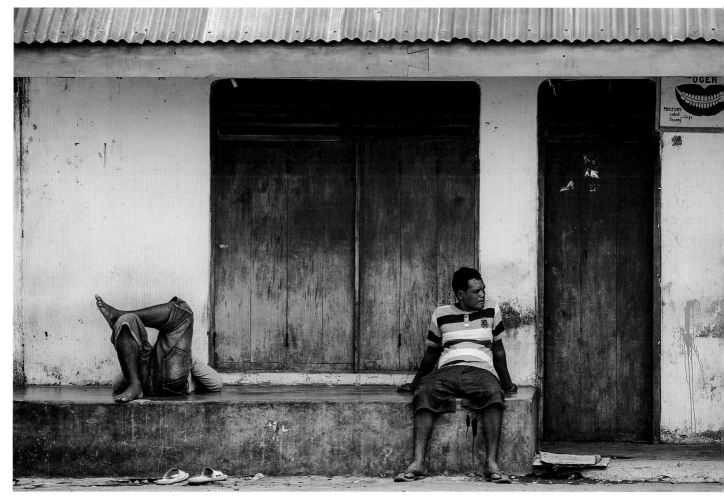

Banda Naira, Indonesia | Canon EOS 5D Mark III | 135mm | 1/500 sec @ f2.8 | ISO100

Using the camera this way means that you can use the AF-On button to pre-focus on something that is about the right distance for the shot you are expecting to make. Then when you press the shutter button to take the photo the camera will NOT try to re-focus. Once focus is set, it's a case of waiting to see if your expected/hoped for combination of elements actually happens. Cartier-Bresson referred to this as 'zone focusing', where you set the focus to a certain distance, depending to a degree on the lens you are using, then the depth of field (DoF – as determined by the aperture you are using) will create a 'zone' within which you can shoot without refocusing.

Zone focusing is easier to do with wider lenses and almost impossible with telephoto lenses. A 35mm or 28mm lens is perfect for this technique – it's not so wide as to give an odd perspective but has enough DoF to keep things mostly sharp between, say 2–3m, using maybe f5.6. Once you have this in your mind, you start looking for action that will occur roughly 2.5m away from you – you have to move yourself to maintain that distance from your potential subject.

Perfect focus is incredibly hard to achieve and what might be unacceptable in some genres becomes acceptable in street work. The sheer spontaneity of this kind of work necessitates a bit of imperfection – too perfect and images can look staged. There are endless examples of amazing moments in time caught 'just so', that are actually not that sharp when examined closely.

Shoot loose

For the more hardcore street style images here is a tip that will help you get more consistent results. Cartier-Bresson, a framing purist if ever there was one, would turn in his grave to hear me say this, but if you shoot a tiny bit 'loose' – allowing a bit of extra room around the subject – you can tighten up your crop later, to frame the action in precisely the way it needs to be framed. I am interested in results, not techniques, so, with the resolution available to us these days, cropping the image slightly to improve the framing is just common sense. No-one cares how hard a photo was to take – they just want to enjoy the image.

Cameras

The internet is full of discussions about which camera model is better than another, or the relative merits of this brand over that one. I'm not going to buy into that discussion because the simple fact is that almost all modern digital cameras are capable of excellent results as long as they are used within their capabilities.

'The single most important component of a camera is the twelve inches behind it.'
– **Ansel Adams**

Having a better camera will not necessarily lead to better photos, but it will make it easier to get better photos. You still need to be in the right place and at the right time and point the camera at something interesting, but better, more specific, cameras will make the actual taking of the shot that much more reliable. In terms of cost, let price be your guide: you get what you pay for with pretty much any camera.

Points to consider

— A faster, more accurate autofocus system will give a higher proportion of sharp images in low light.

— A bigger sensor will usually show less noise in low light.

— The time between pressing the shutter and the camera actually taking the shot (shutter lag) can make or break an image.

— High-end cameras are often weather-proofed and will work even in the rain.

— Cameras will only shoot so many images in quick succession before the internal memory fills up and the camera pauses. The better cameras will shoot longer sequences.

Compact cameras

These are lightweight, unobtrusive and good value cameras, excellent for keeping in your pocket 'just in case'. The zoom lenses on current compacts can be excellent and might be all you need. Watch out for poor shutter lag, slow autofocus and noisy high-ISO shots. Used within its capabilities a mid-range compact will produce excellent results, but in low light they struggle and if you want to shoot fast-moving subjects, then the slow autofocus will be a problem.

The cheap pocket cameras around the $100–300 price point are going to be quite limited but once you head up the price range there are some compact cameras that truly rival the image quality of mid-range dSLRs. At the time of writing, the Leica D-Lux, Canon G16 and G1X, Nikon Coolpix P7800, Sony RX10 and others at the top of their product ranges are fully capable of publishable quality images.

Jodhpur, India | iPhone 6 | 4.1mm | 1/290 sec @ f2.2 | ISO32

dSLR (digital single-lens reflex)

Generally considered to be the ideal camera, although I'd argue that this is because they look like 'real' cameras from back in the day! But a word to the wise; a low-end dSLR can actually be considerably worse than a top of the line compact on pretty much any measure.

The big advantage of dSLR cameras is, of course, the fact that they have swappable lenses, something you cannot do with a compact camera. This gives you access to multiple ranges of lenses, from basic zooms up to exotic super telephotos costing $15,000 or more. The high-end dSLRs are also truly amazing photo-making tools – they effortlessly focus on moving subjects, shoot up to 14 frames per second and can keep working in sub-zero conditions and in the pouring rain. But whilst the images they create can be amazing, the cameras themselves are heavy and expensive, which does not suit everyone.

Other cameras

This is where it gets more interesting. We are seeing a distinct shift away from the traditional dSLR towards mirrorless cameras that have no optical viewfinder; instead it has an Electronic Viewfinder (EVF) so you are actually looking at the image exactly as it is seen by the sensor. We are now seeing cameras with EVFs of such high quality that they are hard to tell from an optical system and the benefits of the design are already paying dividends. Mirrorless cameras, in particular the Sony A7r Mk2, and the Leica Q, offer a smaller camera with amazing image quality and the responsive handling that even the best dSLRs struggle to match.

I have been shooting with the Leica M for quite a few years, having moved away from my Canons for general purpose travel work. I love the fact that I can shoot 90% of what I need with a single camera slung around my chest and three tiny lenses – no bag, no weight, so comfortable. By the time this book is published there will be a new Leica available which might even trump the M, so that might be my next purchase!

Recommendations

It's terribly tricky to make useful recommendations because your needs will differ from mine, and from everyone else's too.

Your budget will have a big influence on your available options but if you trawl the internet forums and camera websites you might start to see some 'sweet spots' of price and capability. As an example, the Canon 5D Mk3 has proved to be a fantastic balance between price and features. It's a little bit bulky for a casual user but for the committed enthusiast it is a very capable camera.

Ta Prohm, Angkor, Cambodia | iPhone 5 | 4.1mm | 1/20 sec @ f2.4 | ISO100

I am not familiar with the Nikon range but I believe the D750 is a similarly well-priced and specified camera.

If you don't want to lug around a full dSLR kit – and, to be honest, even one dSLR camera and three lenses can be quite a burden – then a really good compact or mirrorless camera is a realistic option. But don't scrimp on price – if you get a modest compact you will outgrow it quickly, so jump in at the top of the range and you'll find those models offer a much more pleasant shooting experience.

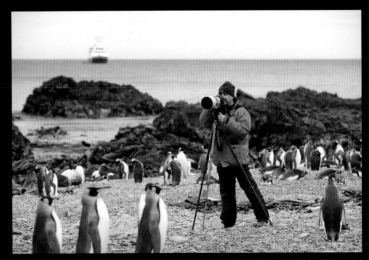

Sandy Bay, Macquarie Island, Sub-Antarctic Islands, Australia | Canon EOS 5D Mark II | 135mm | 1/250 sec @ f4.0 | ISO100

Chapter 13

Weather

Brisbane, Australia

I love mist and fog. As soon as I see it forming in low-lying areas
I get quite excited because I know there are strong images to be
had. An awareness of weather patterns and what they might lead
to is important for any travel photographer, because you can make
informed guesses as to what might be possible the next day and plan
your shots accordingly. This image was taken from a hill to the south-
west of Brisbane CBD, where there is a cafe and a concrete platform
from which to admire the view. The most important factor in this
shoot was getting to the location in plenty of time – I was in position a
good 90 minutes before sunrise and I was the only one there for about
half an hour. The lights in the foreground are the street lights shining
up through the fog; later on, these lights were far less obvious.

– SONY A7 MKII | LEICA 90MM | 10 SEC @ F5.6 | ISO100

01 **Weather affects light quality and light quality affects the photograph**

02 **Learn to interpret weather forecasts**

03 **Plan to shoot according to the likely weather conditions**

04 **Make weather a feature of your shots**

Bluff Knoll, Stirling Ranges, Western Australia | Leica S2 | 35mm | 1/750 sec @ f5.6 | ISO160

> 'There is no bad light. There is spectacular light and difficult light. It's up to you to use the light you have.'
>
> – JAY MAISEL

In Chapter 7 we looked at light quality and how different angles of light show up your subject in different ways. Closely associated with light quality is the weather, because what's going on in the sky has a huge impact on the types of light you will be dealing with on any particular day. Light quality is one thing, but the weather is also a subject in itself.

Think about classic European paintings from the 17th century onwards, when landscape painting became more and more popular. Look at paintings by Constable, Turner, Friedrich, Monet, Rubens, Lorrain and others and you will see, without exception, their landscape paintings include clouds – no-one ever painted featureless blue skies or solid grey overcast skies! Their skies all had texture and drama, and the same is true for the best landscape photographs.

An awareness and appreciation of the weather is an important part of the travel photographer's toolbox. I am always looking at local weather forecasts to see what the likely conditions are going to be. Of course I can't do anything about it, but I can be influenced by what weather is likely and plan to shoot accordingly. The weather can be a real opportunity for shots in itself.

Fog

Fog is a great example. Misty mornings are a rich source of fine images no matter where you are in the world. High humidity at dawn, combined with a drop in temperature and still air, will sometimes provide the right conditions for fog to form – water vapour condenses into water droplets suspended in the air.

Some places are very prone to fog – San Francisco is frequently subject to advection fog which rolls in from the Pacific Ocean. The Grand Banks of Newfoundland is known as the foggiest place in with world, with fog forming on over 200 days per year.

Brisbane, where I live, has cool dry winters and occasionally, when the conditions are just right, the city can be blanketed in fog with just the tallest buildings showing through. The image on the previous page came about after a considerable number of near misses from heading up the Mount Coot-tha Lookout well before dawn when the conditions looked promising. Sometimes there is nothing going on, sometime too much fog gives you nothing. This time it was perfect.

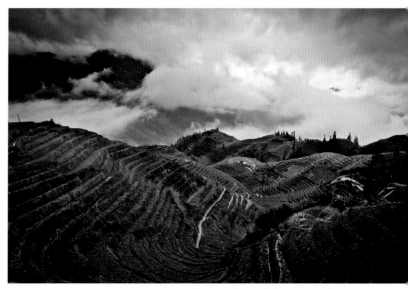

Ping An, China | Leica S2 | 30mm | 1/4 sec @ f11.0 | ISO160

Know a little about the weather

Some basic knowledge of how weather patterns operate can give you a hint of what's coming up. This can be day to day, or over seasons. Take the tropics of Australia, for example – Darwin has a mostly dry, clear winter but come November you start to see build-ups of colossal cumulonimbus clouds as the wet season approaches.

An important part of my research into new locations is looking at climate charts to see what weather conditions are likely at different times of the year. For example, there is no point in heading off to Darwin in February if you want a comfortable photography trip because it is incredibly hot and humid. Plus getting around is very hard because of the extreme rainfall. On the other hand, you might see some incredible cloudscapes and lightning displays, so putting up with the conditions could lead to awesome photos.

Russkaya Bay, Kamchatcka, Russia | Leica Q (Typ 116) | 28mm | 1/1000 sec @ f2.8 | ISO400

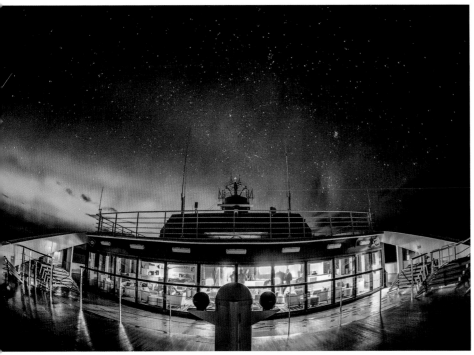

Northern Lights. '*Le Soleal*', Russian Far East | Canon EOS 5D Mark III | 15mm | 1 sec @ f4.0 | ISO6400

Storms and rainbows

Storms can be viewed on weather radars to see how they are tracking. Different countries have different weather station capacities but it's always worth checking to see if you can find local real-time radar on the internet. Storm cells show up clearly on radar and to be able to see where they are heading gives you the chance to be in the right place at the right time. There is a whole subculture of 'storm-chasing' and you can learn a lot from different groups' websites.

Rainbows are another weather phenomenon worth understanding. Rainbows are formed by the light from the sun refracting back to the viewer from water droplets in the air. The different wavelengths (colours) are refracting at slightly different angles, with the result that you see a 'splitting' of the colour components of white light.

This is why rainbows are always coloured in the sequence of red to violet, through orange, yellow, green and blue. It is also why rainbows are always directly opposite the sun's position – if the sun is on the horizon you will see a half circle, and for increasing angles above the horizon you will see a smaller and smaller arc.

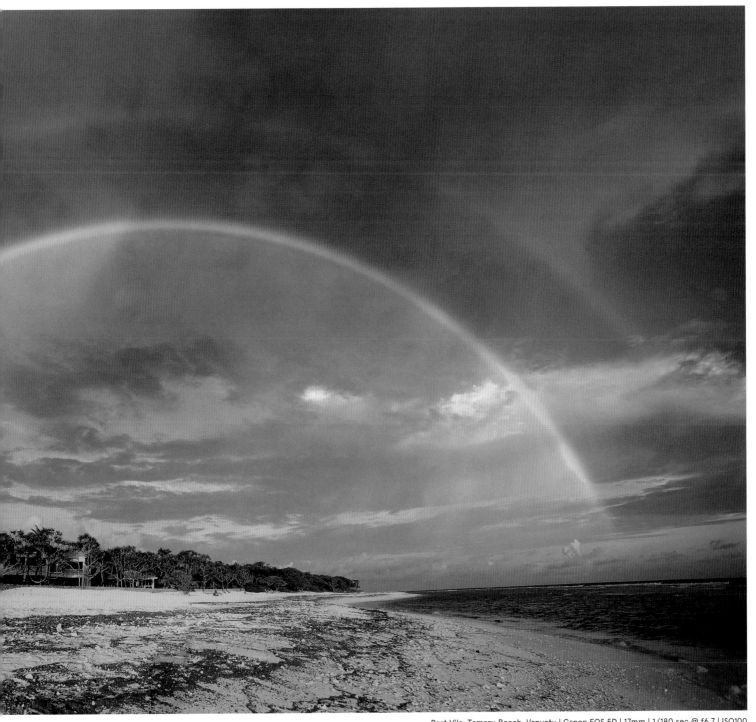

Port Vila, Tamaru Beach, Vanuatu | Canon EOS 5D | 17mm | 1/180 sec @ f6.7 | ISO100

Rainbows are also always the same size – 84 degrees across – so you'll need a lens of 18mm or wider to capture a full rainbow in one shot. More importantly, rainbows are 'personal' – they only exist for the viewer because you are seeing light reflected back to your eye. As you move, the rainbow moves with you, so if you want to compose your photo in such a way that the rainbow 'points' at something, all you have to do is move yourself and the rainbow will dutifully follow you.

If you want to delve more into the science behind the various weather phenomena that make good photos I can recommend *Color and Light in Nature* by Lynch and Livingstone. It's a great read and covers all the different light effects caused by nature, right down to incredibly rare events such as the legendary 'green flash' – look it up!

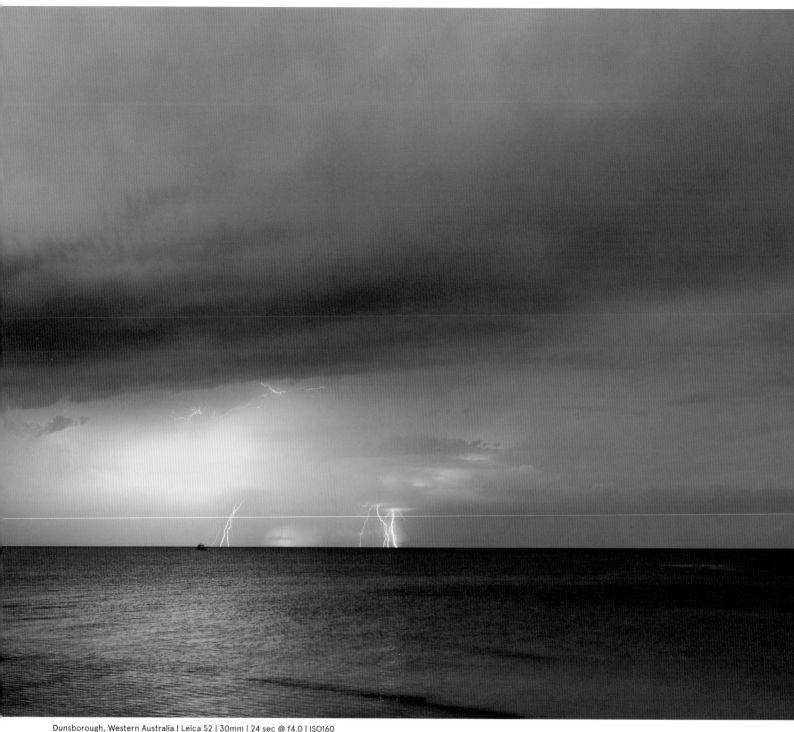

Dunsborough, Western Australia | Leica S2 | 30mm | 24 sec @ f4.0 | ISO160

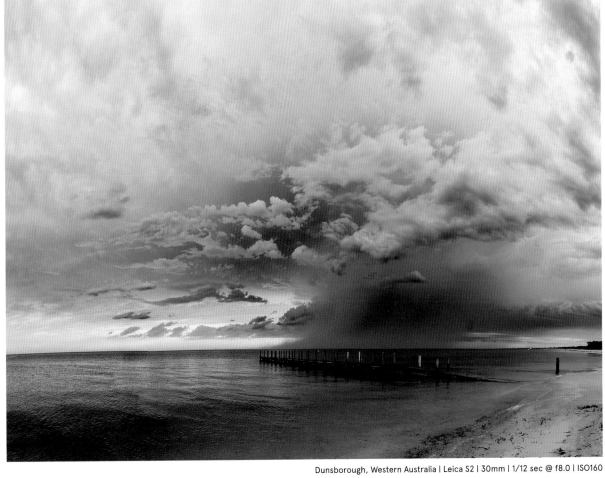

Dunsborough, Western Australia | Leica S2 | 30mm | 1/12 sec @ f8.0 | ISO160

Scale

King George Falls, Western Australia

Big things look even more impressive if you can include a human figure and shoot from a reasonable distance away. The flattening effect on perspective when using a long lens gives a sense of 'looming' and actually shows a truer scale of the small human figure against the larger object, in this case a massive early season waterfall. I was able to hop off the inflatable onto a small rocky ledge so I could shoot with a tripod and this image became a very widely published one for the cruise ship company that I was working for.

— CANON EOS 5D MARK II | 200MM | 1/60 SEC @ F3.5 | ISO200

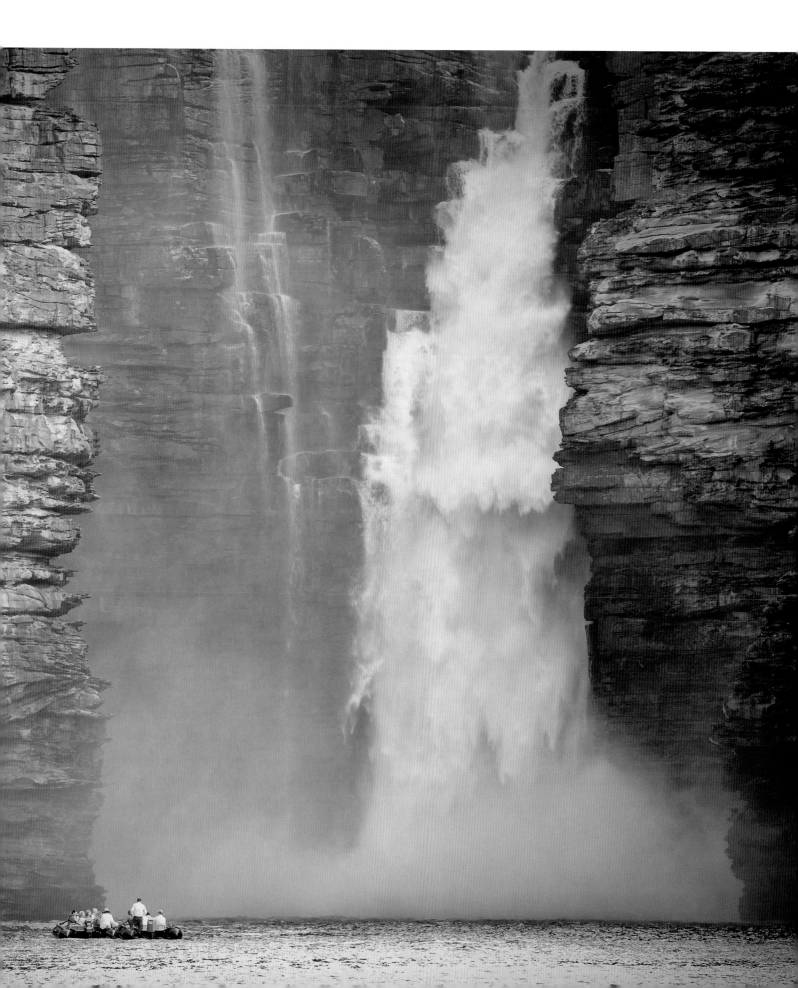

01 Including a small human element somewhere in the shot shows scale very clearly

02 Excluding scale clues is useful for abstract photos

03 Subtle scale hints give the viewer a nice surprise when they see them

Pentecost River, The Kimberley, Western Australia | Canon EOS 5D Mark III | 59mm | 1/3200 sec @ f5.6 | ISO400

'All the technique in the world doesn't compensate for the inability to notice.'

– ELLIOTT ERWITT

Approximately 90% of American adult males are between 5' 5" and 6' 3" according to the 2008 US Census figures. To extend that to other countries and the global population, 90% of all adults are within a 10 inch range of heights, or to put it another way, adult heights vary less than 15% for 90% of the population.

Why mention this? Well, the size and shape of a human figure is very, very familiar to us – we see it pretty much all the waking hours of our lives. Because of this, the human figure has become the de facto yardstick by which we measure relative scale when we see something big or, to a lesser extent, small. Look at a distant cliff and it's hard to gauge the size until we see a human figure standing on top. Our minds accept the figure as being the same distance away from us as the cliff and so we can make a relative judgement of scale. The cliff height is unknown and so is its distance away from us, but introduce a human figure and neither of those facts are important – our minds use the figure as a reference and that's all we need to get a sense of scale and roughly how far away an object is.

Bryce Canyon National Park, Utah, USA | Canon EOS 5D | 17mm | 1/60 sec @ f11.0 | ISO100

Give me a clue

How our brain processes visual input is fundamental to our 'getting' a photo, because a 2D photograph completely lacks any real clues about the actual size of the subject in the photo. Quite literally, a 1000 foot high cliff is now only 10 inches high on the page. Luckily for us our minds are more sophisticated than that, otherwise we would never be able to comprehend what we see in a flat photo print. We recognise the photo of a cliff as just a picture depicting a cliff and we make the reasonable assumption that the real-world cliff is bigger than what we physically hold in our hand. We can conceptualise the cliff and interpret the photo accordingly.

The ways in which the mind and the eye determine what they are observing are complex but reasonably well understood (see *Eye and Brain* by Richard L. Gregory for lots more depth on this subject). The brain tries to fit what it 'sees' to certain hypotheses or educated guesses. Basically, if it walks like a duck, sounds like a duck and looks like a duck – we will see a duck.

The fun comes when you mess around with the visual clues that we use to work out what we are seeing – these are called optical illusions and are quite important in photography.

By mixing up the clues that we reveal in a photo it is possible to trick the viewer into not quite believing their eyes. Scale is the easiest to mess around with. You can shoot certain subjects in a way that offers no clues as to the size of the subject – that's what many abstract photos are. Erosion patterns are a great example because they are similar to look at whether they are large patterns in mudflats seen from 5000 feet up in a plane, like the photo at left, or if they are small patterns on the beach beneath your feet. (For the geeks amongst you, this is what fractal means – similar shapes repeating at different scales, like the coastline on a map – no matter how much you zoom in or out it's still a jagged outline.)

Show scale for impact and meaning

While it can be entertaining for a photographer to control how an object is interpreted and deliberately confuse the viewer, travel photography is more concerned about making things clearer and being more informative.

If I photograph something big, the image is more useful to the viewer if they can judge how big. That's where the human figure or man-made object comes into play. Look back to the opening shot in this chapter and put your finger over the inflatable with the people in. Does the scale now seem to shift? To me the waterfall just does not look as big without the boat. Reveal it and the scale of the waterfall is clearly established – and it is mighty!

A technique I use all the time to establish scale is to introduce a small human-sized object into the frame somewhere. These two photos of Bryce Canyon are good examples. The image below was taken after deliberately waiting for some people to come into view, to provide an indicator of scale. You get a good sense of the height of those rocky hoodoos, which are all the more impressive for it.

Compare it to the other shot, which still shows amazing colours and rock formations, but the scale is impossible to judge.

Bryce Canyon National Park, Utah, USA | Canon EOS 5D | 135mm | 1/750 sec @ f2.8 | ISO100

Mount Leake, Mornington Station AWC, Australia | Canon EOS 5D | 17mm | 1/250 sec @ f6.7 | ISO200

If you want to be a bit more sophisticated about it, make the scale-setting object really small and place it in an unlikely part of the image, maybe right in one corner, somewhere not very obvious. When the viewer sees the photo for the first time they may not be able to immediately judge the scale. There will be a moment of puzzlement – 'what am I looking at?'. Then, the scanning eye sees the tiny figure tucked away in the corner and the whole image snaps into the correct scale with a bit of an 'Aha!' moment for the viewer. This is known in art history circles as the 'beholder's share' (Ernst Gombrich, 1909–2001), the idea that the viewer should do a little bit of work to interpret the image so that they then feel a little frisson of pleasure when they 'get it'.

The Taj Mahal photo on p. 016 is a good example – the solitary guard is hard to spot but once you see him, the scale of the mausoleum is immediately established.

Flinders Ranges, South Australia | Leica S (Typ 006) | 70mm | 1/8 sec @ f11.0 | ISO100

Monument Valley, Utah, USA | Canon EOS 5D | 85mm | 1/250 sec @ f5.6 | ISO100

Storage and laptops on the road

I love the fact that I no longer need to worry about film on long trips – all the stress about x-ray machines and hot climates has been a thing of the past for over a decade now. The trouble is, now I have to lug around a laptop, cables, chargers, adapters, external hard drives, card readers etc. It's less fragile for sure, but no less stressful.

Cambodia | iPhone 5 | 4.1mm | 1/50 sec @ f2.4 | ISO64

New Delhi Express, India | iPhone 6 | 4.1mm | 1/15 sec @ f2.2 | ISO250

Rather than go through the ins and outs of this laptop or that tablet, I'll just tell you what I have found to be an effective set up on the road. There is no right or wrong here, whatever works for you is fine, but there are still ways to be as efficient as possible.

Laptops

For me, the choice of laptop – 13" MacBook Pro with Retina screen – is a total no-brainer. I don't think any other product offers the same balance of power, price and portability as a maxed out 13" MBP. The Mac Air is a bit down on power, the 15" model is a speed demon but a bit heavy, so the 13" model is a Goldilocks laptop – just right.

Internal drive

Spend a bit more on the biggest internal drive you can afford. I confess to having scrimped here, buying the 256GB solid state version, and I wish I'd gone for a higher spec model. This is because there is not enough room on the SSD hard drive for the operating system, applications and all the photos that you shoot on a trip. I now need two external hard drives instead of one, which means more cables and things to carry.

External hard drives

You need external hard drives for back up. As soon as possible you should be copying your photos off the cards and onto the laptop and the external HD so you have two copies in existence. I also recommend keeping the SD (secure digital) or CF (compact flash) cards full until you get home, then you can safely reformat and reuse them. It's a good insurance policy, but you do need enough cards to last an entire trip; it's a good thing they are relatively cheap.

I use Western Digital external hard drives, specifically the Passport Wireless series in the 1TB size. They are light and small, so they are easy to carry around and connect with a fairly fast USB3 connection.

In summary

Do some research and spend a bit of time getting the right tools of the trade for safe storage. Your livelihood can depend on it. All I need is the laptop itself, its power brick, the two HDs and their respective USB cables. I don't need a card reader because all my cameras shoot on SD cards and the MacBook Pro has a built-in SD card slot. Check if this is the case for your equipment.

One last thought – because you are backing up your images to two different hard drives (you are, aren't you?) then don't travel with them together. Take the laptop with you in your hand luggage as usual but put the backup HD in your checked luggage, buried deep in your clothes. It would be awful if your cabin bag got stolen at the airport with both the laptop and the backup HD in it.

Chapter 15

Light modifiers

Samford, Queensland, Australia

Ray is a volunteer at the Samford Museum and he completely looks
the part as a blacksmith. Museums don't have to be big institutional
buildings, some are themed or outdoors and staffed by local historical
societies like this one. They are a great place to shoot portraits and
details of old equipment or memorabilia – often just asking permission
and offering to share the photos with the museum will give you all
the access you need. I lit the background with a small, remotely
triggered flash to add some detail to the dark background but the
rest is purely available light. I also shot at f2.0 so the background is
slightly out of focus, even with a wide-angle lens – this gives the shot
much more apparent depth and Ray stands out very clearly because
your eye is always drawn to the sharper parts of a photo more than the
unsharp parts.

– LEICA Q (TYP 116) | 28MM | 1/80 SEC @ F2.0 | ISO1000

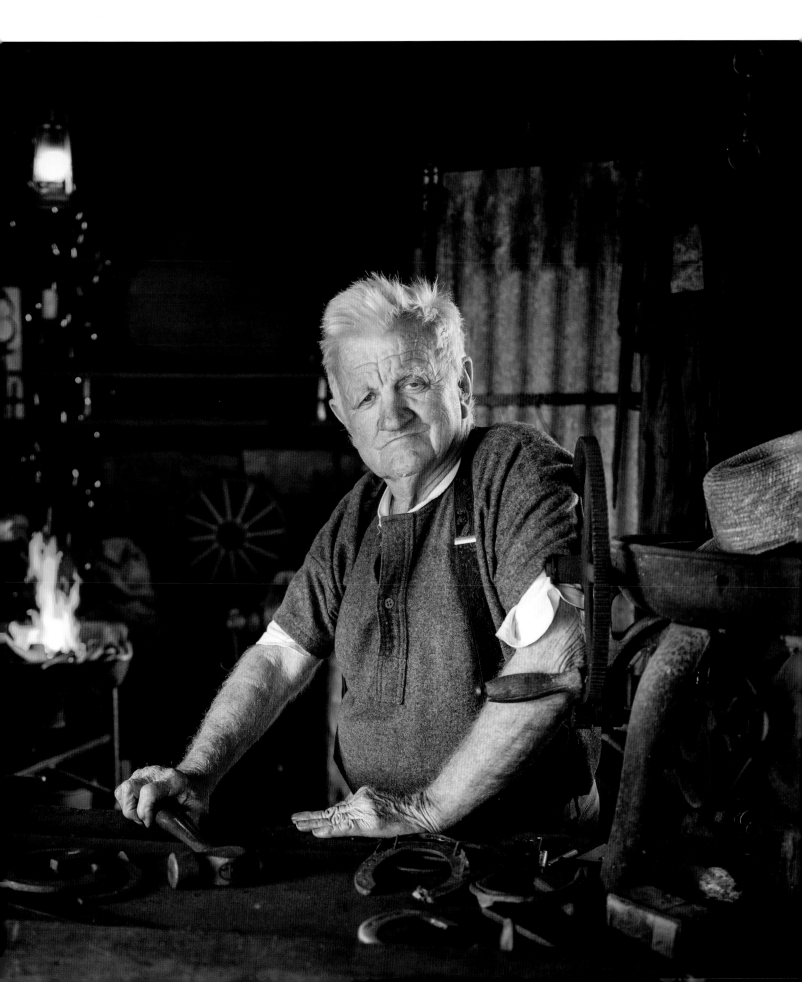

01 **If the available light is not what you would like, consider shaping it to your needs**

02 **A small remote pocket flash can transform a photo by slightly lighting up a dark background**

03 **An overhead 'scrim' is excellent for portraits in harsh light**

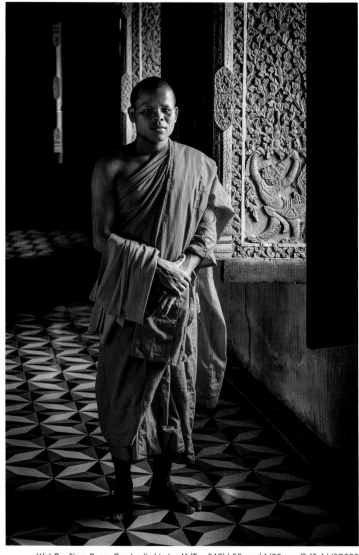

'A portrait is not made in the camera but on either side of it.'

– EDWARD STEICHEN

Do you let the light control how you shoot? Or do you take control over the light and mould it to your needs?

The quality of light is critical to any decent photograph, this much is clear. But what if the light is not quite right for what you want to, or need to, shoot? Do you come back another day? Maybe you accept second best and click the shutter anyway.

Another way to approach this conundrum is to master some techniques which allow you to redirect the light slightly, or even add your own. I am not talking about completely lighting the scene like it's a movie set (although that has been done too); no, what I am suggesting is using the occasional reflector or small supplementary flash to mould and polish the available light into something better.

Wat Bo, Siem Reap, Cambodia | Leica M (Typ 240) | 50mm | 1/90 sec @ f2.4 | ISO800

Strobes or flash guns

Take the opening shot, for example. It could be anywhere in Europe but in fact is not far from where I live in Australia and was taken as part of a workshop I did for Leica Akademie Australia. The blacksmith in the foreground is pleasingly lit by available light coming in from under an awning – it's a nice big soft light source, typical of the sort of light that works well for portraits. The rim light on the side of his face comes from an open door out of sight to the right of frame, which I controlled by opening and closing the door slightly.

In the background, however, there is no light apart from the flames of the fire. The fall-off of light from the foreground is so severe that to the camera it looked almost solid black. If I increased the exposure to bring in some shadow detail I risked not only over-exposing my main subject's skin tones but also killing the 'mood'.

The solution was to put a small battery-powered flash at the rear of the shed, facing to the left as you look at the image. It was triggered with a small radio slave unit and the power was manually set to be just enough to show the other blacksmith in the background. I don't think you would ever know it was there unless I told you.

Compare this shot to the unedited and uncropped version taken without the flash (below). This was taken as an 'exploratory' shot, if you will, to get a sense of how the shot was going to look and what exposure I needed.

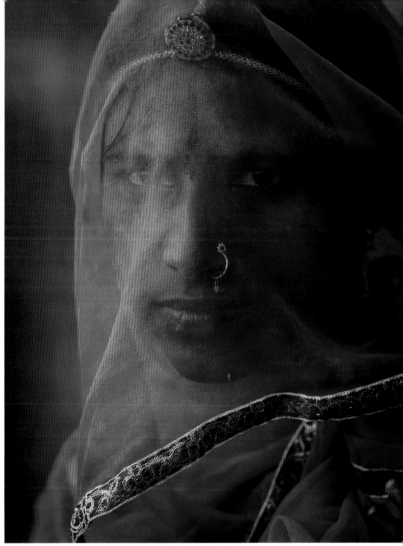

Osian, Rajasthan, India | Leica S | 70mm | 1/125 sec @ f2.8 | ISO200

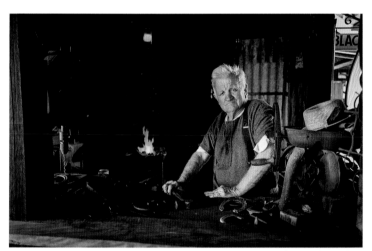

Samford, Queensland, Australia | Leica Q (Typ 116) | 28mm | 1/80 sec @ f2.0 | ISO1000

There is nothing in the background, just a big black void. (You can also see where the side light to the face is coming from.) I could have decided to recover the shadow detail 'in post', but in my experience that is never as good as lighting it properly in the first instance. Artificially lightened shadows can look terribly flat and you risk revealing noise.

I simply placed a small flash on a shelf at the back of the shed and, guessing, set the power to about 1/16. I didn't want to overdo it. As it turned out I was spot on but you can shoot test shots to gauge the exposure easily enough – as long as your subject does not get bored! The radio trigger means I don't need line-of-sight to the flash so it can be properly hidden.

All good so far but there is one more 'trick' up my sleeve. Flash light is the same colour as daylight – 6500K or thereabouts. Most interior lights are much warmer than daylight, they are a red-orange colour as you can see from the photo – the lamp hanging from the roof is distinctly warm in tone. I always add a 'warming' gelatine filter (a full- or half-strength Colour Temp Orange gel from Rosco) to my flashes when I'm photographing an interior to mimic the colour of interior light.

Notice how the blacksmith at the rear is very 'warm' compared to his mate in the foreground? I set this up so that the light in the rear appears to be coming from both the lamp above his head and the forge fire, so it should be the same colour – not daylight but a very warm orangey red. It sounds obvious when you think about it but it is little details like this that make the image successful.

Adding a glimpse of sunlight

You can use a battery powered flash to simulate low sunshine in the later afternoon when the light is already low. Again, using a warm gelled light, I can skim a light across a subject to give it a low sun effect; just a hint of a cross light is what I am looking for.

The key to getting a totally plausible effect is to take the flash as far away from the subject as you can and still get an exposure, so you will need a reasonably powerful flash like a Canon 600EX or a Nikon SB910 and a radio trigger or some other triggering device. By taking the flash right away to the side and raking it across the subject at a sharp angle you avoid the dead giveaway for flash and that severe 'fall off' of the flash effect from one side of the frame to the other. Real sunlight is just as bright on the right of the frame as the left so the flash needs to simulate that.

The image to the top right of the women outside their house in Rajasthan is flash-lit, not sun-lit. The sun had actually gone behind some clouds (see image to right, bottom) and did not look like it was going to reappear so I added a little strobe sidelight to simulate the late afternoon sun. The trick, if you can call it that, is not to overdo it – just brighten up the shot and add some sparkle to the eyes. The flash must be gelled (as discussed on the previous page) to about the same colour as the late sun or it will look too blue-white, which is a total giveaway.

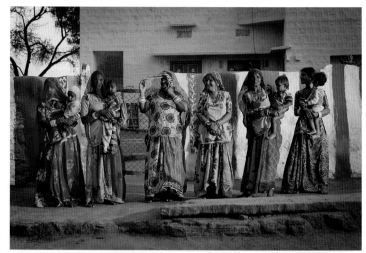

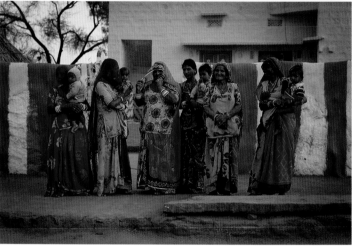

Osian, Rajasthan, India | Leica S (Typ 006) | 70mm | 1/125 sec @ f4.8 | ISO200

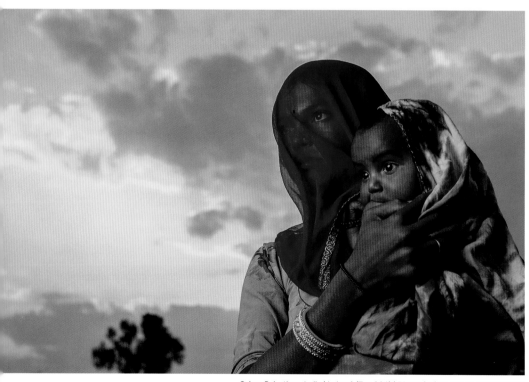

Osian, Rajasthan, India | Leica S (Typ 006) | 70mm | 1/125 sec @ f9.5 | ISO200

Diffusers

I will often use a light diffuser if the light is too harsh, particularly a type called a 'scrim'. A scrim is a piece of mesh or translucent fabric in a frame, which diffuses the light hitting your subject. You put it between the subject and the light (the sun usually) so it softens the major light source. (Some reflector types can do double-duty because you can change the fabric covers from reflective to translucent.)

This imam in India is in full sunshine but standing in front of a shaded background, in this case a shaded patio. This is important because the scrim will reduce the exposure for the face (by partially blocking the sunlight), leaving the background overexposed. The round scrim is held such that it shades his face from direct sun but because it is translucent it becomes a bright round light source itself, rather like a big beauty dish or softbox. At midday this will not work quite as well because the scrim will have to be directly over the subject's head, giving an odd top light effect, but all through the afternoon and morning you'll get a nice frontal light from well above the eye-line which brings out the shape of the face and cheekbones.

Osian, Rajasthan, India | Leica S (Typ 006) | 70mm | 1/250 sec @ f4.0 | ISO200

Osian, Rajasthan, India | Leica S (Typ 006) | 70mm | 1/3000 sec @ f4.0 | ISO200

The light quality from such a scrim is much better than the usual technique of standing your subject in the shade because with a scrim the light is directional and close rather than just flat.

Chapter 16

Interiors

Langzi Village, Guangxi, China

This ancestral hall was a last-day bonus location, set up by my guide without telling me. He just told me he had something planned for the last day but it was to be a surprise. This hall is almost totally abandoned but there is a caretaker who still lives there and keeps the place swept. I don't think anyone visits because he was very happy to have someone to talk to. I shot this at an angle because I wanted to place the small figure of the caretaker well off-centre as a point of interest (and scale) to be 'discovered' by the viewer. The contrast range is high because the sky is visible but luckily it was a cloudy day so the clouds are not too bright. Exposure was critical – the sky needed to be just within the sensor's brightness range so that the shadows could retain good detail; this is where camera histograms come in handy.

— LEICA S2 | 30MM | 1/45 SEC @ F8.0 | ISO320

01 **Interiors usually require a tripod for the very best results**

02 **The brightness range from shadows to windows is extreme**

03 **At least some post-processing is critical to getting pleasing and realistic results**

Lower Antelope Canyon, Page, Arizona, USA | Canon EOS 5D | 24mm | 3 sec @ f11.0 | ISO100

> '**If I have any 'message' worth giving to a beginner it is that there are no short cuts in photography.**'
>
> **– EDWARD WESTON**

In Chapter 10 we looked at landscapes, an important part of any set of images that attempts to capture a sense of place. Buildings and architecture are also essential subjects for travel photography, particularly heritage buildings like cathedrals and temples, and their interiors require a more technical approach if they are to look appealing.

Interior photos can also be extended to include natural interiors such as caves and canyons; the same principles apply to manage the low light conditions and/or high contrast.

High contrast

The problem in achieving quality interior shots is not one of seeing and composition, although the usual guidelines for framing and balance still apply. The difficulty usually lies in the contrast. Because of the high-contrast nature of most interior spaces, even the best cameras have trouble recording good information in the deepest shadows of the inside at the same time as the much brighter exterior, such as the light through the windows. Imagine a cathedral interior – the deepest recesses of the ceiling are very dark compared to the luminous stained-glass windows lining the nave. If a camera is set to expose the inside with any kind of meaningful information in those dark recesses, then the windows will 'blow out' to a featureless white and, conversely, if you capture the amazing colours of the stained glass then the roof will appear as a featureless, solid black area in the final shot. You can't have both exposed correctly, at least not in the same shot.

And there is the key – 'not in the same shot'. Why not take two shots, one exposed for the windows and one for the deep shadows? You have the whole tonal range captured, but in two (or more) shots, not just one. With a modest amount of post-production it's not too hard to combine the multiple shots into one.

Rouen, France | Leica T (Typ 701) | 18mm | 1/80 sec @ f6.3 | ISO800

Some cameras even have a built-in mode for this, often referred to as HDR mode (high dynamic range). If your camera has this feature, you can use it by turning on the HDR mode, making sure the camera is steady and then setting the self-timer so you don't move the camera when you press the shutter button. The camera will shoot three frames in quick succession, varying the shutter speed between shots so that one image is 'overexposed', one is normal and one is 'underexposed'. Then it will combine the exposures internally by using the 'overexposed' shadows and the 'underexposed' windows to smooth out the huge contrast range. Different cameras work in different ways, and the results can sometimes be a bit mixed, but it's sure worth a try.

Broutana Bay, Kuril Islands, Russia | Leica S2 | 30mm | 15 sec @ f11.0 | ISO160

Keep steady

Interior shots can be a lot of fun because they are essentially static subjects, so you can take great care to get the image as well composed and technically excellent as possible. Tripods are almost mandatory and should be used unless it's not possible – many public buildings will not allow tripod use, citing safely concerns.

If you can't use a proper tripod then here are some ways that you can create a steady camera position without breaking the rules.

Use your camera bag and/or jacket to make a pad for the camera to sit on. A soft bag can often be used in this way because you can squish the camera down onto the top of the bag, frame the subject using the rear screen (Live View on a dSLR) and then use the camera's self-timer to take the photo with your hands well away. This technique works really well as long as you can find a place to put your bag that's not too precarious.

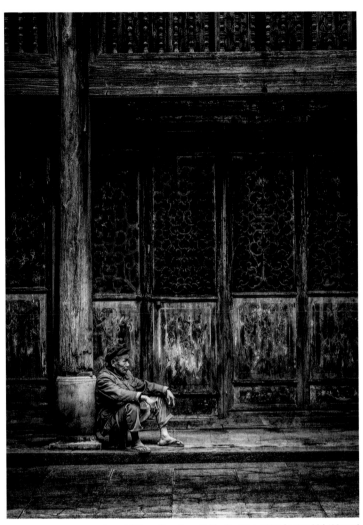

Cao Dai temple, Mekong Delta, Vietnam | Canon EOS 60D | 15mm | 1/8 sec @ f5.6 | ISO800

Another way is to use a mini-tripod with discretion. Technically it's a tripod, I know, but it looks so non-professional that it's easy to avoid attention. I have had a tiny Manfrotto tabletop tripod for about 25 years. It doesn't get used much but when I know I will be visiting churches or cathedrals I put it in my bag and on numerous occasions I have been able to put it on a pew shelf, or a table somewhere, or even the floor, and get sharp photos at a low ISO for maximum quality. As an alternative to using a very high ISO and hand holding the camera it's an excellent technique. I have been experimenting with flexible GorillaPods too; they don't need a flat surface like a mini-tripod does, but are a bit less stable, which can be a problem when using slow shutter speeds.

If you can't find a place to rest the camera, even leaning it (or yourself) against a post or anything solid will lessen the dangers of hand holding at slow shutter speeds.

Post-processing

To get the absolute best results, relying on the camera's internal automatic HDR processing is less than ideal – the results can be great or awful, and there's not much you can do if it looks bad. For predictable and controllable results you'll need to combine your exposures on a computer using HDR software. To keep things simple here I'll not delve into HDR techniques too much (see p. 166) but suffice to say that my favourite software, Adobe Lightroom, has an HDR blend option built in to version 6 so you don't need to buy and master other complex software.

Jodhpur, Rajasthan, India | Canon EOS 5D Mark II | 30mm | 1/250 sec @ f5.6 | ISO800

Domed roof of Galleria Vittorio Emanuele II, Milano, Italy | Leica M(240) | 18mm | 1/30 sec @ f5.6 | ISO200

Salisbury Cathedral, UK | Canon EOS 5D Mark II | 17mm | 1/15 sec @ f5.6 | ISO400

Lenses

Lady Elliot Island, Great Barrier Reef, Australia | Canon EOS-1D X | 15mm | 1/500 sec @ f6.7 | ISO100

In general terms, there are three types of lenses on the market:

- **Standard or normal** – lenses which roughly match the perspective and view of the human eye

- **Wide angle** – a lens which captures a broader view than the human eye

- **Telephoto** – lenses which magnify the view to a varying extent

Within those groups a lens can have a fixed angle of view (primes) or a variable view (zooms).

Lenses also vary in the widest aperture that you can choose. For example, Leica offer four 50mm standard lenses – f2.5, f2.0, f1.4 and f1.0. Prices vary considerably; 'fast' lenses (with an aperture setting of f2.0 or wider) will always be more expensive – and heavier – than their 'slower' counterparts.

Most zooms are more modest, offering a maximum aperture that varies slightly as the lens zooms, usually from f3.5 to 5.6. Some have a maximum aperture of f2.8 or less throughout the zoom range but these tend to be, once again, heavier and more expensive.

Price affects quality too. High-priced lenses tend to be not only faster with respect to the maximum aperture, but also sharper both across the entire field of view but also at the widest apertures. Broadly speaking, lenses are sharpest at an aperture that's a couple of stops away from their maximum aperture; for example, photos taken with a modestly priced zoom might be really crisp at f8 but visibly soft at f3.5, whereas a top-of-the-line Leica lens costing 10 time the price will be just as sharp at f1.4 as at f8.

You get what you pay for, but be aware that small increases in quality come with big jumps in price!

Useful lenses

For travel photography you'll not want to carry around any more lenses than are necessary. This necessitates making a few compromises – no surprises there, photography seems to be all about compromises sometimes!

Let's look at the best options for a photographer who has chosen a mid-range dSLR as a workhorse camera.

FIRST LENS

In terms of balancing performance and convenience you really can't beat a 24-70mm f2.8 zoom (or equivalent). It's not exactly 'compact' and will set you back about US$2000, but it's a brilliant go-to lens for so many situations. At 70mm and f2.8 it's an effective portrait lens, at 24mm and f11 it's a top-quality interior or landscape lens. If you want to spend a little less and get a smaller lens, a 24-70mm f4 will work well too. Just avoid the cheaper lenses with the wide zoom range – these are seductively convenient but the image quality can be compromised.

SECOND LENS

This is a harder choice. Do you go longer or wider? I think wider lenses are harder to use effectively and the 24mm you have already is pretty wide. So I'd suggest looking at a telephoto lens of some sort.

Three lenses stand out, and most camera brands have an equivalent in their ranges:

- 70-200mm f2.8
- 70-200mm f4.0
- 135mm f2.0

The first one listed has become a de facto standard for pro photographers. It's versatile, fast and high quality, but it's heavy and costs over US$2000. For a bit over US$1000 you could get the f4 version, smaller, equally sharp but one stop slower. Losing one stop does not mean much for exposure but the autofocus systems work better with f2.8 lenses or faster.

My personal preference is for a 135mm f2.0. It's compact, superb quality and costs under US$1000. The f2.0 aperture means you can get lovely out-of-focus backgrounds and the autofocus likes the extra light that is drawn in. OK, so it's not a zoom but I can live with that.

A 24-70 zoom with a 70-200mm zoom (or 135mm prime) can deal with 95% of shooting situations – outside that, you'll need to look at more specialist lenses.

THIRD LENS AND BEYOND

Here are some lenses that, over the years, I have found to be very useful for travel work:

- 16-35mm f2.8 or 17-40mm f4 – wide for interiors and landscapes

- 100mm Macro – close focusing for details

- 300mm f4 – perfect for wildlife or candid people shots

- 24mm Tilt Shift if you do a lot of architecture and interiors

- 50mm f1.4 – this humble standard lens is cheap, very high quality and fast. Not to be underestimated.

Travel photography necessarily involves actually travelling (!) so always remember that you have to carry all this stuff. Taking too many lenses can be confusing (which lens shall I use today?) and/ or plain awkward when you have to lug it all around busy airports and train stations.

Tufi, Papua New Guinea | Canon EOS 5D | 135mm | 1/180 sec @ f4.0 | ISO200

Travel photography kits and combinations

For the budget-conscious traveller, have a look at one really good compact camera, for example Leica D-Lux, Canon G17 or Nikon Coolpix P7800.

For a do-it-all, medium priced, not-too-heavy camera and lens combo you could consider two mid-range dSLRs, like Canon 6D or Nikon D750, with a 24-70mm f4 zoom and a 135mm f2.0 lens or a 70-200mm f4 zoom.

For mirrorless fans on a mid-range budget, have a look at the Sony A7 Mk2 with the Zeiss 24-70mm f4 and Sony 135mm f4.

At the high end of the market, anything made by Leica is great for travel, in particular the T-System with the 11-23mm and 55-135mm zooms. For the ultimate travel camera, Leica's new mirrorless camera, the SL (Type 601) is hard to beat.

Chapter 17

Portraits

Chandelao, Rajasthan, India

It's all about the eyes – if you can capture those well, then you have
done half the work. This man was watching my progress as I explored
the backstreets of a village while the sun was setting; he just stood
there, wrapped in his blanket and stared. Looking back I saw a nice
ochre-coloured mud wall behind him and figured that it would
make a good background if I could eliminate any other distractions.
Because he was about 10 metres in front of the wall I used a long lens
to dramatically compress the perspective and throw the wall out of
focus. By small adjustments of my own position I was able to position
his eyes and the wall edge in the frame on the exact thirds intersection,
as per classical composition guidelines. His eyes never left me and his
piercing gaze is the centrepiece of this shot.

— CANON EOS 5D MARK II | 300MM | 1/640 SEC @ F2.8 | ISO1600

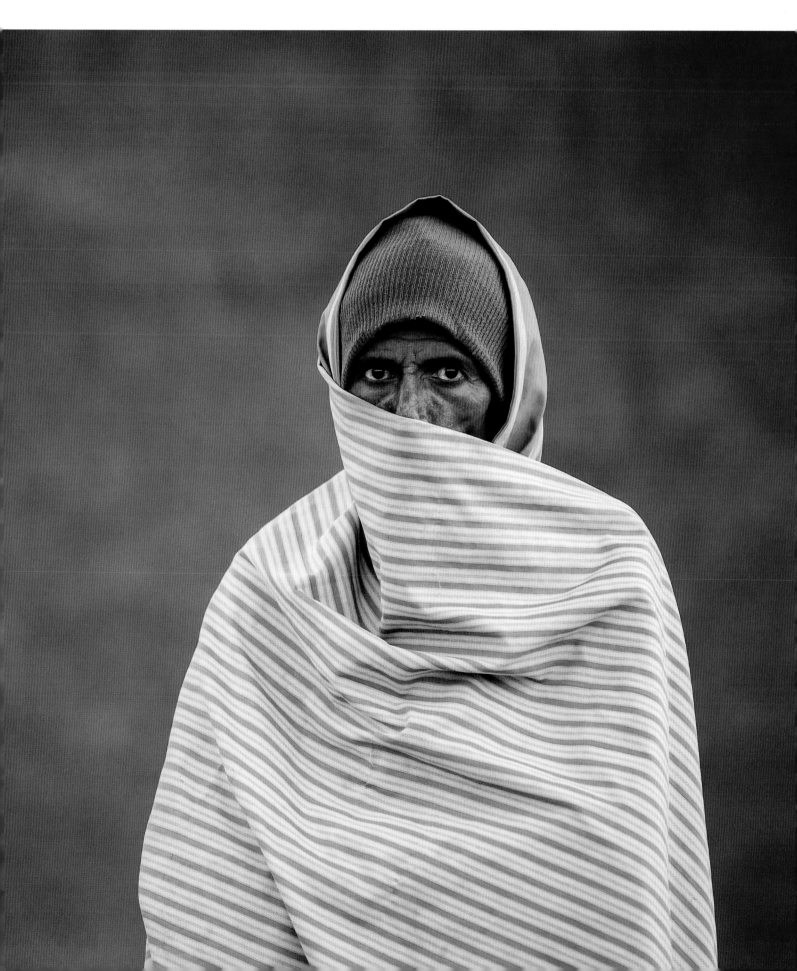

01 **The eyes are the most important part of a portrait**

02 **Use a short telephoto lens for a more flattering portrait**

03 **Shoot plenty of images – fleeting expressions are hard to catch**

04 **Take your time**

Jiuxian Village, Yangshuo, China | Leica S2 | 120mm | 1/60 sec @ f2.8 | ISO160

'The most difficult thing for me is a portrait. You have to try and put your camera between the skin of a person and his shirt.'

– HENRI CARTIER-BRESSON

Travel is all about people and places. People live in the places, so any set of travel images would be incomplete without good portraits to go along with the 'sense of place' photos.

Let's be honest, portraits are challenging. Not only do you need to actively engage with a complete stranger and ask them if it's OK to take a photo of them, but, beyond that, you need to be on top of your technique such that you can effortlessly deal with the technical aspects of the photo. There is nothing quite so off-putting for your subject than agreeing to a photo request only to have the photographer fumble around with lens choice and exposure settings. You'll quickly lose the moment.

Gairiava Village, Tufi, Papua New Guinea | Canon EOS 5D | 85mm | 1/180 sec @ f4.5 | ISO200

It's all in the eyes

'The eyes are the windows to your soul'. Shakespeare might have been quoting from Cicero but many writers over the years have used this phrase. Eyes grab our attention as soon as we see a face – try it for yourself. Look at one of the portraits in these pages and try to be aware of where your eyes are looking. I think you will find that it is almost impossible to look away from the eyes for any length of time and your attention will oscillate between them.

It is therefore very important that the eyes be in focus, really in focus, and if one eye is nearer to the camera than the other, like in a 3/4 profile shot, then the nearer eye should be the sharper of the two. If the eye is not sharp then the photo is a dud – not the tip of the nose, not the ears – if anything at all is sharp in the photo then it must be the eyes. I'll even go out on a limb here and say that whilst many photographic 'rules' can be broken, this is the only one that is inviolable.

Lenses and focusing

My strong preference for portraits is to use a modest telephoto lens, something a bit longer than a 50mm standard lens, say, 85mm or 100mm (assuming a full frame camera; see p. 118). The slight compression of perspective makes the nose look a tiny bit smaller and is generally considered to be more flattering to faces.

Focusing is critical. Be prepared for your subject to move slightly towards or away from the camera between shots. When you are close, the depth of field you are working with is quite small, maybe 25mm or less – or even as little as 2–3mm in the case of a fast lens like an 85mm f1.2.

A good portrait does not look staged, even though it really is. Expressions need to be genuine – not necessarily smiling, but relaxed and accepting of the person with the camera standing right in front of them. I like the type of shot where the subject has a steady gaze directly to the camera, with maybe a hint of a smile, or just a slight twinkle in the eye.

We are unbelievably sensitive to the subtlest shift in expression; a smile involves at least 10 muscles but if it doesn't extend to the eyes then we can pick it immediately as a fake smile. Facial expressions are a big part of how we communicate and over the whole evolution of human beings we have become highly attuned to tiny shifts in head angles, eye lines, eyebrow levels and lips' positions. Coaxing a genuine expression out of a complete stranger is no mean feat.

Assei Village, Sentani Lake, Jayapura, Indonesia | Canon EOS-1D C | 135mm | 1/640 sec @ f3.2 | ISO200

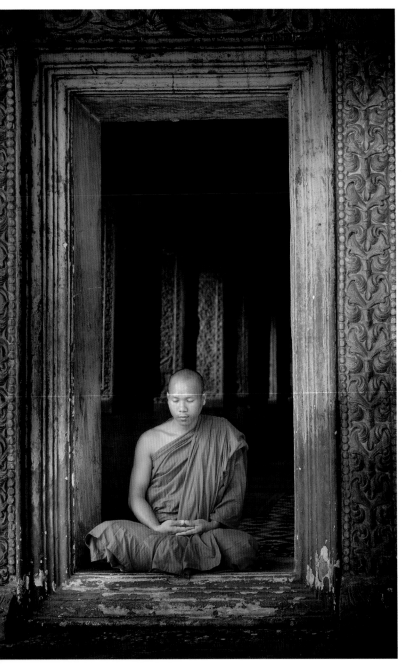

Wat Bo, Siem Reap, Cambodia | Leica M (Typ 240) | 50mm | 1/180 sec @ f2.0 | ISO800

I find that modern autofocus is the key here – it's just too hard to judge fine, critical focus by eye (unless you use Live View to magnify the image and check for perfect focus, by which time your subject has probably moved again). I use the centre AF point in the viewfinder because, in most cameras, it is the most accurate and sensitive, even in top-of-the-line dSLRs such as Canon 1Dx or Nikon D4s (at the time of writing).

Using the centre focus point usually means that you end up with the eyes in the middle of the frame. Yes, we are told never to put the subject in the middle of the frame – and it's a good rule – but there are two ways around this.

Firstly, focus as usual, then, holding the shutter button down halfway to lock the focus (this works on compact cameras as well as on big dSLRs), recompose the shot to frame it properly. This takes a bit of practice but can be done very quickly.

Secondly, and a bit controversially for those who want to get it 'right in camera' every time, simply use the centre focus point to lock onto the eyes and shoot away without reframing. If you shoot a little bit loosely, in other words leaving some extra space around your subject's face, you can then crop the shot to a more pleasing framing later on. This works best with high-resolution cameras which have pixels to spare, and has the added advantage that by shooting from a little bit further away, you are less in your subject's face, which they will find more comfortable. The slight downside is that you have some work to do later in post. Overall it's an easy method which will give you more consistent results.

Take your time

Another 'rookie mistake' is to rush the process. Once you have gone to the trouble of setting up a portrait, make the most of the opportunity. Your sitter will make it clear when you have outstayed your welcome; so, whilst it's a good idea to get a few frames in the bag as soon as possible, relax, slow down, and do it right. If you appear relaxed then this makes your sitter relaxed too. Try stopping shooting for a few minutes and have a bit of a chat – it's supposed to be fun!

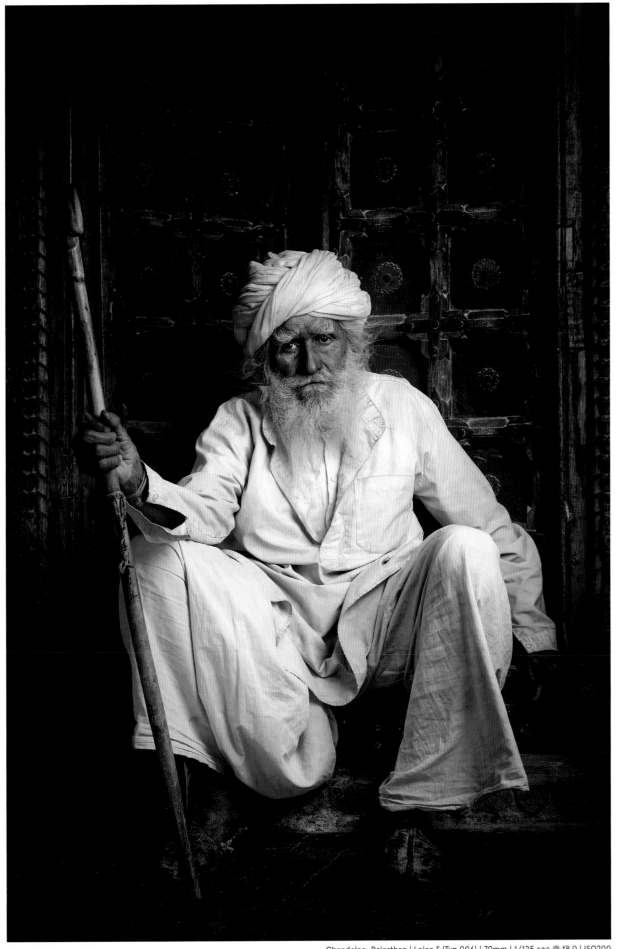

Chandelao, Rajasthan | Leica S (Typ 006) | 70mm | 1/125 sec @ f8.0 | ISO200

Chapter 18

Cultural
sensitivity

Orkhon Valley, Mongolia

It's always nice to be able to capture moments of real life, apparently
free from the presence of the photographer. In this image I had
been invited into the family ger (yurt) and had gone through all
the appropriate social customs expected of guests – drinking the
fermented horse milk, inquiring after the health of the yaks and so
on. An awareness of the local cultural expectations and etiquette will
often lead to better access for your photos. In this case, Grandfather
continued with his chores of setting and lighting the fire, and then
checked on his grandson asleep in the bed. It was a lovely moment,
captured discreetly on my rangefinder camera.

— LEICA M (TYP 240) | 24MM | 1/90 SEC @ F2.4 | ISO1600

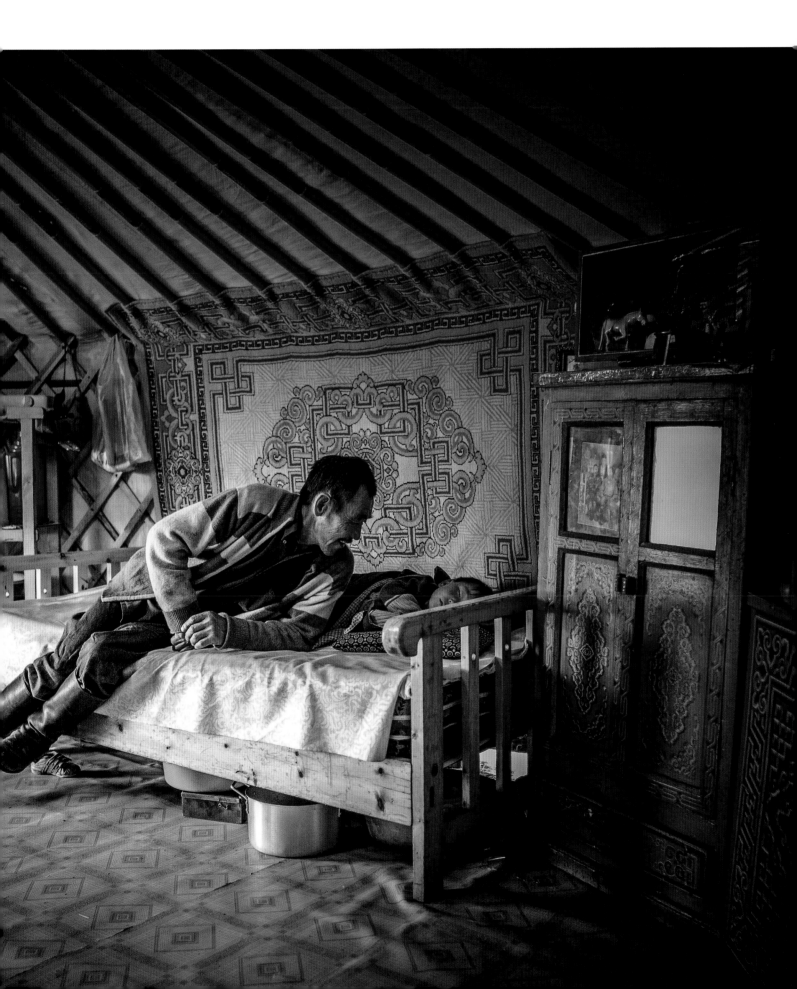

01 **Learn what is polite and what is rude in the local culture**

02 **Find out how to greet people correctly; it will win you friends**

03 **Following an inadvertent faux pas, apologise profusely**

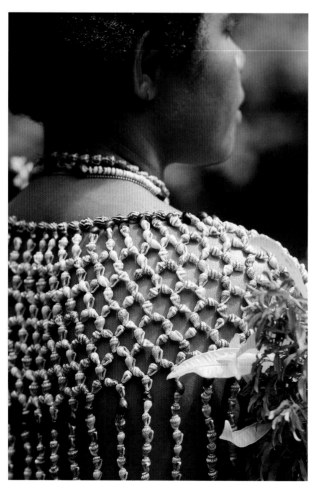

Tufi, Papua New Guinea | Canon EOS 400D DIGITAL | 85mm | 1/1500 sec @ f2.8 | ISO200

'You can find pictures anywhere. It's simply a matter of noticing things and organizing them. You just have to care about what's around you and have a concern with humanity and the human comedy.'

– ELLIOTT ERWITT

The Merriam-Webster Dictionary defines the word 'culture' in three relevant ways:

1. Culture: the beliefs, customs, arts, etc., of a particular society, group, place, or time.

2. Culture: a particular society that has its own beliefs, ways of life, art, etc.

3. Culture (of): a way of thinking, behaving, or working that exists in a place or organization such as a business.

All three of these uses of the word 'culture' apply within the context of travel photography because an understanding of the term will affect how we approach our image making. For example, from a practical point of view, Buddhism can be considered a culture because there are many similarities in the way it is practised in different parts of the world. The culture of Buddhism encompasses certain ways of doing things that need to be

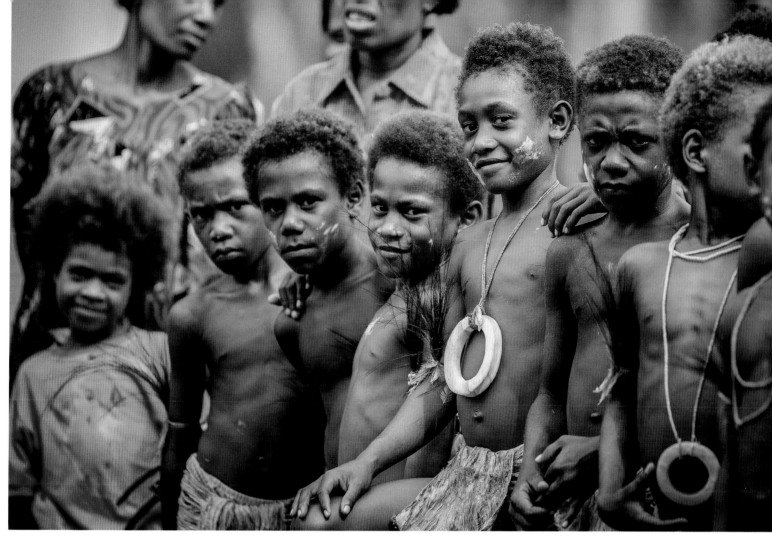

Papua New Guinea | Canon EOS 5D | 300mm | 1/500 sec @ f4.5 | ISO400

respected by the prospective travel photographer and it is terribly important not to be rude, even if it's by accident. Wilfully ignoring local customs is the height of disrespect in my view.

For instance, in Mongolia, there are plenty of customs (dictated by Mongolian culture) which should be respected by visitors. Eating with the left hand is a big no-no (much like in many parts of the world); never touch a Mongolian man's hat; and do not walk between the two central poles in a ger. There is no way you can guess these things, they can appear arbitrary to people from other cultures, so it is really easy to commit a faux pas without even knowing it.

Fortunately, people are generally quite forgiving of visitors who seem to lack civility, but that's no reason not to be informed about how one should behave. Tolerance should never be relied on. Or, to look at it another way, you can impress your hosts no end by behaving well and following their various social etiquettes. It's only respectful, after all. If you do make a boo-boo and are picked up on it, or you sense a sudden chill in the atmosphere, then profuse apologies are in order.

I suggest that before launching yourself into a foreign culture you research the various 'whoops' situations before you go. Once you are there, a good guide will always help you with local customs, so ask his or her advice.

Pitfalls to avoid

— Pointing the sole of your foot at someone is very insulting in Islamic culture. You are saying 'you are beneath my feet'.

— It's considered crude to eat with the left hand (even if you are naturally left handed) in countries where a lot of food is eaten with the fingers. I hope I don't have to spell this one out ...

— Pointing with a single index finger. Use the palm with all four fingers extended to direct attention.

— Touching people on the head, in Asia particularly.

— Handshakes can be long, short or inappropriate depending on the culture. In Fiji they are long and intense; in Cambodia you would not shake a monk's hand.

— A 'thumbs up' in the Middle East can be considered very crude.

— PDA – public displays of affection. Actually illegal in some Middle Eastern countries.

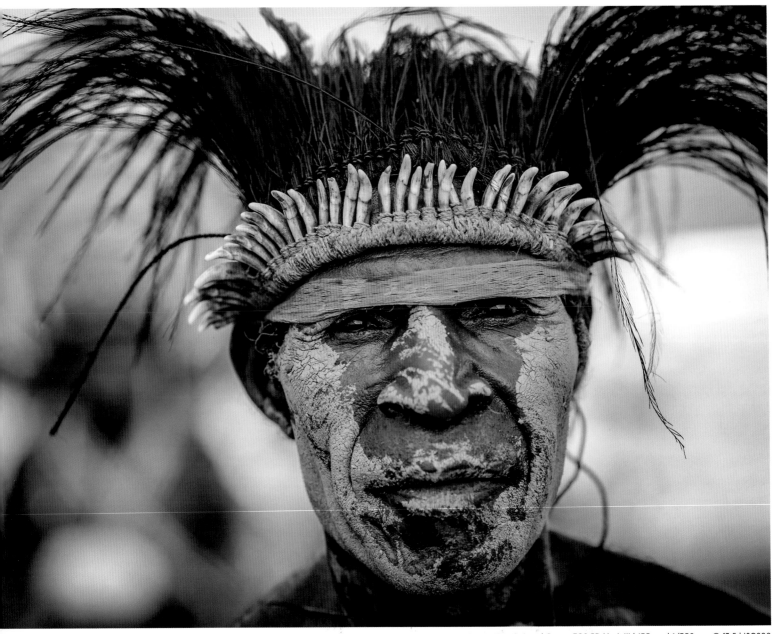

Wewak, Sepik River, Papua New Guinea | Canon EOS 5D Mark III | 135mm | 1/350 sec @ f3.5 | ISO200

— Wearing inappropriate clothes. As a general rule, you should cover your shoulders, mid-section and knees. This level of modest attire is recommended for many Italian churches. In Islamic countries, women should, at the very least, cover their shoulders and legs. Seek advice on head scarves. Lots of potential for trouble with clothing, especially for women.

— Take your shoes off when entering a house in Japan, or a temple in Asia and many other places.

— Talking across, or stepping on, the threshold of a dwelling is to invite bad luck in many cultures.

— Old people in China are sometimes photographed for their families at the end of their lives so might be reluctant to be photographed by you.

— In India, veils are worn by married women when out in public – don't ask them to lift them.

— Putting your chopsticks upright in your rice bowl in any country where chopsticks are used.

— Clearing your plate. In Asia, scraping the last food off your place indicates that your host did not feed you enough, so always leave a little behind. In Spain, eat it all.

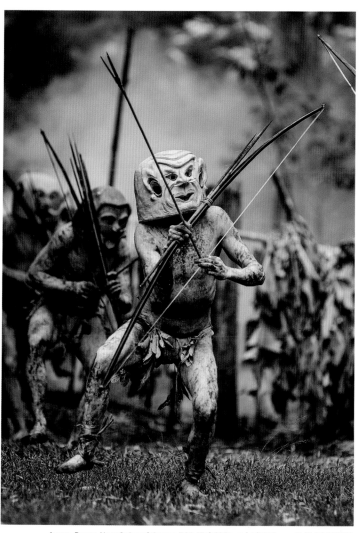

- Burping or not burping. Rude in most Western countries; rude not to in some parts of Asia.

- Never refuse vodka in Russia – it's like refusing to shake hands.

- In Mongolia always accept a drink of airag (fermented horse milk) when you enter a ger as a guest.

- If someone wants to take a photo of you, take the time and let them.

- Don't dis the King in Thailand – it's rude and you'll go to jail.

There are many, many more. It always pays to be aware of what's rude and what's polite in the country you are visiting. Being correct and polite will win you friends and cost you nothing – being ignorantly rude, and worse, not caring, will limit your opportunities and might spoil your trip.

Asaro, Papua New Guinea | Canon EOS 5D | 300mm | 1/1500 sec @ f3.5 | ISO200

Bigge Island, Western Australia | Canon EOS 5D | 19mm | 1/90 sec @ f5.6 | ISO800

Filters

In this age of digital photography we have become used to modifying the 'look' of the photo after shooting it, using a computer. There's no problem with that but occasionally it's wise to modify the light before it enters the lens because there are some things that only a filter can do.

Filters fit onto the front of the lens, either as a round screw-in type which needs to match the size of your lens, or bigger square filters which fit into a filter holder which can be adapted to any lens size.

The benefits of the latter system are obvious – you only need one filter to fit on any lens – but the drawback is that it takes time to fit the filter holder system to the lens and it's something else to carry around. Examples of filter systems of this type are the consumer grade Cokin range and the more 'pro' grade (and expensive) Lee system. Screw-in filters, on the other hand, are quick to use and take up less space but they need to fit the lens you are using. One way around this is to use stepping rings to adapt a big filter down to a small lens. You buy a filter for the biggest lens you own and then a set of stepping rings to fit that to all your other lenses – this is the approach I take personally and it works fine.

Neutral Density (ND)

This broad category of filters are designed to have no colour (neutral) but to absorb light and extend exposure times. They come in various strengths – 1 stop (x2 or 0.3), 2 stops (x4 or 0.6) etc. For extremely long exposures you can buy strong ND filters that absorb 10 or even 16 stops of light so you can shoot very long exposures in daylight for creative effect.

Long exposures are excellent for blurring slow-moving subjects like clouds and water. Normally you need to wait until it gets dark to be able to use long enough exposures so that the movement is recorded, but using a strong ND can allow you to 'force' long exposures even in full daylight.

For example, a 10-stop ND will change the exposure from 1/60 second at f16 (full daylight) to 15 seconds at f16, long enough for water to go nice and blurry.

Be aware that the cheaper brands can often show a distinct colour cast, often towards the green. The better brands tend to be more genuinely 'neutral' in colour.

Graduated filters (grads)

These filters are half clear and half a filter type with a smooth transition from one region to the other. They work best with slide-in square filter holders because they need to be adjusted up and down, or rotated, for best effect.

The most frequently used grads are Neutral Density grads, which allow you to darken the sky but leave the foreground unaltered, thus reducing the overall contrast of the scene. Like normal ND filters they come in a variety of strengths, measured in 1-stop increments. I find the most useful ones are the 2-stop and 3-stop ones; less strength has little effect and more looks quite artificial.

Some photographers love to use these filters, preferring to see and capture the effect in-camera. Other photographers, including me, prefer to shoot two images at different exposures and combine them later in Photoshop. The latter technique is undoubtably more accurate (the filter only has a straight-line transition), but is more time consuming and requires a basic level of skill in Photoshop masking.

You can also get coloured grads so you can change one half of the photo to a different colour. For example, a tobacco or orange grad makes a bright sky look more like a sunset without altering the foreground. Personally I prefer to do any image adjustments

Yarra Ranges National Park, Victoria, Australia | Canon EOS 5D | 24mm | 4 sec @ f8.0 | ISO100

Protection

Putting a sheet of glass between your expensive camera lens and the elements can be an excellent idea. It's far better to wipe spray off a sacrificial glass filter than to keep rubbing at the front element of your lens. Most people use a basic Ultra Violet (UV) reducing filter and have one for each lens. Be aware that saving money here can be a false economy – match the filter quality to the lens quality as much as possible.

If you like to shoot images at night, such as lit-up cityscapes, beware of leaving filters on the lens unnecessarily. It's not uncommon to see a double image of bright lights caused by internal reflections within the filter itself. The better the filter quality the less apparent this will be but it's still a potential problem.

I tend to only use protection filters when I know there is a danger of lens damage such as on a windy day on the beach with sand and salt spray in the air.

Colour filters

These are far more relevant for film capture where colour correction can be needed. It's just too easy with today's cameras to adjust the colour of the image in the camera. Warming or cooling the image is much easier done with either the camera's white balance setting or in post-production in the computer. I have not used a traditional colour-correction filter for many years.

like this in post-production but some people swear by their grad filter collection.

Polarisers

These filters remove reflections off shiny surfaces like glass, water and glossy leaves. They also darken blue skies and add contrast to white clouds which makes them quite effective at making skies look more dramatic.

Polarisers are almost always round screw-in filters because they need to be rotated to get the best effect. Looking through the camera, you turn the filter until you can see the image change. You don't need to always use the maximum effect either – at high altitudes the sky is already a very strong blue and polarising it further can be a case of 'over-egging the pudding'.

Because polarisers work to physically reduce reflected light there is no post-processing 'analogy' like there is for colour corrections or graduated filters. You cannot replicate in Photoshop the effect of removing the shine from leaves in a rainforest, thus adding to the sense of lushness. It's for this reason that I always carry a polariser – sometimes it's just the right tool for the job and nothing else will do.

Summary

Filters are an essential part of your camera kit. My recommendation would to be to buy one UV filter for each lens you own to act as a barrier against damage and dirt, a polariser to add punch to blue water, blue skies and forest scenes and, as an option, a 10-stop (ND800) filter for long exposures.

Chapter 19

Perspective

Borobudur, Java, Indonesia

Wide-angle lenses exaggerate perspective, making close objects look proportionately bigger and more distant objects look smaller, even more distant. This has the effect of making the image look deeper than it really is. Wide lenses also tend to make any lines in the corners of the frame converge towards the centre and this draws the eye along with them. I framed this shot using the two flanking stupas to lead the eye towards the next row of stupas and thence to the distant volcano. An 18mm lens really pulls in those corners geometrically; it's one of my favourite lenses.

— LEICA M (TYP 240) | 18MM | 4 SEC @ F16.0 | ISO200

01 **Perspective translates the 3D world into a 2D photograph**

02 **Use perspective to show depth**

03 **Wide-angle lenses exaggerate perspective, making close things look bigger and distant things look smaller**

Andamooka, South Australia | Canon EOS 5D Mark III | 50mm | 1/250 sec @ f5.6 | ISO100

'To compose a subject well means no more than to see and present it in the strongest manner possible.'

– EDWARD WESTON

A formal definition of optical perspective would be something like 'the way objects appear to the eye, based on their spatial attributes and position relative to the observer'. That may or may not make things clearer!

From the photographer's point of view optical perspective is a term used to describe the way that objects appear smaller in a photograph the further away they are and, conversely, how they look bigger the closer they are. This might sound too obvious to be worth discussing but it turns out that optical perspective, or just 'perspective', is one of the most powerful tools at your disposal when you compose your photos.

A familiar real-life example of perspective is the way that the sun and moon appear roughly the same size in the sky but are actually vastly different sizes. It's only because the moon is nearer than the sun that it appears to be the same size when, in fact, it's much, much smaller than the sun. For a photographer, using perspective in a photo is about controlling the sizes of objects relative to each other within the frame of the camera.

Using perspective creatively

Here's a good example from a recent trip to the South Australian outback.

In the first image the windmill looks minuscule compared to the huge ramparts of Wilpena Pound in the background. In the second photo, a similarly sized windmill appears to tower over the Elder Ranges in the distance.

Flinders Ranges, South Australia | Leica S (Typ 006) | 120mm | 1/60 sec @ f11.0 | ISO100

The only thing that has changed is my position when I took the photo. By coming a lot nearer to the windmill I can make it look larger in the frame because it is closer to the camera whilst the hills are still a reasonable distance away. This simple concept means that I can control how objects appear in the frame relative to each other by moving myself around both side-to-side as well as forwards and backwards – thus objects can be positioned in the frame in any number of different places even though they are not actually moving themselves.

Perspective also becomes a useful concept when you want to show three-dimensional depth in an image. As we all know from primary school, parallel lines apparently get closer together the further away they are. The classic image is one of power poles and railway lines receding into the distance, much like this shot of the railway lines in Marree. The railway lines are parallel but perspective makes them appear to converge to a point. I used this phenomenon to draw your attention to the (apparently) small

locomotive by positioning myself between the two sets of lines so that both pointed directly towards the train.

Marree, South Australia | Leica S (Typ 006) | 30mm | 1/45 sec @ f11.0 | ISO100

Shadows cast by the sun are actually parallel too and in the same way that railway lines recede, so do shadows. In the image from Blinman Gymkhana (below) I have used the shadows both as a strong graphic element and also to lead your eye to the spectators in the wool bale rolling competition.

You can use perspective to make visual statements too. In this shot from the opal mining town of Andamooka (opposite) I wanted to portray the power of the excavator compared to a human figure, so I simply came closer to the bucket with a wide-angle lens and made it look much bigger compared to the very familiar scale of the human figure beyond. If the two subjects had been similar distances from me the drama would have been lessened. I have created a kind of optical illusion by using perspective to make the excavator bucket a lot bigger relative to the figure so as to make a stronger and more interesting image.

Blinman Gymkhana, South Australia | Canon EOS 5D Mark II | 24mm | 1/800 sec @ f8.0 | ISO100

Dimond Gorge, Kimberley | Canon EOS 5D | 38mm | 1/500 sec @ f4.0 | ISO100

Dimond Gorge, Kimberley | Canon EOS 5D | 135mm | 1/350 sec @ f2.8 | ISO100

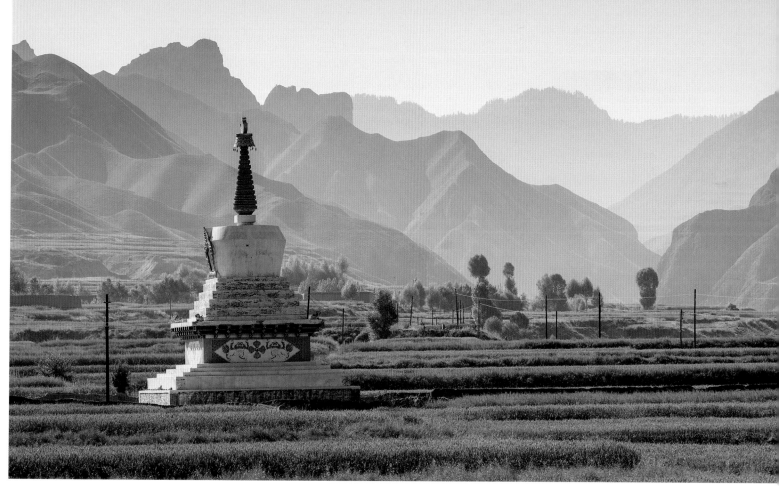

Huojia Village, Tongren, China | Leica S2 | 120mm | 1/1000 sec @ f4.8 | ISO160

The role of lenses

Lens choice is important. Wide-angle lenses – 20mm, 24mm, 28mm, etc. – tend to exaggerate perspective as you get closer to a subject. This is one of the reasons that wide lenses make poor portrait lenses. For instance, when you come close to a face the nose looks a lot bigger than it should compared to the ears because it is a lot closer, and the result is less than flattering! Wide lenses make near things look bigger and far things look smaller and so can be said to be 'stretching' the perspective.

Longer, or telephoto, lenses have the opposite effect. They tend to bring distant objects apparently closer to nearer objects – this is called perspective compression and it's another useful tool to control the visual relationship between objects in your frame. The two images of Dimond Gorge in the Kimberley (opposite) clearly show how two different lenses, from the same position, give a very different impression. The wide image is more sweeping and expansive, whereas in the telephoto shot the cliffs seem to loom over the canoe and thus look much bigger. Perspective can be controlled by either moving your own position relative to the subject, or, in the same position, using lenses of different focal lengths.

Aerial perspective

Aerial perspective is another form of perspective that affects photography and can be used to show three-dimensional depth.

It describes the effect of hills receding into the distance and becoming lighter, less contrasty and more blue. Because the hills are progressively further away, there is more atmosphere between them and you. This means more scattering of the light and thus the reduction of contrast, increase of lightness and a general 'cooling' of the colours. Because we see this every day in the real world, whether we notice it or not, it is a very strong visual clue that some things are further away than others. Aerial perspective is at its strongest when using a long lens to also compress the optical perspective, shooting into the light and on hazy days when the effect is more pronounced. (Note, aerial perspective is of the air, not from the air; you don't have to be in a chopper.)

The above image from China is shot straight into the light using a telephoto lens for maximum effect – the overlapping ridges get progressively lighter with the lowering of contrast and the increasing blueness emphasising the effects of distance.

Chapter 20

Details

Long Wu Lamasery, Tongren, China

Easy to shoot, hard to see. This pair of feet is actually an eroded imprint in some floorboards outside a shrine. Each monk, over many decades, has stood and knelt in exactly the same place with the result that the wood has been slowly worn away in the shape of a pair of feet. Only in the low evening light is this visible clearly, so it's one of those many fascinating details that can pass unnoticed. Photographers need to be good at seeing these little vignettes because they add an extra dimension to any set of travel photos.

— LEICA S2 | 35MM | 1/60 SEC @ F4.0 | ISO160

01 **Sometimes the details are as important as the bigger picture**

02 **Carry a lens that can focus closely**

03 **Keep your eye open for small, interesting details; 'seeing' is a critical skill**

Yosemite, Eastern Sierras, California, USA | Canon EOS 5D | 27mm | 1/20 sec @ f8.0 | ISO50

Long Wu Lamasery, Tongren, Tibetan Plateau, China | Leica S2 | 120mm | 1/25 sec @ f5.6 | ISO320

'It is an illusion that photos are made with the camera ... they are made with the eye, heart and head.'

– HENRI CARTIER-BRESSON

We all love going to exotic places, right? There is nothing like fresh sights to inspire the creative juices but when you are in exciting new locations it's all too easy to be overwhelmed by the entire scene right in front of you and overlook small details that might be equally significant or at least add context to the surroundings. Look for the details and you might be surprised at what you find.

When I am in a new place I tend to look for the obvious images first. I may have some preconceived images in my head from prior research or it may be that there are certain 'must-have' images that are too obvious to ignore. This is a reasonable approach because even though the obvious image might be considered a cliché, that's no reason not to shoot it because the reason it's a cliché is probably because it's actually a good image! Your own take on it might be subtly different, the weather might offer you different light or your post-production techniques might distinguish it from the other images already out there.

On a recent trip to China I visited the Long Wu Lamasery in Tongren where large groups of monks gather in the main courtyard to chant and debate (see image on p. 168). This image is the 'obvious' shot – wide, encompassing the whole scene, with a good tonal range and a reasonably balanced composition. It's the safe option and a genuinely useful editorial or stock image so it's an essential image.

But obviously there is a whole lot more to such a place, so once the straightforward images are in the bag it's a really good idea to start to look around and try to find the little detail images that you will have missed while capturing the bigger picture stuff.

In the Long Wu Lamasery, in addition to the worn floorboards, I spotted another interesting setting. When the monks go into the main prayer hall, where photos are not allowed, they take off their boots and leave them scattered all about the entrance doors. Right next to the doors are some beautifully painted wooden panels so to combine the boots and the panels makes an image which tells another part of the story. Easy to shoot once you see it.

Seeing

Many of the examples shown so far in this book, particularly landscapes, are not difficult photos to capture from a *technical* point of view. Even for very high-contrast subjects with full sun and deep shadows, modern digital cameras can capture excellent shadow and highlight details which can be easily be revealed in Adobe Lightroom or some other raw processing software. These sort of images are more about being in the right place at the right time and trusting the camera to 'do its stuff'.

Detail images are less easy to create – or should I say they are easy to shoot, but harder to see in the first place. In other words, none offer a challenge to the camera, but you as the photographer need to see them to shoot them, and this takes a bit of thought and practice.

Here are a few pointers to help with that thought process:

1. Look up. It's so easy to see simply what is in front of you, but the world exists in three dimensions and something that is just outside your field of view could be a compelling image.

2. Look down! Same deal here, what's down at your feet could be really cool.

3. Look over your shoulder as you explore a new location. As you walk around, your point of view continually changes, so looking at where you have been from where you are now might reveal an image that you didn't notice as you walked past.

Isola Pescatori, Lago di Maggiore, Italy | Leica M (Typ 240) | 50mm | 1/60 sec @ f3.4 | ISO200

Photography is about communicating – telling stories if you will. This can sometimes be done in one single image to be hung on a wall, or in a set of images such as might be published in a magazine. Multiple images allow for a deeper description of a place, so it's important to keep your eyes open for opportunities.

Getting sharp, well-exposed, high-resolution images has never been easier. The technological shifts in photography over the past ten years have democratised the process of shooting images to the point where just about everyone can produce publishable quality images – even my phone can produce decent A4 prints. Given that the technical playing field is now more or less level for most image makers, it now comes down to what you point your camera at – what you notice with your own eyes and then translating that into an image.

Peepal, Rajathan, India | Leica M (Typ 240) | 50mm | 1/180 sec @ f4.8 | ISO400

Il Duomo, Milano, Italy | Leica M (Typ 240) | 50mm | 1/60 sec @ f4.0 | ISO400

4. Following on from tip #3, reverse your course after walking through a new location for the first time. The change of viewpoint may reveal missed opportunities.

5. Think small. Tiny details are easy to miss but can make excellent images.

6. Pay particular attention to backgrounds. A small detail might be really interesting but make sure what is behind it does not distract or confuse.

7. Use limited depth of field to draw attention to a detail. (See p. 150.)

8. Once you have captured the obvious must-have shots, consider limiting yourself to a single lens such as a 50mm for a while. Then your eye will be tuned into images that will work with that lens and will not be distracted by all possible images.

9. Climb up high and look down.

10. Get down low and see what this new angle reveals.

Detail shots need not require fancy gear either. That's what I am alluding to in tip #8 above. A simple fixed 50mm lens has a perspective much the same as the human eye and so the images it creates have a realism that's hard to beat. Photos taken with lenses like this can have an immediacy and realism that telephoto or wide-angle lenses do not have, and the challenge of working with a fixed lens can lead to 'seeing' in a new way. This frees up your visual mind for looking and seeing, a critical skill to nurture if you are on the prowl for those elusive detail images.

West Thumb, Yellowstone National Park, Wyoming, USA | Canon EOS 5D | 19mm | 1/90 sec @ f8.0 | ISO100

Depth of field

You may have noticed that some images are sharp from the nearest object in the frame right through to the most distant. Other images have only one thing sharp, with the background of the image appearing as a pleasingly blurred region, making the subject stand out.

To blur or not to blur

Depth of field (DoF) is the optical phenomenon, or illusion, that causes this effect; deep DoF equates to most things being sharp, and shallow DoF renders the background out of focus for creative effect. Control of this factor is essential to a successful photograph. DoF is mostly controlled by the aperture settings but like with most things photographic, it's not quite as simple as it would appear.

Aperture

Put quite simply, a large f-number like f16 gives deep DoF and a small f-number like f2.0 will give you a shallow DoF and tend to throw the background out of focus.

Confusingly, a large f-number is actually a small aperture physically, i.e. a narrow hole in the lens iris if you look into the front of the lens. Conversely, a small f-number corresponds to a large iris size which lets more light in. The easiest way to remember is that small f-numbers give you least DoF and the larger f-numbers the most.

These two images from Mongolia make the point: the snuff-pot was shot at f2.8 and so the region of sharpness is very narrow, drawing your attention to the subject, whilst the shot of the temple ger was shot at f11 and is tack sharp from the front to the back.

As a broad rule of thumb, small details and portraits can look fantastic shot at wide apertures for minimal DoF whilst scenes, interiors and vistas look best when everything is sharp.

How it works

As the aperture is closed down to a smaller and smaller hole the angle at which the light converges onto the sensor narrows too. This has the illusion of increasing the region of sharpness both in front of and behind the subject. I say 'illusion' because in reality the only thing sharp is whatever you are actually focused on: DoF is nothing more than a region of 'acceptable' focus. What this means is that if something is only just out of focus and this degree of blur is less than the eye can clearly see, then the image looks sharp. It's only when the degree of blur becomes greater than the eye can resolve that something actually looks blurred. This degree of blur increases both in front and behind the subject as the aperture is closed down; this gives the illusion of a band of focus, even though it's actually a rather vaguely defined area.

Gandan Monastery, Ulaan Baatar, Mongolia | Leica M (Typ 240) | 75mm | 1/1500 sec @ f2.8 | ISO400

Delgerlin Choirin Khiid Monastery, Gobi Desert, Mongolia | Leica M (Typ 240) | 75mm | 1/15 sec @ f2.8 | ISO200

This also has consequences with respect to the size at which you print your images – yes, print size affects apparent DoF. Small prints will have more apparent DoF than large prints, which is somewhat counterintuitive but nevertheless true.

Lenses

Without overcomplicating matters, long telephoto lenses give the impression of having less DoF than wide-angle lenses and so a lens like a 135mm (on a dSLR) works well as a portrait lens if you want the background nicely out of focus. Landscapes are generally shot with wide lenses because you can fit more of the scene in the frame and more of the subject will be sharp from the foreground to the distant horizon.

Creative uses

PORTRAITS

Use narrow DoF to throw the background out of focus. This will give a 3D effect and will tend to separate your subject from a potentially distracting background. Make sure the eyes are tack sharp even though the tip of the nose and the ears might be less so. On a dSLR, wide apertures of f2.8-4.0 are good. On a compact you'll need to use the widest aperture available and even then it might not be wide enough – one of the weaknesses of small sensor cameras.

LANDSCAPES

Here compacts have the edge and have no trouble getting everything sharp at f4-5.6. A dSLR, on the other hand, will need to use f11 and even then, very close objects might still look a bit soft.

ACTION

The wider apertures on a dSLR allow higher shutter speeds and, like for portraits, having an out of focus background can be very effective. With compacts you'll face the same problem as for portraits.

WILDLIFE

Consider wildlife shots like portraits. These are often shot using long lenses, so narrow DoF is almost always assured.

Delgerlin Choirin Khiid Monastery, Gobi Desert, Mongolia | Leica M (Typ 240) | 18mm | 3 sec @ f16.0 | ISO200

Chapter 21

Planning

Bayon, Cambodia

The temples in the Angkor Thom complex near Siem Reap in
Cambodia are hard to photograph well because there are frequently
busloads of visitors exploring the ruins. This is where planning comes
in. From previous visits I knew that the vast majority of visitors are
on tours and that seeing in the dawn at Angkor Wat is a part of their
package itinerary and then they go back to their hotels for breakfast.
My thinking was that if almost everyone is at Angkor at dawn, then
they can't be elsewhere – so I went to the other temples such as Bayon,
Ta Prohm and Preah Khan in the pre-dawn and mostly had them
all to myself until about 8.00am when the visitors came back after
breakfast. By that time the light was harsh anyway! A simple plan but
an effective one.

– LEICA T (TYP 701) | 11MM | 1/320 SEC @ F11.0 | ISO100

01 **Spend some time before the trip researching the places you need to go – forewarned is forearmed**

02 **The internet is your best friend for travel planning**

03 **Use Google Maps and Google Earth for route planning**

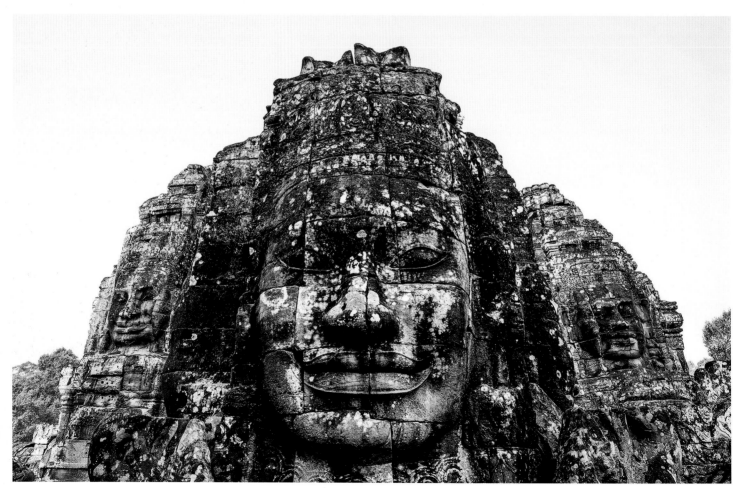

Bayon, Angkor Thom, Cambodia | Leica T (Typ 701) | 11.6mm | 1/125 sec @ f11.0 | ISO100

Preah Khan, Siem Reap, Cambodia | Leica T (Typ 701) | 15.9mm | 1/3 sec @ f11.0 | ISO100

'Common sense is the chief enemy of creativity.'

– PICASSO

Creativity comes into play when you arrive at your destination and start shooting, but common sense is what you use when you are planning the trip. I understand what Picasso is getting at but, for travel photography at least, both common sense and creativity are needed to get good results.

In Chapter 3 we looked at anticipation and what to expect (or hope for!) as far as shooting opportunities are concerned, but there is a whole raft of practicalities that need to be addressed in order to get to, and around, your chosen destination.

Research

You may be sent on an assignment, in which case your destination is chosen for you and the images you are being hired to create are probably predetermined. More likely, though, you have yourself chosen somewhere that you'd like to go – so, where to start?

If I am heading off to a totally new country, then I will approach my research slightly differently to a return visit to somewhere

I have been before. My thinking and planning will also be influenced by the reason for the trip.

If I am shooting stock images in a new country, then the best approach is to identify the most significant places and try to create an itinerary that picks up what a cynic might call the 'low hanging fruit'. As an example, if I was off to Cambodia for the first time then I would be unwise to overlook Siem Reap and the Angkor temples. Sure, they have been photographed a billion times before, but I don't have those images in my own files and anyone who asks me for photos of Cambodia is quite likely to want images of those temples. Not only that, but there is always the chance of getting an amazing photo of a well-photographed place purely because the light just happened to be amazing and *you* were the one to capture it.

This is me thinking 'commercially'. I need to shoot images which will make me money in the most cost-effective way and the obvious images are often the ones that have future sales potential. On the other hand, if you are shooting purely for your own enjoyment and to experience a new country, then you might choose to get right off the beaten track and head into the more obscure parts of the country.

Regardless of your motivation, the research that you do will be much the same. Questions you need to ask, and answer, would run something like this:

— How long and how much? These are the big questions which set the pace of your entire trip: how much time do I have and how much money can I spend?

— How many locations in how many days? This is a tricky one to answer – there is a tendency to go for quantity over quality but I have found over the years that I get a better overall quality of images if I spend more time in fewer places. This does, of course, depend on your motivation – if it's an assignment, you might not get much choice!

Wat Bo, Siem Reap, Cambodia | Leica M (Typ 240) | 50mm | 1/350 sec @ f4.8 | ISO800

Working out an itinerary

If you had 12 days for a trip, I would try to go to four different places for three days each. It takes a good 24 hours to settle into a new place and even after 30 years of travelling I still need that first day to get oriented when I arrive in a new place, especially cities. Whenever possible, I recommend you aim for three days per location.

Once you have decided on the list of places you want to visit, you then need to work out an itinerary that minimises travel time and maximises shooting time. This is where Google Maps comes in because you can work out driving distances between places, but be aware that whilst the distances might be accurate, the expected travel times that Google reports might be wildly wrong and totally impractical.

If you are hiring a guide or working through an agency, this is where you would start to ask questions of people who have first-hand experience of the locations you intend to visit. Any itinerary should be based on your needs, but tempered by what is actually possible.

Don't forget to check for local public holiday dates, as many shops and banks will be closed. Some places are closed on certain days, which could be awkward if your only day in a particular location coincides with a regular closure. Hagia Sophia in Istanbul is closed one day each week, for example.

North Gate, Angkor Thom, Cambodia | Leica M (Typ 240) | 50mm | 1/90 sec @ f5.6 | ISO200

Hotels

Choice of accommodation depends a great deal on budget – obviously! However, there are ways to make the most of your budget.

I try to find hotels that can double-up as shooting locations for cityscapes. Elevated viewpoints are not that easy to track down in a couple of days, so try to book a hotel which has either a room balcony with a great view, or a rooftop terrace – or both. Google Earth is a good tool here because you can find the hotel location and get a sense of what can be seen from the rooms or the roof. The photo of Sydney Harbour Bridge on p. 184 was taken from hotel room.

City centre hotels have the disadvantage of being potentially noisy and over-priced but they have the huge advantage of being right in the thick of things, so you can just walk out the door to find street scenes, cafes and so on. Outlying hotels are better value but you often need to get a taxi to the city centre, the added cost of which can end up the same as the city hotel would have cost in the first place.

Don't waste budget on resort facilities. Spas, gyms, massive pools, marble foyers and such all add to the cost of the rooms. Better to find a simple, clean hotel in a good location – TripAdvisor is a good resource for finding out what hotels fit your needs.

Bayon, Angkor Thom, Cambodia | Leica T (Typ 701) | 83mm | 1/25 sec @ f7.1 | ISO100

Preah Khan, Siem Reap, Cambodia | Leica T (Typ 701) | 55mm | 1/8 sec @ f8.0 | ISO100

Angkor Wat, Siem Reap, Cambodia | Leica M (Typ 240) | 50mm | 1/500 sec @ f6.8 | ISO200

Preah Khan, Siem Reap, Cambodia | Leica T (Typ 701) | 11mm | 1/60 sec @ f8.0 | ISO100

Guides

Xiaqunsi Lamasery, Kanbula, China

After being given rare permission to shoot inside the main prayer
room, I was delighted to find a young novice monk reading his sutras
alone in the darkened space. The light from the single door was
spilling across his desk, relieving the mood of the gloomy interior and
revealing the incredible tapestries hanging from the roof. This was
a tricky shot – the monk needed to be sharp and I needed maximum
detail in the darkened room. I compromised on a high ISO and a
shutter speed that was long enough to capture the light but not so long
that the monk would be blurred as he moved, however slightly. I asked
him, through my guide, to hold still and he kindly obliged.

— LEICA S2 | 35MM | 1/3 SEC @ F6.8 | ISO640

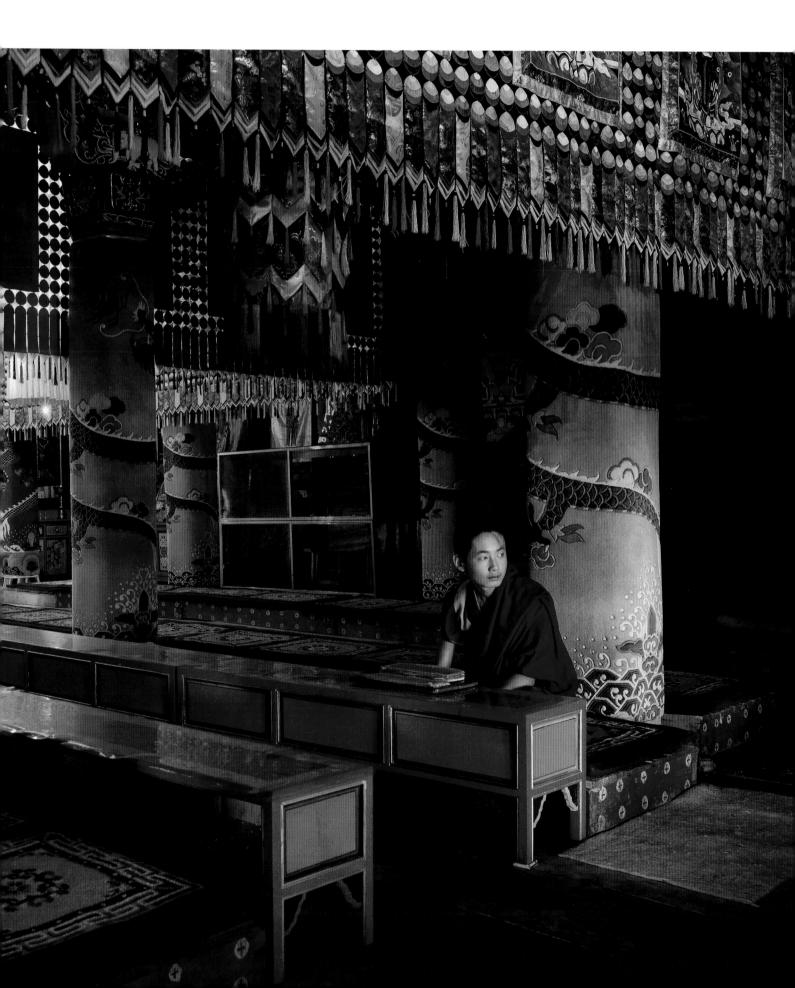

01 **Employing a good local guide is the best investment you can make**

02 **Guides will already know a lot of things that it will take you hours or days to find out yourself**

03 **Not all guides fully understand photographers' needs**

'I don't think you can create luck. I think the main ingredient for photography is curiosity. If you're curious enough and if you get up in the morning and go out and take pictures, you're likely to be more lucky than if you just stay at home.'

– ELLIOTT ERWITT

For many years I tended towards a photographic approach where I was an 'independent traveller' and wanted to find out for myself where the good photos were to be found, rather than asking around and being shown the same places as everyone else.

This is OK as far as it goes, and can be a lot of fun, but it is highly inefficient. No-one has infinite time; most of us have a specific amount of time within which to create our images, and often a very limited amount of time at any one location. It's just the way it is. Learning to make the most of the time you do have is one of the skills you'll need to nurture if you are to get the most out of your trip and this is where a good guide comes in incredibly handy.

The image on the preceding pages is a great example of an image that I would never have been able to create without a guide.

New Delhi, India | Leica M (Typ 240) | 90mm | 1/2000 sec @ f4.8 | ISO400

I was leading a photography workshop in China and on the last day we had to take a detour. The new route took us up and over some high mountains, right past a monastery which didn't show up on any of my maps. Our guide said that we might be interested to look inside and so we stopped for lunch.

We had been told before, in other monasteries, that photographs are not allowed in the inner temple. The trouble is, the inner temples are where all the really cool stuff is! They are full of rich tapestries, intricate thangka paintings, colourful carpets and so on – irresistible to photographers.

And so it was at Xiaqunsi; we were welcome to have a look and take photos around the courtyard and exterior but not inside. That was until we got chatting with one of the senior monks (interpreted through our guide naturally) and explained that we were visiting from Australia and were enjoying our trip. Just making conversation really ...

Delhi railway station, Delhi, India | Leica M (Typ 240) | 18mm |
1/45 sec @ f8.0 | ISO800

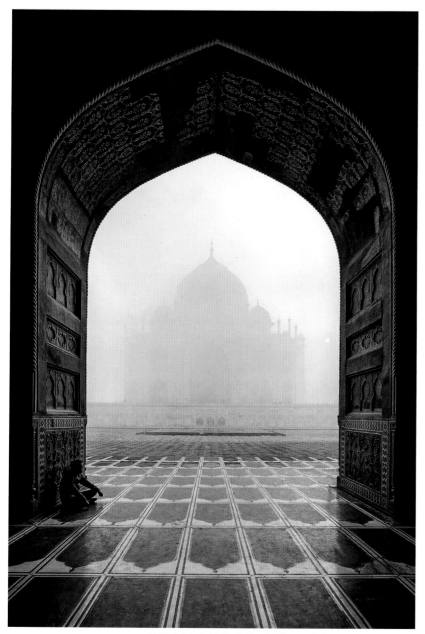

Taj Mahal, India | Leica M (Typ 240) | 18mm | 1/180 sec @ f5.6 | ISO200

When the senior monk found out that we were taking photos just for ourselves, he then asked if he could see them. There ensued a huddle around some of our cameras so he could see the photos on the rear screen, followed by him beckoning us into a backroom where there was a relatively modern office complete with PC. Then he asked, via the guide, could he please have copies of some of the photos. Sure, we said, how about letting us in to shoot some photos in the inner temple? 'No problem', says he!

We then made the most of the opportunity, especially after we found a young monk inside, studying his sutras bathed in glorious side light. There was no way we would have ever been able to get this kind of access without a guide being able to facilitate good communications between our two respective cultures.

Pushkar, India | Canon EOS 5D Mark II | 135mm | 1/320 sec @ f4.0 | ISO200

What to look for in a guide

Hiring a guide can be a bit hit or miss; after all, you will not get to find out how good they are until you arrive. This is where recommendations come in, or travelling as part of a photo tour where the guides are a known quality.

A good photography guide will be able to do the following:

— translate the local language into your own language, and vice versa

— have a good understanding of how to work with two different cultures, without offending either

— have good local knowledge and good local connections

— understand what photographers need

— be prepared to work hours that might be a bit different to normal tour groups.

These last two points are critical. Photographers are just as likely to get all excited about some grungy old building at the side of the road as they are about the 2000-year-old temple they are scheduled to visit. Whilst the temple might be culturally or historically interesting, it might not be visually interesting for some reason. There is an amazing Jain temple in Rajasthan that is quite spectacular – but it's so popular with pilgrims that it is all covered in steel railings for crowd control. No good for photos, so we spent much less time here than anticipated. A good guide is a flexible guide, who understands that we photographers are an odd lot and you can't always second guess what we want!

Drivers

Drivers are often the unsung heroes of photography trips. Sometimes they double up their duties as guides but that's not really their role. Where possible, choose a driver who speaks your language, even just a bit – it makes life so much easier!

You'd be really unwise to attempt to self-drive a trip in many countries; driving styles can be so different that driving yourself around would be incredibly stressful, not to mention highly unsafe. Some countries, such as Vietnam, simply do not allow foreigners to rent cars. For a modest fee, maybe US$75–100 per day, it is quite possible to hire an air-conditioned car with driver and, just like hiring a guide, it's money very well spent. In Siem Reap, Cambodia, for example, hiring your own tuk-tuk driver for a full day might only cost US$20–25. Tootling around the Angkor temples and having someone wait for you whilst you explore the ruins is not only a very pleasant way to get around but also allows you to concentrate on your photography.

Chandelao, Rajasthan, India | Canon EOS 5D Mark II | 300mm | 1/2500 sec @ f4.0 | ISO200

Some guides work rigidly by the itinerary and tend to prioritise making sure that the group gets all the locations ticked off the list. The guides that work best with photographers are the ones who go with the flow and can make new arrangements as the trip progresses (up to a point, of course). Some early starts and late nights are par for the course; make sure your guide and budget are prepared for this.

I was honoured to be named as the AIPP Travel Photographer of the Year in 2014 and out of my four winning images, three of them would simply not have existed without the input and assistance of my regular guide in India.

Having a driver take a lot of the stress and safety concerns out of your shoot. It's also extremely practical when it comes to achieving your photography aims. You can save heaps of time by being dropped off at a busy location without having to worry about parking and then have the car pick you up at a predetermined time. You can leave stuff in the car too, knowing that your driver will always be with it. All in all, this is a huge help when it comes to what's important – getting your images.

HDR

It's not uncommon for the range of tones in your subject, from dark shadows to bright highlights, to be simply too broad for your camera to capture in one shot. You would normally have to decide whether to sacrifice the highlights or the shadows since you can't have both.

Dealing with high-contrast subjects

A typical example would be if you were photographing the inside of a building, such as an old shearing shed; it would be very difficult to have a single good exposure for the interior without the windows recording as pure white with no detail at all. It would be cool if we could create an image where the inside is well exposed and at the same time, we can see something of the outside showing through the windows.

If you need to capture tones that won't 'fit' into one single exposure then shoot two images – one for the shadows and one for the highlights. In the case of the interior shot, you could shoot one image correctly exposed for the inside and one for the outside. The first shot would have overexposed windows and the second would have an underexposed interior but correct exposure for the windows.

Then, back in the digital darkroom, you can combine the two shots to take the best information from each image – this is known as HDRi or High Dynamic Range Imaging.

Combining shots with HDRi

As already mentioned, you need to shoot at least two photos at different exposures so that one has good detail in the bright areas and one has good detail in the dark areas. As a bare minimum, shoot two photos, three is much better, and for really contrasty scenes even five or six might be necessary.

Most modern cameras offer an auto-exposure bracket feature which allows you to set the number of shots and the exposure difference between them. A good start would be to set the camera to shoot a sequence of three photos with a 2-stop difference between each one. Then you end up with one dark image shot at -2 stops relative to the meter's recommendation, a 'normally' exposed shot and one light image at +2 stops. Collectively they would capture the whole brightness range on the subject even though no single image is 'correct'.

In this example I came across an old laundry in an abandoned naval base in far eastern Russia. Since it was the middle of the day, the inside was quite gloomy and the outside was harsh, bright sunlight. My eye could easily deal with the range of brightness between the windows and the inside but all cameras are very limited in this regard, even the most expensive ones. So I shot two frames, with a 3-stop difference between them, using a tripod.

Here are the two images, one with good interior detail but an overexposed sky, and one with a dark interior but a good exterior and sky. The third image is the combined result and you can see how the tones are now 'compressed' into a more manageable range.

Broutana Bay, Kuril Islands, Russia | Leica S2 | 30mm | 1/4 sec @ f11.0 | ISO160

Which software?

You do need some specialised software to blend the images together and there are plenty to choose from. Here are just a few (all work on Mac and PC) recommendations.

Luminance HDR This freebie is a good place to start, simple and intuitive, if a little bit limited.

Photomatix Essentials or Pro A stand-alone application that has become the de facto standard for HDR enthusiasts because of its range of options and high-quality results. It's free to try but adds a watermark to saved images until you buy a licence.

Adobe Lightroom 6 This now has a built-in HDR tool which can process and auto-tone a set of images taken at different exposures. For straightforward images it would do very well, but Photomatix is still the most potent app out there.

Once you have your sequence of images you'll need to open them all into the HDR application so the software can combine them into one image. The exact details of how this happens vary hugely from application to application, but in general the software automatically creates masks that allow data from differently exposed images to appear in the final image. In the case of an interior photo, the software would create a mask for the bright windows, allowing the darker image to appear in the windows and the lighter image to appear everywhere else.

Step-by-step

When shooting the images in the first place, it's a good idea to use a tripod because the weakness of this whole technique is that nothing should move between one image and the next. Obviously this is not always possible – trees sway in the breeze, people in the shot will move and clouds drift across the sky. Software can deal with this to a certain extent but it's better to minimise movement at the outset.

My own method is quite simple. I set the camera to Aperture Priority, set an appropriate aperture, say f8, and then auto-bracket three images at 2-stops difference (you might need to refer to the manual to see how to set this on your own camera). Using a tripod when possible, I use the self-timer to trigger the camera, or a cable release if not, and the camera will shoot all three shots in one operation, varying the shutter speed between each one to change the exposure.

Later, using Lightroom 6 to import the images, I select all three images in the sequence and choose Photo > Photo Merge > HDR from the menu. This software will combine the three images into a single image and re-import it back into Lightroom as a new file. I then simply adjust the various Exposure sliders (in the Basic pane) for this new image until it looks right.

'Looking right' will vary from person to person; some folks might like the more extreme grungy effects of Photomatix, but personally I prefer a realistic look. It's your photo and you can make it look however you like! One trap to beware of, if you like the 'realistic' look, is not to overdo it and darken skies too much. Skies should be bright, as they are in real life, and if clouds look too dark it's a dead giveaway that it's an HDRi shot.

Chapter 23

Consent

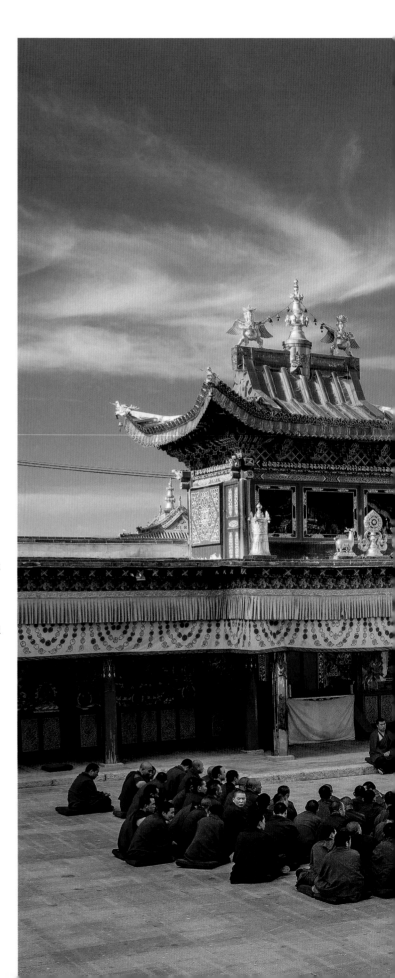

Long Wu Lamasery, Tongren, China

Sometimes it would be nice to be invisible, to be able to record life
as it really happens, without any influence on the events unfolding
before us. Sadly, this is not possible because our very presence affects
what we capture in our images. I think it's important to make sure
that you are not imposing on, interfering with, obstructing, annoying,
offending or otherwise disrespecting your subject matter. I am much
more comfortable shooting in situations where I know I have some sort
of permission, even if it's merely a tacit approval or just a nod of the
head. It was unusual for the monks in this lamasery to allow visitors to
watch the chanting and debating that goes on in the main courtyard;
our guide was able to ask on my behalf and as long as I didn't speak and
mostly stayed out of sight I was allowed to shoot.

— LEICA S2 | 35MM | 1/45 SEC @ F11.0 | ISO160

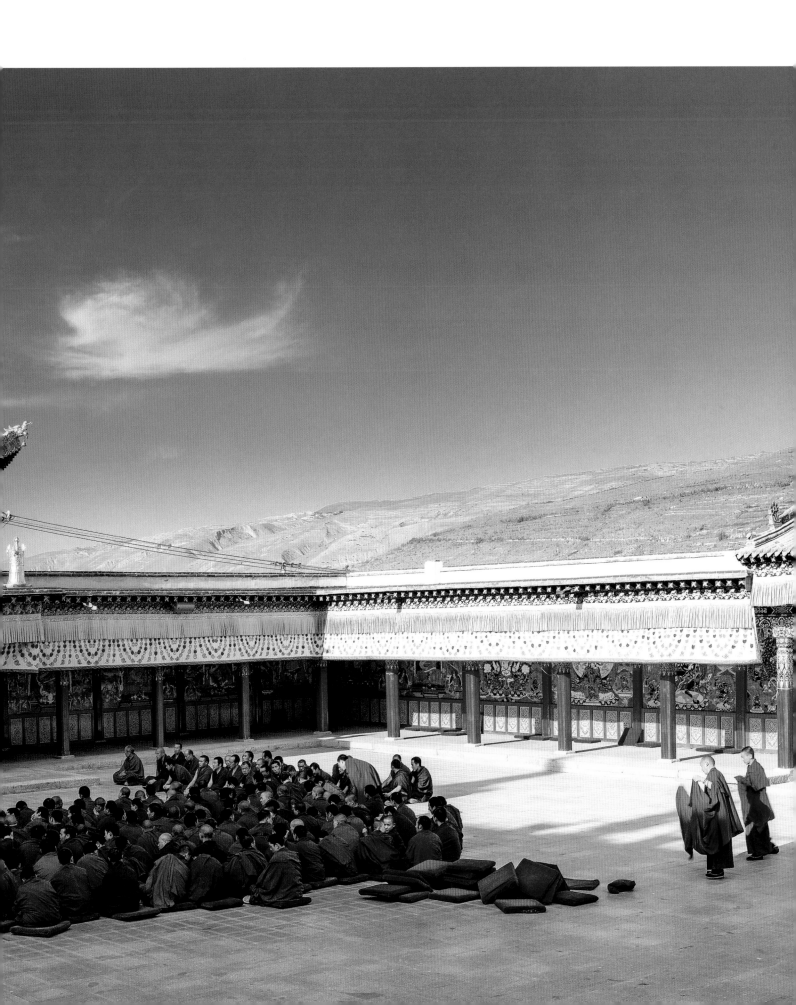

01 **Asking permission is polite, but inevitably alters the scene**

02 **Respect for your subject is more important than 'getting the shot'**

03 **Be aware of the general cultural attitude to taking photographs**

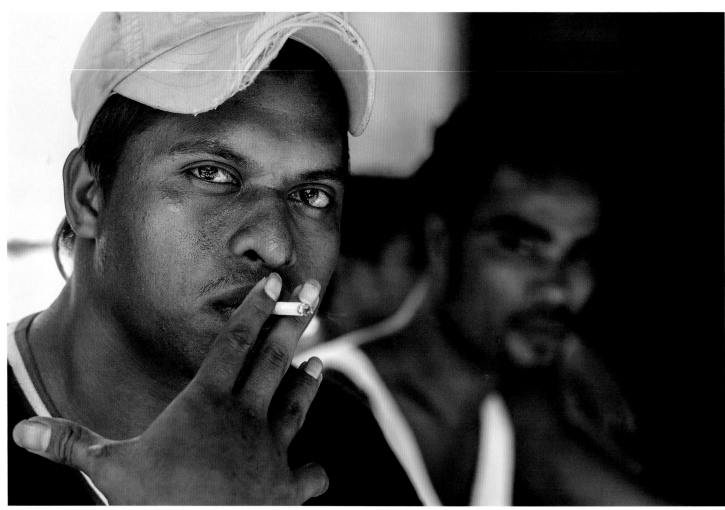

Kisar, Moluccas, Indonesia | M Monochrom | 90mm | 1/500 sec @ f5.7 | ISO640

Kisar, Moluccas, Indonesia | Canon EOS 5D Mark III | 44mm | 1/320 sec @ f11.0 | ISO200

'If you take a picture of a human that does not make him noble, there is no reason to take this picture. That is my way of seeing things.'

– SEBASTIÃO SALGADO

Travel photography, to a large extent, involves photographing people. A question I frequently get asked is how do I go about approaching people and get their permission to take their photo.

This is a tricky question because like so many things in photography the answer is often, 'Well, it depends ...'

Here's what I think about the issues of approach and consent; not everyone will feel the same way of course, but this approach has served me well over the years.

My primary guiding principle is respect for the subject. Yes, the word 'subject' is a bit impersonal, but the more accurate 'the person I'd like to make a photograph of' is a bit of a mouthful. If I put myself in their shoes, how would I feel about being photographed in my home, in my place of work or on the street?

Personally, I used to be less than thrilled about being photographed, which is a bit odd given that I like to make photographs of other people. Nowadays I've got over that and make an effort to let other people photograph me if they like – it would be a little hypocritical to do otherwise.

People in different parts of the world react very differently to having a camera pointed at them. In India, whilst there will be the occasional person who waves you off, most people are delighted to be photographed, even to the point of approaching you!

Dam Dek Village Market, Siem Reap, Cambodia | Canon EOS 5D | 37mm | 1/90 sec @ f5.6 | ISO200

In Australian cities the opposite is often true; people are very suspicious of cameras on the street and can be quite aggressive in wanting to know why you are taking photographs. If there are children around, well, that's a whole Pandora's box of privacy issues which I don't want to get into here. In the Australian outback, there is a lot less suspicion about photography. It's much easier to shoot photos of people in small country towns than in cities. I don't know why there is such a big difference in attitude, but being sensitive to local attitudes is a very important skill to develop as a photographer.

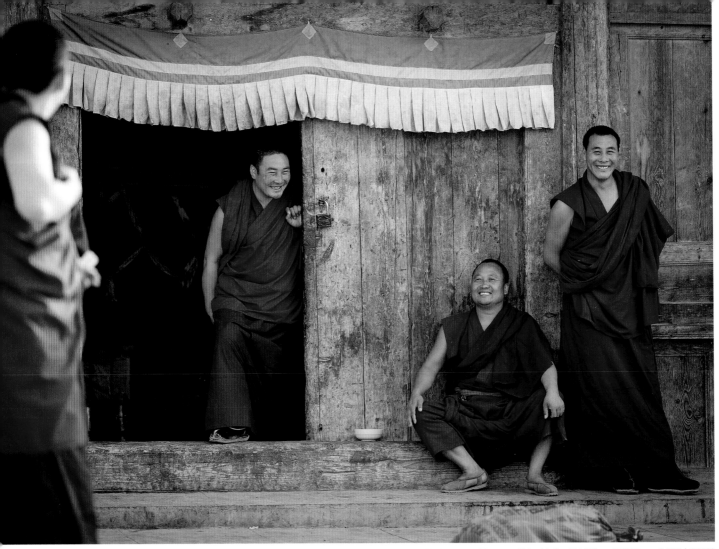

Long Wu Lamasery, Tongren, China | Leica S2 | 120mm | 1/180 sec @ f2.8 | ISO160

As a photographer, there is also the question of how comfortable you feel about approaching a total stranger in a public place and essentially asking them to give you something. This is very confronting for some people – photographers, broadly speaking, are more likely to be 'observers' rather than 'engagers'. Stepping outside your 'protected zone' behind the camera is a big deal but it has to be done if you want to get good people photos.

In Chapter 1 we looked at getting involved and engaging with what's going on around you, but let's extend that thought and talk about permission and forgiveness.

Permission means asking beforehand to shoot a photo. Pros: a polite and respectful approach has the potential to lead to a more considered and formal type of photo if the subject is willing. Cons: you immediately alter the situation by interrupting what's going on; the photo can no longer be a 'real' slice of life.

Forgiveness is when you take the photo anyway and, if it annoys anyone, say sorry. Pros: you have a better chance of capturing genuine 'real life' moments (if you are good enough). Cons: it is less respectful and a bit more assertive; this can lead to some confrontations if handled badly.

Long Wu Lamasery, Tongren, China | Leica S2 | 35mm | 1/1000 sec @ f4.8 | ISO640

172

I lean towards the former approach and I think it shows in my photos. However, it's only a leaning, not a rigid philosophy. I am also quite likely to quickly grab a photo that's simply too good to miss. How often I do this will depend to a great extent on the vibe I get from the people around me. I know this is a bit of a hazy concept but, for instance, in India, where most people are happy to be photographed, I'll be a lot more likely to shoot first and ask questions later (metaphorically speaking of course!). The same goes for much of Southeast Asia, but in the Middle East, Europe, USA, Australia, I'll be a lot more circumspect. I'd be very unlikely to wade in with my camera in Sydney, but at an outback community event like a rodeo I'll shoot away quite happily.

How do you turn consent into a spontaneous photo? Does consent preclude an unprompted and natural photo? Here's a method I use to get the sort of shots I want.

East Java, Indonesia | Leica M (Typ 240) | 28mm | 1/45 sec @ f8.0 | ISO400

For relatively static street scenes such as street vendors, markets, etc., I much prefer to ask before I shoot a frame and by doing so I accept that I have forever altered the 'moment'. I'll then take a couple of snapshots with my subject (usually) grinning at the camera, making no serious attempt to direct them. Sometimes, with that out of the way, I will thank them but not move away. Subjects like market vendors – who are more interested in selling stuff to the next customer or are just plain busy – will fairly quickly lose interest in me and at that point I will shoot some more images, the images I really want. Once they have agreed to a photo, and I have taken it, I then feel I have tacit permission to shoot some more. These images will be the ones that are far more real because I am now effectively invisible, even though I am in full view.

Even hanging around for a while with a camera in full view can allow you to fade into the background. You can become part of the scenery and eventually start shooting some images where your presence is mostly ignored.

Yangshuo, Guangxi, China | Leica S2 | 120mm | 1/60 sec @ f2.8 | ISO640

Remember, shooting photos should be seen as a privilege not a right, even if you do, in fact, have the right under the local law. Photographers should make sure they are familiar with the laws and restrictions on photography in the country or site they are visiting.

You do not have the right to offend or annoy people just because you want a photo. With a friendly, open attitude, and a willingness to back off if you think you are unwelcome, it's not too hard to get spontaneous images, better still if you can get permission to shoot them in the first place.

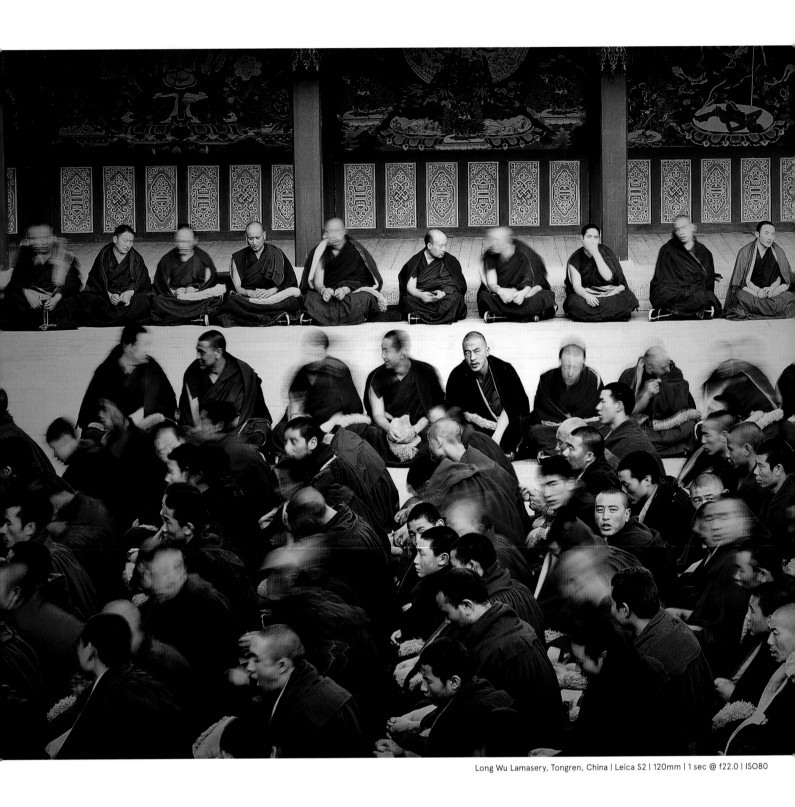

Long Wu Lamasery, Tongren, China | Leica S2 | 120mm | 1 sec @ f22.0 | ISO80

Melbourne, Australia | Leica Q (Typ 116) | 28mm | 1/60 sec @ f2.0 | ISO1250

Siem Reap Markets, Cambodia | Leica M (Typ 240) | 50mm | 1/250 sec @ f13.0 | ISO400

Chapter 24

Colour

Spice Islands, Indonesia

Sailing in the early morning across an unusually calm sea, I was taken by the patterns left behind on the water as the flying fish skittered across the water's surface, escaping the approaching bow of the ship. The water, being so calm, was mirroring the intense blue of the sky, so I chose to simplify the shot down to just the colour and the water patterns. To keep it tight I used a medium telephoto lens set to f5.6 for a bit of extra depth of field, and then it was a case of waiting until a fish came out at just the right place in the water. They are fast, these flying fish, so you don't get much warning. I turned off autofocus and fixed the focus where I anticipated the best shot would be – a stakeout if you like. I then shot lots of frames over a 30-minute period and this is my favourite from the set. A strong diagonal, movement left to right, no distractions and an intense colour.

— CANON EOS 5D MARK II | 135MM | 1/1500 SEC @ F5.6 | ISO800

01 Colour can be the entire subject, but be careful of auto white balance

02 Complementary colours are powerful subjects

03 Colours evoke emotions

Whitehaven Beach, Australia | Mamiya RZ67 | 50mm | 1/500 @ f8 | ISO100

'Color is seductive. It changes as it interacts with other colors, it changes because of the light falling upon it, and it changes as it becomes larger in size.'

– JAY MAISEL

A colour photo can be two things – it can be merely 'in colour' or 'of a colour'. In this chapter I want to look at photos of colours, where the colour itself is the primary source of interest rather than something that merely supports the rest of the shot.

Take a tropical beach under a clear blue sky, for example; here the blueness of the scene is the primary point of interest, so we need to emphasise it and work with the strong colour to simplify the image down to its most important parts. This means trying to avoid conflicting large areas of colour – small areas of a complementary colour can add a nice counterpoint but two bright colours can compete for attention.

Auto white balance gotcha

For a large proportion of subjects AWB is quite useful, but, where there are strong colours dominating the shot, beware – the camera will 'see' an error and will try to correct it. Case in point, this shot of Whitehaven Beach in Queensland. The camera interprets the blue sky and blue water filling the frame as a blue colour cast and will add red to compensate – compare the difference. (See also White balance, p. 182.)

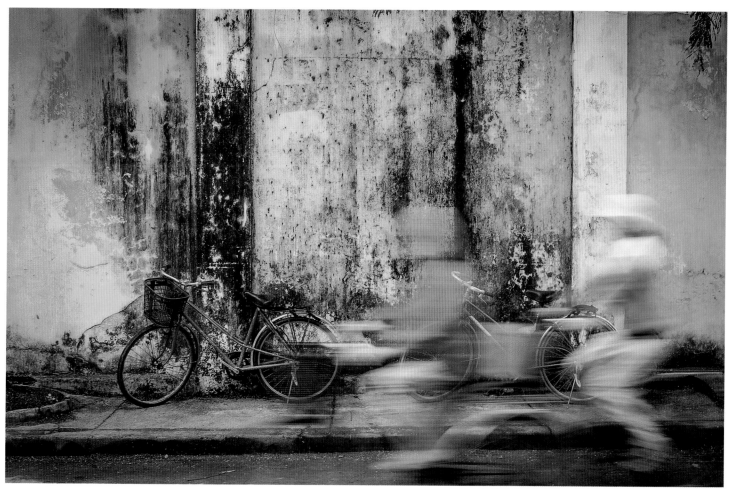

Complementary colours

You can think of colours as occupying the rim of a wheel – from red at the top (zero degrees), clockwise to green (120 degrees), to blue (240 degrees) and back to red at the top again. Colours that are on opposite sides of the wheel are known as complementary colours:

— red/cyan

— green/magenta

— blue/yellow

One dominant colour with a smaller area of its opposite colour can make both colours look more intense, particularly the smaller area of colour. The eye works in mysterious ways indeed. It's outside the scope of this book, but if you are interested then I recommend reading *The Age of Insight* by Eric R. Kandel, which has a very readable section on colour perception as it relates to art.

Opposing colours can be said to have high colour contrast – even a low contrast image tonally can have high colour contrast, and vice versa. The image of the blurred cyclists in Vietnam has high colour contrast but low tonal contrast because there are no bright highlights or shadows but the red/blue/yellow colours are very different from one another.

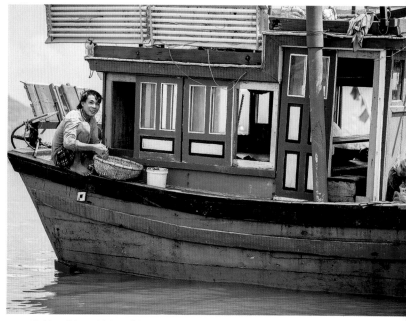

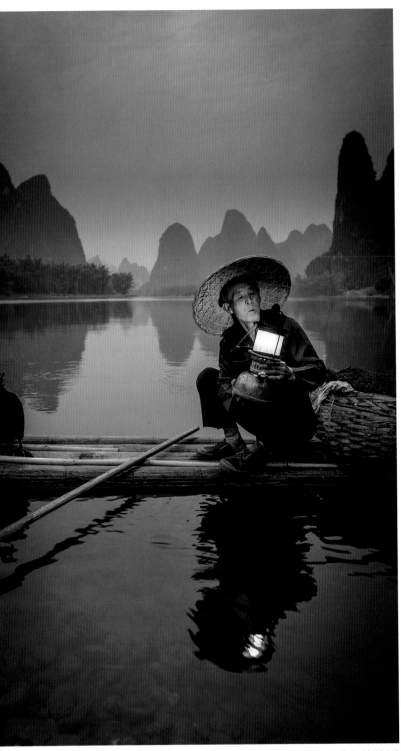

Xingping, Li River, China | Leica S2 | 30mm | 1/30 sec @ f4.0 | ISO640

Of all the colour contrasts, the most powerful is the cool blue to warm orange-yellow contrast. We find this very pleasing to the eye and if this contrast can be included in a photo so much the better. For example, skin is generally a warm tone and if you take a portrait of someone against a cool blue background their skin will seem to take on a healthy glow. The photo of the cormorant fisherman in China uses this contrast for maximum effect – cool post-sunset light versus a face illuminated by the warm light from a lantern. The face leaps off the page and even seems to come forward in the image, making it subtly three dimensional.

Next time you watch a movie on DVD, particularly a thriller, freeze a frame and see if you can spot that the shadows have often been tinted slightly blue during the editing and colour grading process. The tinting makes any faces or skin tones in the frame stand out even more and so leads your eye to them. It's true, check it out.

Emotional colours

Over the years, artists and philosophers have come to realise that colours can be associated with strong emotions and moods. Scientific research on colour psychology suggests that colour affects our feelings and can prompt physiological responses. Colours really do evoke emotions and subtle colour toning can add to the mood of a photo, complementing the subject itself.

A documentary photographer working on a story on homeless people in the cold inner city might choose to add a bit of blue to the shadows to hint at the bleak existence he is trying to portray. Conversely, in travel photography you might like to use a slightly warm palette to make the photo more generally attractive – always good in travel brochures.

Most toning is between cool and warm. Unless you have good creative reasons to do so, magenta or green tones just look like a mistake, as does red and yellow. For those who want numbers, hue values of 40 (orange) and 240 (blue) are a good warm/cool combination when used subtly. Note that these are not actual opposites on the colour wheel, almost but not quite.

Colour confusion

If some colour is good then more colour must be better, right? Wrong. Too many colours fighting for attention in one photo just make for a confusing image. Pick a single strong colour and work with it, adding in one other contrasting colour but not two if you can avoid it. This image below of a colourful parade in China is certainly dramatic but, to my eye at least, it's very confusing. Better to try and isolate one strong colour by shooting a lot tighter, pick out some details and try to eliminate some of the duelling colours from the frame – if that's even possible in such a colourful place!

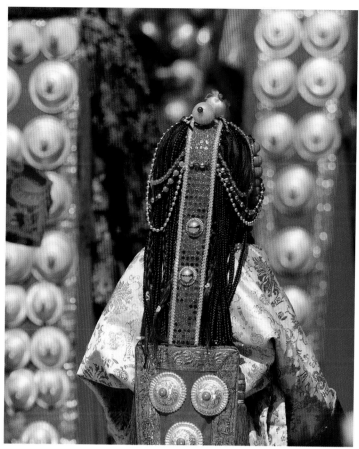

Siheji Temple, Tongren, Tibetan Plateau, China | Canon EOS 60D | 270mm | 1/8000 sec @ f5.6 | ISO800

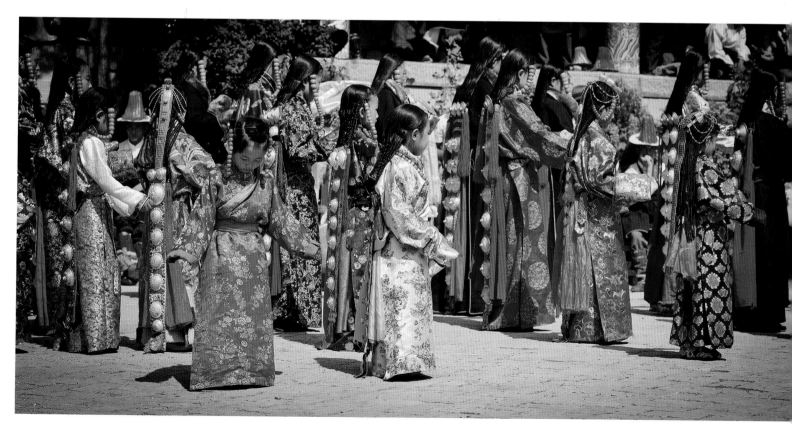

Siheji Temple, Tongren, Tibetan Plateau, China | Canon EOS 60D | 270mm | 1/8000 sec @ f5.6 | ISO800

White balance

I think that most people who own a half-decent camera would have heard of the term *white balance*. **It's the setting you change when you go from indoors to outdoors, or on a cloudy day. The purpose of this setting is to make sure that a white object still looks white in the final image. If you are not sure which setting to use, then you can use Auto and the camera makes a best guess at an appropriate setting, which is usually good enough – although not always, as we shall see later.**

So, what is this 'white balance'? What does 'daylight' mean and why is it important?

Light is not always neutral in colour. It can be very yellow-orange (warm) in the case of sunsets and indoor incandescent light bulbs, or very blue (cool) in open shade, or any colour in between.

The measure of this colour tint is called the *colour temperature*: imagine a cannonball in a blacksmith's fire, heated progressively until it glows hot. As it gets hotter it will glow 'red hot' and as the temperature increases further it will tend towards more of a blue-white, what we might call 'white hot'. The temperature of the ball directly relates to the colour of the light given off and is thus called the colour temperature and is expressed in degrees Kelvin or '°K' for short. (It is also assumed that a light radiates the different components of white light – red, green and blue – in equal amounts, which is not quite true in practice, but that's another story.)

A low number is 'warm' i.e. a low-voltage desk lamp is maybe 3000 °K and open shade will be very 'cool' at maybe 9000 °K. This is slightly counterintuitive as a 'cool' cast is actually a higher colour temperature.

It follows that if the White Balance setting of a digital camera does not match the colour temperature of the actual available light then a white, grey or neutral coloured object will obviously no longer appear neutral. If you take a shot outdoors but have the camera set to Indoors, then the resulting image will be quite strongly blue in tone (below). Conversely, using an Outdoor setting indoors will produce very red-amber results. Try it and see.

Stone House Museum, Boulia, Queensland, Australia | Canon EOS 5D Mark II
34mm | 2 sec @ f11.0 | ISO100

Even the consumer models have at least six fixed settings: Daylight, Cloudy, Shade, Tungsten, Fluoro and Auto. One of these is very likely to be pretty close to what you need. Personally I use Cloudy for almost all photos, and occasionally Indoor (Tungsten) for interior shots.

JPEG or raw?

This is a question that is much discussed by photographers and both file formats have their pros and cons. However, when it comes to colour temperature there is a huge advantage to shooting raw if your camera offers the option – this option will usually be found in the Image Quality menu.

The fundamental difference between the two formats is that setting the camera to JPEG mode means the camera processes raw files to create finished JPEGs. Using raw mode means the camera does not do any processing at all, this must be done later

When using the JPEG mode the camera uses whatever colour temperature is set in the camera menus to process the file. If this is set wrongly then the resulting image will have a strong colour cast and, whilst it is possible to adjust the colour later, this is very difficult and will result in not only some slightly odd colours but also reduce the file quality quite noticeably.

If, on the other hand, you use raw mode, you can set the colour temperature later in the raw processing software and, best of all, this is a reversible or non-destructive process. If you don't like the results you can always go back to the original file and reprocess it. You can fine-tune the colour balance too and if colour fidelity is critical you can even use a colour meter to precisely set the raw converter to the right setting.

Camera previews and Auto WB

Many of us judge our images by looking at the LCD screen on the back of the camera. Be aware that the image you are looking at is a JPEG image which will be affected by the white balance setting that you are using. Even if you are shooting in raw mode, knowing that you can finesse the WB later, this preview will still show you an image based on the currently set WB. If you have set it wrongly for the prevailing light conditions, then it may be a bit off-putting.

A case in point is shooting sunsets. If you have the camera set to Auto WB you will see that the colours of that wonderful sunset look drab and muted on the back of the camera. This is because the camera sees the strong orange-yellow colours of the sky as a colour cast to be 'corrected' whereas in reality you want to keep those colours. Setting the WB to Daylight, not Auto, will fix this problem.

The same goes for any image with a strong colour dominating the scene. Those deep red Simpson Desert dunes, the amazing Great Barrier Reef blues and the lush Daintree rainforest greens will all be muted if you use Auto WB. Turn it off, set the correct WB and those intense colours will be accurately recorded.

Boulia, Queensland, Australia | Canon EOS 5D Mark II | 300mm |
1/1500 sec @ f4.5 | ISO100

Creative use

It's not always necessary to worry about so called 'accurate' colours and picking the 'right' WB. Sometimes subjects just look better if they are a bit too warm or a bit too cool. Personally, I see white balance as a creative choice rather than a technical choice – in this second shot of Webb Bridge in Melbourne I have used the Tungsten (Indoor) setting to deliberately get a strong blue cast, giving the subject a more metallic and industrial look. This works well for cityscapes, but even for natural landscapes a slightly cooler tone can be very effective.

Webb Bridge, Melbourne, Australia | Sony A7R | Leica 18mm |
3 sec @ f11 | ISO100

White balance 183

Chapter 25

<u>Cityscapes</u>

Sydney Harbour, Australia

A good cityscape should make it clear which city you are looking at, so including some of the most recognisable buildings is important. I could not find an angle to include the Opera House in this shot but I have the Sydney Harbour Bridge as the main subject and the Sydney Tower in there as 'support'. Luna Park in the foreground is not so well known, but it adds a splash of light and the spinning circular ferris wheel contrasts nicely with all the other rectangular shapes. This is a dusk shot, taken about 20 minutes after sunset, when the ambient light and the artificial lights balance out nicely. My vantage point is my hotel room, chosen and booked for this exact shot. I had to shoot through the glass but with the lights out and a cloth over the camera, which was tight up against the glass, I eliminated the reflections which would totally spoil the shot.

— LEICA M (TYP 240) | 90MM | 4 SEC @ F6.8 | ISO200

01 Cities look at their best at dawn and dusk

02 All cities have some sort of vantage point for a good overall view

03 Major cities often have iconic buildings or monuments that identify them, so including them in the photo clearly 'places' the image

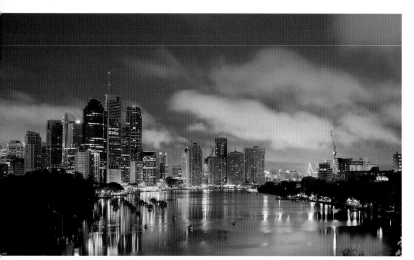

Brisbane, Australia | S2 | 70mm | 12 sec @ f4.0 | ISO160

'The photograph should be more interesting or more beautiful than what was photographed.'

– GARRY WINOGRAND

Cities can be drab, dull, dirty, noisy, frenetic, confusing and many other unpleasant things. At the same time, when the natural light is just right, office lights are twinkling and the dawn sky is reflecting off the glass facades of the skyscrapers, a well-photographed cityscape can be a thing of beauty – just as Garry Winogrand said.

Dawn and dusk

As with so many photographic subjects, cities look their best in that transition time between night and day. After dusk there will be a crossover time when there is still enough natural light to make an exposure and the lights in the offices and apartments are coming on. For a few minutes, as the natural light levels drop, there will be a balance between the two and this is when you get those classic city skyline shots such as the one that opens this chapter. Dawn is good for natural light effects, clear air and quiet streets but dusk is usually better for sparkling city lights because many of the artificial lights will still be turned on.

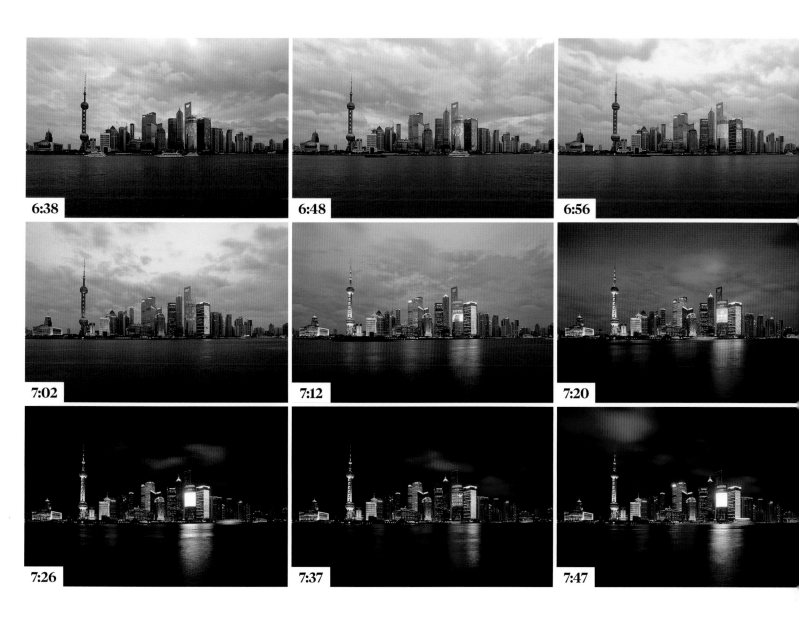

The key is to know when to shoot, when that balance between natural light and the artificial city lights gives you the most pleasing results. There are smartphone apps (see p. 033) that can tell you this down to the minute, but, as a rule of thumb, the best time is roughly 20 minutes after the sun has set or 20 minutes before the sun rises. This will vary according to latitude because the sun appears to go down much faster in the tropics than in the far north or south.

This sequence of nine images shows how the light varies from later afternoon through to dark, and I think the best choices are images 5, 6 and 7 because the balance between the sky and the city lights is the most pleasing. Sunset was 7.00pm that day and the best shots were from about 7.15–7.25pm.

I should also point out that the exposures for many of the later images were approximately 5 seconds or more, so a tripod or some other stable support was critical to getting a sharp image.

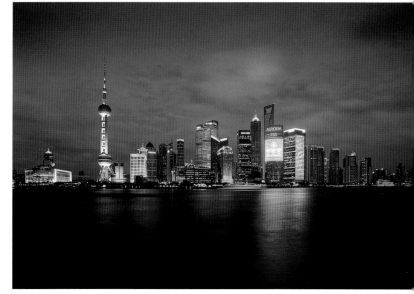

Shanghai, China | Canon EOS 5D Mark II | 19mm | 10 sec @ f5.6 | ISO50

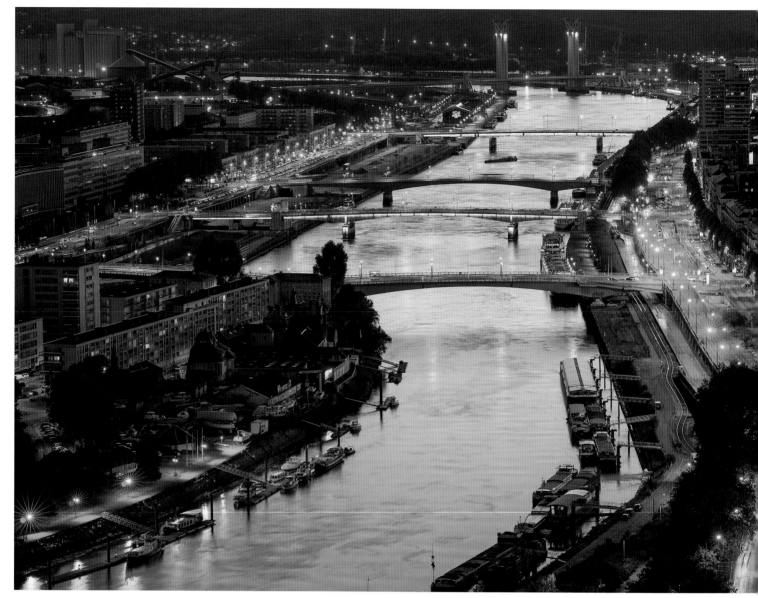

Rouen, France | Leica T (Typ 701) | 75mm | 4 sec @ f2.6 | ISO100

Vantage points

The tourism departments of major cities want people to visit, and it's their job to attract visitors. Luckily for them, many cities have very distinct skylines with some sort of clearly visible, iconic structure looming over the rest of the city. Paris has the Eiffel Tower, Shanghai has the futuristic Oriental Pearl TV Tower, Sydney has the Sydney Harbour Bridge and the Opera House, London has Big Ben, and Los Angeles, well, the less said about that the better! Some cities have even built such iconic structures quite deliberately so that everyone will recognise it from tourist photos – it's no different to using a logo for commercial product branding.

Photographs of these structures therefore 'place' the shot and so those tourism departments are keen for photos of their cities to be easy to shoot. To that end, there is usually a classic vantage point somewhere around the city with a fantastic view, essentially put there for your personal convenience as a photographer!

This should have been something you found out in your research and it should be one of the first places to visit on arrival. Not only does it give you a great way to orient yourself, but head there at dusk and, almost regardless of the weather, there will be a good shot to be had. Just don't forget your tripod!

So that's one shot of the city, an important one, but also a shot that everyone else will have. Yours *might* be very different though, because every day, with the exception of cloudless skies, the light is different and clouds are in different places. So it's always worth shooting the classic skyline and, once in a while, Nature will smile on you and reward you with an incredible natural light show.

There are, of course, many other vantage points to any city, beyond the obvious ones. Rooftop restaurants and bars, hotel balconies, hilly suburbs, anything raised up and with a clear view will give you a vista. Finding these places should be carried out in your planning phase, and once again Google Maps will be a great

help. One other way that I often find good vantage points is to check out the postcard racks and the souvenir books. It's a great way to find out what vantage points have been deemed worthy by other photographers.

Hotels often have great views but these days, if there is no balcony, it's not always possible to open the windows. Shooting through glass is not ideal but can be done if the window is clean. To avoid reflections of the room behind you, turn off all the lights in the room and position the camera so that the lens hood, if there is one, is touching the glass. If necessary, wrap the camera in a towel so that no light leaks between the lens and the glass. You might be surprised how effective this can be, so when you book a city hotel, try to anticipate the views and select your room accordingly. (The photo below was taken from my hotel's restaurant.)

If you are not staying at a particular hotel, but have worked out it has a great view, it's always worth waiting for a quiet moment and asking the concierge if you can take some photos from an empty room. It's worth a try, they can only say no, and an offer to let them have a copy of one of the photos you shoot can sometimes sweeten the deal.

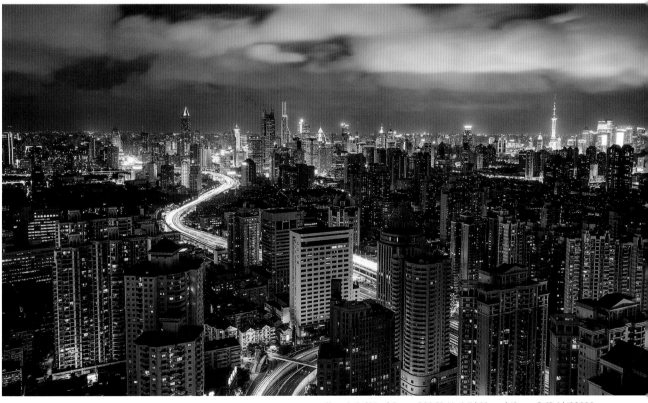

Shanghai, China | Canon EOS 5D Mark II | 29mm | 10 sec @ f5.6 | ISO200

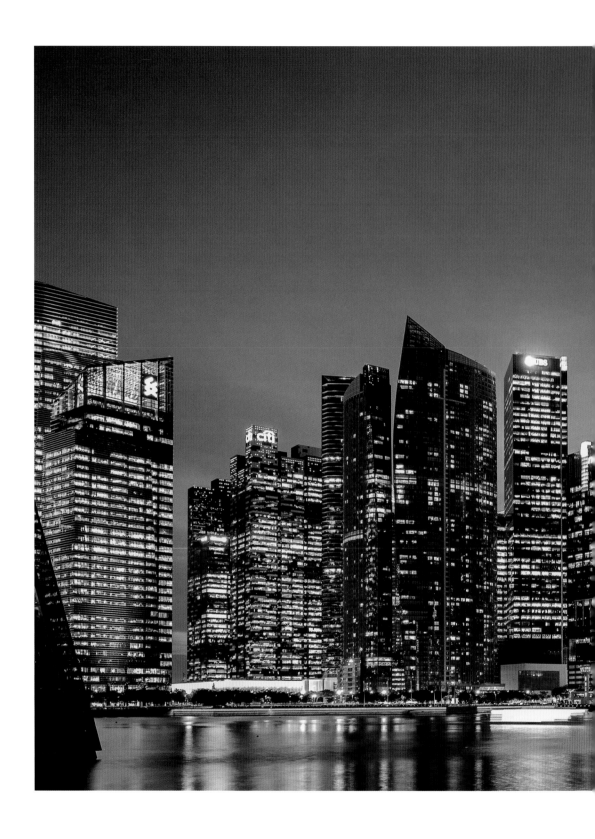

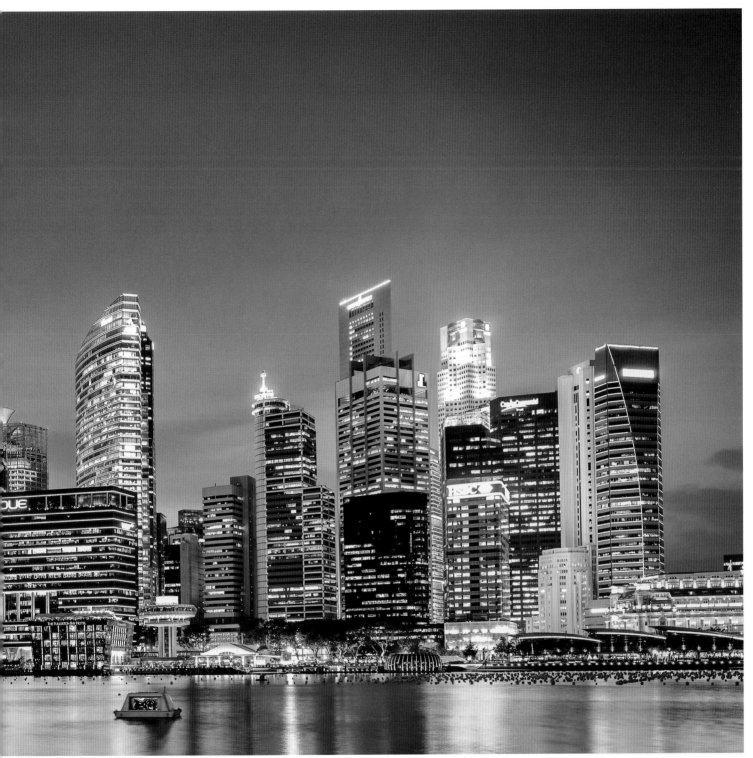

Singapore City | Leica S (Typ 006) | 30mm | 6 sec @ f4.0 | ISO100

Tripods

Eastern Kimberley, Western Australia | Leica M (Typ 240) | 18mm | 1/60 sec @ f5.6 | ISO200

With the availability of higher and higher resolution digital devices, it has never been more important to pay attention to your photographic techniques. A 24 megapixel camera is only going to reveal its amazing quality if the camera is rock steady – the slightest wobble and all that resolution is meaningless.

I'd even go so far as to say that a modest dSLR used very carefully on a good tripod could produce better results than a hugely expensive medium-format digital camera used carelessly on a flimsy tripod.

For guaranteed super-sharp images, it's critical that the camera is held steady, so steady that there is absolutely no movement at the time of the exposure. There should be no wind movement, no pressure from the photographer's hands and no vibrations from the camera's shutter. All of these things can degrade the image and the higher the resolution of the sensor the more obvious this will be. If you have spent a small fortune on the best camera money can buy, then you owe it to yourself to use the best support possible.

On the downside, tripods are awkward to carry, take up space and slow you down if you need to take a quick snap. Some photographers refuse to use them, some use them religiously – we tend to either love them or hate them.

Hardware

Tripods consist of two distinct parts – the legs and the head. It's quite common to think of the legs as the most important part; after all, the stiffness of the legs plays a crucial role in keeping the camera steady. If the wind is blowing and the legs are not rigid enough to easily cope with the camera's weight, then the camera will shift slightly in the breeze. You'll never get a sharp image if you are shooting with long exposures – like this image of a boab tree in the Kimberley under the moon and stars – without a good tripod. A 32-second exposure like this would be impossible without tripod support.

However, it's easy to concentrate on the tripod legs and neglect the tripod head itself – this is at least as important as the legs and a good head on ordinary legs will actually perform better than a cheap head on top-of-the-line legs. Not only that, but the head design plays a critical role: the pivot points, the materials used and the overall design all add up to keep that camera rock solid.

There are two basic types of tripod heads: three-way pan/tilt heads and ball-and-socket heads. Personally I like ball-and-socket heads because they are quicker to operate, if a little less precise, than a pan/tilt head. Most will have a quick-release plate which screws onto the camera's base and then clicks into the head itself. Beware of small heads with rubber pads on the plate – they can still allow movement through flex between the camera and the tripod. The less movement the better.

Many of the differences between various models lie in the controls and the quality of build. The cheaper heads will often be slightly less smooth to operate, use less rigid materials and will generally be less solid.

Things to look for

Rigidity A tripod should not twist and the legs should not flex much. Rigidity is why we buy a tripod in the first place, so this is top of the list.

Weight Heavy is good for strength but bad for portability – your choice! Carbon-fibre tripods are light for their strength but cost more.

Height Too low is bad for your back, but full-height tripods don't pack up so small.

Strength Make sure the tripod can easily take the weight of your heaviest camera and lens.

Leg clamps These should be quick and easy to operate, and hold the leg sections tightly in place. I like the Gitzo twist grips but others like the lever action clamps.

Feet Combination rubber pads and metal spikes are good. Metal spikes are great on rock, as rubber feet can 'squirm' a bit, reducing rigidity.

Construction Well-made tripods will last longer and will be a joy to use, but will cost more. Pay the extra and you won't regret it.

Recommended tripods

— Manfrotto 190XPRO, $280

— Manfrotto 055CX3 Carbon Fibre, $550 plus head

— Gitzo GT3542, approx. $1000

Recommended tripod heads

— Kirk BH3 ball head, US$285

— Really Right Stuff BH40 ball head, approx. US$350

Websites

— Gitzo and Manfrotto, www.gitzo.com

— Kirk, www.kirkphoto.com

— Really Right Stuff, www.reallyrightstuff.com

Dos and Don'ts

Here are some general pointers. Bear in mind that the don'ts are really more of a 'not necessary' than any sort of rule!

DO use a tripod if you want to get the sharpest possible photo of a static subject and you have the time to set it up.

DO use a tripod for any exposures where the shutter speed drops below about 1/15 sec or thereabouts.

DO use a tripod when using a huge heavy telephoto lens for bird or wildlife photography (or at least a single-legged monopod).

DON'T use a tripod when you need to shoot quick, spontaneous photos and there is plenty of light.

DON'T let a loose camera strap flap in the breeze as it can cause vibrations during long exposures. Tie it down securely.

DON'T use a tripod in those public places where they are not allowed. It's a good idea to ask permission beforehand anyway.

Sugarloaf Rock, Western Australia | Canon PowerShot G15 | 6.1mm | 1/100 sec @ f2.8 | ISO400

Hints and tips

In no particular order of importance, here are a few bits of wisdom that I have picked up in my travels.

1. Photocopy or scan your passport ID page and the page which has your entry visa on it, if you have one. Keep the copy on your person at all times.

2. Research your destination before you go. There are endless resources available online; even just look at some Google photos to get a broad idea of what you are likely to be seeing.

3. Do your own seat allocation and reserve a seat at the rear of the plane. Unless you are a high-ranking Frequent Flyer your best bet for getting a spare seat next to you (bliss!) is to opt for the back. Rear seats are also boarded first so you'll often get first dibs on overhead locker space.

4. As long as you are not trekking or schlepping your bags over rough terrain, try using a semi-rigid or rigid four-wheel spinner style suitcase as your checked luggage. If you don't have one of these run, don't walk, to the suitcase shop and buy one. You will not regret it. I now use a Rimowa Topas suitcase and it's amazing. Costly admittedly, but it's hard to break into, rainproof, protects the camera gear and looks cool with a few dents in it.

5. Take no more camera gear than you expect to use. Taking exotic lenses to test out can be fun but also counterproductive; any testing should be done at home. Don't take anything that will not get used – less really is more. You really can shoot entire stories on just a 24-70mm and a 70-200mm zoom. Anything beyond that will either be a specialist lens (like a big lens for wildlife) or a luxury.

6. Pack a powerboard. Hotels are notoriously stingy on power sockets so one international adapter and one four-gang powerboard can be very handy if you need to charge multiple batteries.

7. Always take a spare camera body, one which will work with all your lenses. It does not have to be anything flashy, but if you break your camera or get it stolen, you are in trouble. Insurance will get you a new one when you get home but it does not replace your camera in the field.

8. Pack your camera's battery charger and essential cables in your hand luggage along with your cameras. If your checked luggage does not make it to your destination, you can still work.

9. Photographer's vests might not be the height of fashion but they are very useful for carrying a few extra bits and bobs onto planes. Put your camera over your shoulder, put a lens in each pocket and you will have no trouble keeping your hand luggage under the magic 7 kilogram mark that some airlines are so strict about.

10. Following on from tip #9, stick to the airlines' published baggage allowances as close as possible, even if you know from experience that the check-in staff allow people to get away with much more. The day you turn up with an extra few kilos, expecting that you'll get away with it, is the day they do a spot check and you will end up paying excess baggage, or worse, not being allowed to check your bag until it's lighter.

11. Always plan to arrive at the airport at least an hour before you think you need to. If all goes to plan then you can relax, have a coffee and amble to the departure gate in a mellow state of mind. If it all goes pear-shaped then you have an extra hour to sort everything out.

12. Stash a few hundred dollars of a useful currency ($US are good in many countries) in your camera bag or inside your clothes somewhere while you're travelling. You never know when you might need a bit of extra cash.

13. Make sure you rigorously back up your image files each night.

14. See tip #13. Not that I am paranoid but, as Henry Kissinger once said, 'Even paranoids have enemies'.

15. Take two identical external hard drives to store your downloaded photos; make sure they are identical copies of each other and put one in your hand luggage and one in your checked luggage. If you store photos internally on a laptop, take one external HD and put it in your suitcase.

16. Take your back-up hard drive with you each day, or put it in the hotel safe. If your hotel room is broken into they will take the laptop and anything plugged into it.

17. Take the trouble to learn a few words of the local language. Just simple words like yes, no, please, hello, thank you and some basic numbers can make a big difference. It's amazing how pleased people can be when you make the effort.

18. Be respectful of other visitors and other people with cameras.

19. Never ever joke about security or terrorism at an airport or for that matter, with any security staff anywhere. Security staff do not have a sense of humour (at work anyway).

20. Never ever rant at, or otherwise lose your temper with, airport personnel. No matter how galling it all gets, expressing your anger will always make it worse.

About Nick Rains

Nick Rains has been a full-time professional photographer since 1983, starting off in the UK with sports and commercial work before moving to Australia in 1990. Since then he has specialised in travel and landscape work, shooting assignments for magazines such as *Australian Geographic*, *Outback Magazine* and publishers including Hardie Grant Publishing and Penguin. Nick was named Australian Geographic's Photographer of the Year back in 2002, and in 2014 was awarded the Australian Institute of Professional Photography (AIPP) Travel Photographer of the Year. Nick holds the title of LAIPP M. Photog II within the AIPP and is a National Judge.

Over the past decade, Nick has contributed to various magazines as a writer as well as a photographer, and is currently the Principal Instructor for Leica Akademie Australia where he runs photographic courses for keen enthusiasts – the very people that this book is aimed at.

Capturing the World is Nick's 10th book – other books by Nick published by Hardie Grant include *Australia The Photographer's Eye*, *Coastal Australia* and *Country Australia*. Nick has ideas for plenty more!

About Tim Page

Tim Page photographed his first war at age 19 in Vietnam. His photos graced the covers of *Life*, *TIME* and *Paris Match*, and were the visual inspiration for many films of the period. He was wounded four times, the last time by an anti-tank mine and spent most of the 70s in recovery in the US.

His archive spans 50 years and 94 countries. He is the founder of the Indochina Media Memorial Foundation, which was the genesis of his book 'REQUIEM'. The 'REQUIEM' exhibition is on permanent display in HCMC's War Remnants Museum. Since moving to Australia in 2002, he has covered the Solomon Islands, East Timor, and most recently spent three months as the Photographic Peace Ambassador to the United Nations in Afghanistan. He is the author of 10 books, the subject of two films and nine documentaries. He was recently named one of 'The 100 Most Influential Photographers of All Time'.

His interest and passion now is covering the aftermath of war and bringing the world's attention to the plight of the innocent victims. He is a patron of 'SOLDIER ON' and MAG (Mine Advisory Group) and goes to Vietnam every year to document the ongoing effects of Agent Orange. He has recently returned to live peacefully in Brisbane after 19 months in Cambodia working for the Finnish government documenting a land title distribution program.

Acknowledgements

The publisher would like to acknowledge the following individuals and organisations:

Editorial manager Marg Bowman

Project manager Lauren Whybrow

Editor Kate Daniel

Design and layout Murray Batten

Typesetting Megan Ellis

Pre-press Splitting Image

Explore Australia Publishing Pty Ltd
Ground Floor, Building 1, 658 Church Street,
Richmond, VIC 3121

Explore Australia Publishing Pty Ltd is a division of
Hardie Grant Publishing Pty Ltd

hardie grant publishing

Published by Explore Australia Publishing Pty Ltd, 2016

Form and design © Explore Australia Publishing Pty Ltd, 2016
Text and images © Nick Rains, 2016

A Cataloguing-in-Publication entry is available from the catalogue
of the National Library of Australia at www.nla.gov.au

ISBN-13 9781741175042

10 9 8 7 6 5 4 3 2 1

Printed and bound in China by 1010 Printing International Ltd

Publisher's note: Every effort has been made to ensure that
the information in this book is accurate at the time of going to
press. The publisher welcomes information and suggestions for
correction or improvement. Email: info@exploreaustralia.net.au

Publisher's disclaimer: The publisher cannot accept responsibility
for any errors or omissions. The publisher cannot be held
responsible for any injury, loss or damage incurred during travel.
It is vital to research any proposed trip thoroughly and seek the
advice of relevant state and travel organisations before you leave.

www.exploreaustralia.net.au